PRAISE FOR MOTHER HOWL

"*Mother Howl* is a live wire plugged into a world only Clevenger can see, and once he shares that vision with you, you'll be powerless to look away. Equal parts vicious and elegant, deeply thoughtful and even more deeply human."

Rob Hart, author of
The Paradox Hotel and *The Warehouse*

"Entering the world of *Mother Howl* is like reverse engineering an origami rattlesnake only to realize you're holding a bloodstained murder confession – this book will devour you just as ruthlessly and tenderly as you devour it."

Will Christopher Baer, author of
the Phineas Poe trilogy

"My copy of *Mother Howl* is so highlighted – this exquisite line, that casually pulled off, absolutely perfect phrase – that it sort of looks like it's glowing. Which? This is a Craig Clevenger novel. It does glow. Might burn your fingers, melt your mind."

Stephen Graham Jones, author of
The Only Good Indians

"A wrenching novel about inherited damage and what happens when you try to keep it so far in the rear view mirror that it can't see you – only to realize that it's been there in the seat beside you all along. Weaving Goodis-esque noir, crime, realism, and the supernatural, Clevenger gets the humanness of pain better than any writer out there."

Brian Evenson, author of
Last Days

T0035873

ADDITIONAL PRAISE
FOR CRAIG CLEVENGER

"A very impressive debut. The reader sees it from the con-artist's perspective, delivered in a snappy, first-person voice that Clevenger writes with assured flair. This is a tightly controlled piece of work with an intriguingly original approach to the genre that marks the author out as one to watch."

Metro

"Clevenger has created a manic monologist whose paranoia-inducing world pulls you in completely."

Seattle Times

"Clevenger's talent is revealed in his ability to create a true testament to the resilience of the human spirit."

USA Today

"Immaculately detailed and emotionally explosive: this is roiling, riveting stuff, of a piece with stylish, edgy movies like Memento and Requiem for a Dream."

Kirkus (starred review)

"Clevenger delivers images that sear themselves into your mind. The result is a novel that is hard, pure, remarkably accomplished."

Seattle Times

"Craig Clevenger has crafted an unforgettable antihero in John Dolan Vincent. This is an extraordinary debut."

Richard Kelly, director of *Donnie Darko*

"What sticks out about this remarkable debut are its pitch-perfect shock ending and John Vincent himself – his complex, conflicted mind, original voice and unnervingly self-defeating existence."

Time Out

MOTHER HOWL

BY THE SAME AUTHOR

The Contortionist's Handbook
Dermaphoria

Craig Clevenger

MOTHER HOWL

DATURA

DATURA BOOKS
An imprint of Watkins Media Ltd

Unit 11, Shepperton House
89 Shepperton Road
London N1 3DF
UK

daturabooks.com
twitter.com/daturabooks
Daniel Fletcher's extra finger

A Datura Books paperback original, 2023

Copyright © Craig Clevenger 2023

Cover by Kieryn Tyler
Edited by Daniel Culver and Victoria Goldman
Set in Meridien

All rights reserved. Craig Clevenger asserts the moral right to be identified as the author of this work. A catalogue record for this book is available from the British Library.

This novel is entirely a work of fiction. Names, characters, places, and incidents are the products of the author's imagination or are used fictitiously. Any resemblance to actual events, locales, organizations or persons, living or dead, is entirely coincidental.

Sales of this book without a front cover may be unauthorized. If this book is coverless, it may have been reported to the publisher as "unsold and destroyed" and neither the author nor the publisher may have received payment for it.

Datura Books and the Datura Books icon are registered trademarks of Watkins Media Ltd.

ISBN 978 1 91552 303 7
Ebook ISBN 978 1 91552 310 5

Printed and bound in the United Kingdom by TJ Books Ltd.

9 8 7 6 5 4 3 2 1

MIX
Paper from
responsible sources
FSC FSC® C013056
www.fsc.org

To Sarolyn, and the whole Boyd family

Names

UNCHRISTENING

The boy watched his father slide a flap of cardboard beneath the stray cat lying motionless in the street. He braced himself for the backyard dig though it wasn't in his nature to shovel dirt over the animal's open eyes and slack mouth. He ran to fetch an old bath towel and when he returned the boy saw the cat's eyes close once and then open again. His father put an ear to its chest and confirmed a moth's flutter of a heartbeat.

~

The veterinarian instructed the boy how to feed the cat with a plastic dropper. The boy felt his father's reassuring hand, fingertips splayed across his shoulder and thumb stroking the back of his neck. His own hand steadied after a time and his cat took to feeding without resisting. It was eating solid food on its own by the close of summer though it never limped more than a few feet from its pillow. The boy's parents went away the weekend before he entered high school. He spent Saturday afternoon and evening sitting beside the pillow waiting for his cat to blink again. After dark he put his ear to its chest and listened for a while, then moved a few inches and listened again. He once more retrieved an old towel and then paced the yard for a soft patch of dirt. The boy was fast becoming a man

3

and knew he was expected to act like one but as he dug by the light of the back porch his heart collapsed into itself.

~

When he was fifteen he fell for a girl who wore green ribbons in her hair. They shared two classes, did homework together and were beneath the bleachers after school when they kissed for the first time. The boy wore a blue tuxedo the color of aquarium gravel to the homecoming dance and his father slipped twenty dollars into his pocket and said to be home before sunup.

~

When he was sixteen he saw a young woman's face on the evening news. The boy recognized her but couldn't recall her name. She waited tables at a coffee shop, would sometimes stroke an errant wisp of hair from her face while she took his order. The boy could picture her white plastic name tag with red block letters but not the letters themselves. He remembered the birthmark high on her forehead like a large drop of wine, and the row of piercings down the edge of one ear like tiny rivets. He waited for the television to repeat her name but her picture cut to a reporter standing near a highway. The wind rustled his hair and he gestured to the sloping bank of weeds behind him where a stretch of pale tape with black letters cut the view in half. The screen cut to a picture of the boy's father. Eyes fixed forward but blank, his name and a string of numbers written in chalk below.

The boy stood at the door of his parents' bedroom.

"Mom," he said.

His mother sat on the edge of the bed with her back to him. His father stared back from the small black-and-white television atop the bureau, a still blue light in the dark. Like

standing in a bedroom on the floor of the ocean. The picture cut from his father to the waitress to the ravine and back.

"Mom," he said again.

~

The police arrived, red and blue lights flashing across the front yard. They said there were others, that his father had told them so. They took him out of school for three days and asked him questions. They brought him sandwiches and sodas, chocolate milk when he asked for it. The men would leave and others would come and ask the same questions.

~

The boy and his mother returned home to pack under the watch of escorts while men with gloves, dogs and strange lights searched their property. They slept in a motel where a sheriff's deputy sat in a folding chair between their adjacent rooms. He worked in shifts with another deputy and they held their post for a week, and after that there was a squad car in the parking lot. It was there when the boy went to sleep but gone when he awoke. Then it was gone altogether after two weeks and the boy and his mother were alone. After three weeks a deputy informed them the search of their property was complete. He would not say if they had found anything. The county would reimburse their first two weeks at the motel, but they were otherwise free to remain or return home.

~

The office was quiet but for the humming ice machine outside. Pictures of tropical islands and walls the color of toothpaste. The clerk's hair lay matted on one side of his head and stood straight out on the other, and his glasses magnified his eyes

so he looked perpetually startled. He would pause mid-step to rifle through his memory for the whereabouts of his keys or a burning cigarette, turn around, pause again, then resume his business.

The boy's mother handed the clerk a card and after a moment he handed it back, shook his head and said the card was declined. She offered him another and the clerk did the same. She then opened her pocketbook with such force a spray of coins chimed across the lobby tile. The clerk stared at her third credit card for a wordless stretch, sighed and scratched the stubble on his neck. The boy's mother looked at the clock on the wall of mint-colored brick and said the card belonged to her husband.

The boy raised his hand and held it in the air just above her shoulder. He was almost seventeen and had not shown his affections since childhood. At last his fingertips grazed her sleeve and his mother stiffened as though seized by a current snapping through her.

She settled the account while the boy carried their bags outside, where morning sunlight flared on wing windows and mirror mounts across the parking lot. From a distance the Impala appeared to be sinking into the blacktop. He set their bags down beside the trunk and surveyed the damage. The tires had been cut and jagged lines had been gouged into the paint with the sharp end of a key or shiver of pipe, window fragments sprayed across the seats and shattered headlamps spilled onto the ground.

~

The tow truck arrived after an hour and the boy and his mother were home again at midday to find their house still standing, guarded by a perimeter of plastic streamer no stronger than a line of voodoo chalk. A deputy knocked that evening and admonished them to remove the yellow barricade

tape surrounding their property. Their house and yard were no longer a crime scene and the display was an unlawful use of investigatory materials. He offered to assist but the boy said no thank you and took to removing it on his own, the firstborn son charged with scrubbing the blood from the doorpost. He pulled up the thin wooden stakes and then gathered the plastic ribbon into a garbage bag. His mother retired for the evening and the boy kept the house dark but for a kitchen light. He picked up the telephone and dialed.

"Hello?"

He had asked for her a hundred times by name, the girl with the green ribbons in her hair, mindful not to call too late or during mealtimes. He asked for her again but his tongue stuck to the bottom of his mouth.

"No, she is not," said the voice at the other end. There was not a good time to call back. She would not be free later. He was never to call their house again.

The hum of an empty signal.

The kitchen window exploded and glass fragments sliced through the curtains and a fist-sized rock glanced off the faucet and cracked the sink. The boy crouched on the kitchen floor and covered his ears until the profane jeers receded into silence.

~

He had worked weekends at a movie theater for a year. He arrived one Saturday, his vest and trousers in plastic from the cleaner, when they explained there had been a mix-up and his name was not on the schedule for that evening, that they would see him the next day. Eight days a month became four became two until he arrived one afternoon and couldn't find his time card. "There aren't enough hours to go around," they said. "We're trying to be fair." They told him to check back in two weeks but he knew better.

~

The first time he was jumped they broke the cornea in his right eye. He was still wearing the patch when he was attacked again by men wearing translucent masks, their faces blurred beneath nightmare clown grins. He was sent to the emergency room twice more before he withdrew from school the summer before his senior year and tried to find full-time work. Hotels, grocery stores, fast food drive-throughs and car washes. Thirty-five applications for two callbacks.

The first was for a bellboy position. The bell captain had been upbeat and gregarious on the phone but nowhere in sight when the boy arrived for the interview. He waited for more than an hour before a security guard informed him the position was filled and then escorted him from the premises.

He met later with the manager of a bowling alley who smiled and shook his hand and said he would call. The boy thanked him and went outside to find his windshield shattered. He had parked in full view of the main entrance but nobody had seen a thing.

~

The sign said HELP WANTED – BUSBOY – WAITRESS. He knew the place well and thought they would favor him if he applied. He asked the hostess for a job application and filled it out in a booth next to a vending machine full of stuffed toys. After he returned it to the hostess and she called the manager, the boy waited beside a pastry case filled with peach and cherry pies that looked like glass, like they would shatter if pierced with a fork. The manager arrived, introduced himself and extended his hand as he read the boy's name aloud. His voice died out before he finished reading and he took his hand away. The boy's ears rang and he grew cold. He remembered the waitress with the errant wisps of black hair who had served him coffee

and pancakes before her body was found in a ditch, and he left before the manager said anything else.

~

His name was Lyle, after his father. They called him Junior at home but he was Lyle to everyone else. Lyle had maintained a 4.0 GPA, scored in the top five percent of his class on the SAT and lettered in track and field as a distance runner. But now when he said his name he became invisible. Conversations stopped and people looked away. They became hard of hearing or too preoccupied to notice him. They had to hurry off, take an important call or close early. And when he wasn't invisible he was an accomplice to his father by virtue of his name and every bit as guilty. He was no longer Lyle. His father was a killer and now he was Junior to everyone.

~

The man's red hair was his only distinguishing feature. Were it not for that, Lyle would never have noticed him. On the drive home he struggled to recall the man's face beyond a vague impression, and though he'd waited all morning at the county clerk's office while seated directly across from the red-haired man, he couldn't be certain it was the same man sitting beside him at the lunch counter. Lyle had been staring when the red-haired man turned to him with the slow deliberate manner of a cat. He didn't speak and he didn't blink. He had grey eyes like painted glass and the blank expression of a mounted animal head.

"Excuse me," Lyle said. "My mistake. I thought you were someone else."

A hollow half minute passed with the man staring at Lyle.

"And who else would I be?" he said.

"No, it's just, forget it."

The man resumed eating, chewing his food as though demonstrating how to do so. And then with the slightest glance and dip of his chin he put Lyle at ease.

"Yeah. I mean, I thought I recognized you. Been at the courthouse all day."

The man nodded. He studied his French fries as though inferring some encryption within their arrangement.

"I was petitioning for a name change." Lyle winced at his own nervous chatter but the words took control. "Waste of time. Court rejected my request. They said ten to fifteen days after the application for a hearing date but after six weeks I still hadn't heard from them. Went down there in person and waited all morning and they just denied me. Handed everything back with that big red stamp across the front."

The red-haired man wiped his hands with his customary deliberate motion, then stared directly ahead until he had finished chewing before he turned to Lyle again.

"Let me see your paperwork," he said.

~

They met again at a burger stand, with Lyle bringing half the payment in cash as the red-haired man had instructed. He told Lyle to keep his given name, as it lessened the chance of him slipping up, but he should carefully consider his new surname. Anything too common could be scrutinized as an alias. Anything too obscure invited questions about a family history he didn't have. Lyle sat down and passed the fat envelope beneath the table, brushing the man's knee.

"What are you doing?"

"You asked for–"

"Don't act like you're breaking the law," the man said. "That's how you get caught."

Lyle set his payment on the table in plain view. Without looking about or showing any hint of nerves, the red-haired

man picked it up and tucked it inside his coat. Lyle waited for
him to show his badge and announce himself, for the squad of
cops in full body armor to surround him, guns drawn. But the
red-haired man only stared at Lyle, expressionless.

"Name?" he said.

"I thought–"

"Have you settled on a name, or do you want me to do it
for you?"

"I haven't, not yet." Lyle looked away, embarrassed. Across
the street, a bank of transformers hummed with electrical
current, secured behind cyclone fencing. Lyle blurted out,
"Edison."

"Lyle Edison, then. That's all for now." The red-haired man
stood and left.

He hadn't eaten, and Lyle never saw his hands except when
he took his payment. But there on the table was a slip of paper
with the time and place of their next meeting. Like a magic
trick.

~

The broken cornea had cost money. So had the wired jaw,
the porcelain teeth, the steel ankle screws and the chain of
stitches, splints and casts that were no sooner healed than
followed by another injury. His new last name had cost even
more. When he met the red-haired man for the third time, his
college savings were almost gone and he'd put his car up for
sale. But he at last held a driver's license, birth certificate and
Social Security card all bearing EDISON in lieu of his birth name.

The red-haired man regarded his food as though he
recognized waffles and orange juice from a guidebook or
documentary.

"I keep forgetting your name," Lyle said.

"Good."

"You mind telling me again?"

"Call me whatever you want." Then he gave Lyle the sort of unsolicited wisdom that seventeen-year-olds are prone to ignore. "Most of my clients are either in trouble or up to it," he said. "I've seen enough to know you're neither one." He tapped the envelope with his knuckle. "So you understand, all this in here, it's just paper. It doesn't say who you are, just what your name is, nothing else. If you think it changes anything but words, like you think it'll make you any different, then you're going to feel cheated. You'll just have to do it again and it still won't work."

"I'm not following you," said Lyle.

"No, you're not." The red-haired man finished his breakfast without saying anything else, as though he were eating alone. That was the last time Lyle saw him.

~

Lyle regarded the moment when he was held to account for the crimes of his father by virtue of his blood and his name to be the moment he was no longer a boy. He pondered his unwitting transition into manhood as he chased a stream of butane into an upturned hubcap with a matchstick struck on the pavement. The flames crested and faded with the burning of his birth certificate, middle school diploma and his notice of withdrawal from high school. Black flakes ascended on the updraft, circling the dim ribbon of smoke that darkened when the laminated cards took light: his old student ID, Social Security card and driver's license. Each recoiled at sleepwalk speed into a crackling black knot until the fire died and the fading smoke took his old name with it.

~

Lyle Edison dropped his license and money through the Greyhound station till. The woman behind the glass held the

license level with Lyle's face for an instant, then dropped it back with his change. She circled the platform number on his ticket and handed it through, then called for the next passenger in line. Lyle hoisted his bag and it felt weightless. He headed to the concourse, moving against the tide of arriving passengers. They checked their watches, scanned the overhead timetables and flagged their waiting loved ones. A man standing beside a row of newspaper machines played a wheezy rendition of "Saint James Infirmary" on a harmonica. Lyle dropped a dollar into the upturned fedora and the harmonica player dipped his head in acknowledgment.

He boarded a bus before noon and disembarked from a different bus in the dark of morning. He paid two weeks' rent up front in a backpackers' hotel for a room with a twin mattress on a metal frame, a single window facing a brick wall within arm's reach, and a four-story drop in between. He shared a common bathroom with the other tenants: transient European students who stayed out until dawn, conspiracy theorists, environmentalists and traveling activists. Bicycle messengers sporting tribal haircuts and road rash. Writers who argued with each other the works of long-dead authors, who smoked pot and spoke plans for all to hear about an underground newspaper but Lyle never saw them write anything.

One of the bicycle messengers asked Lyle about the scar hooked beneath his eye. It was the first time someone had been openly ignorant about the reason behind his injuries, and the choice of possible truths overwhelmed him. The messenger spoke again before Lyle found a reply.

"Check this," he said. He pressed Lyle's fingers to his face where Lyle felt the skin slip across the nailhead welt fixed above his cheekbone, the titanium pin from a hit-and-run.

The messengers were a bedraggled lot. Leathery racing-dog muscles and skin parched and peeling from exposure. Dirt blackened the hair on their arms and ringed their eyes, and their shins were flecked with oil and road grit. They crushed

beer cans in their fists, kicked doors open and slammed them shut. They invited Lyle to drink with them and he accepted. He hoped it would smooth out the stammering and brainlock that seized him whenever he spoke to one of the girls at the hotel. The beer was thin and sour beneath a layer of bitter foam. Lyle nursed a single plastic cup until it turned warm.

The Austrian girl had enormous brown eyes and moon-white hair woven into hundreds of tiny braids. She smiled at him once and Lyle's face turned hot but she left the city before he ever spoke to her. The Parisian girl had the dark skin of her Caribbean parents and she was older than Lyle. She leaned in close when he spoke, admiring his command of French, and Lyle smelled cinnamon and flowers in the air close to her. She spoke to him in English, her accent heating her words into vapor that gathered in hot droplets on his ear and when the first trickle broke loose and slid down his neck he kissed her. She did not resist but after a short time leaned back and held both his gaze and his hands and then she smiled. Lyle's heart pounded and he flushed with lust and embarrassment. She had spoken of her boyfriend in Paris. Lyle looked at his shoes and his words scattered. She took his face in her hands and lifted it to hers, then whispered to him. He was a sweet young man, she was very fond of him. A chain of endearments drifting between her language and his. Her lingering kiss followed, as sincere as it was final.

Lyle Edison worked off the books for three years. Bicycle messenger, house painter, odd jobs. Either rent or groceries, but rarely both at once. Free clinics and the dental school. Both asked for his ID, but the dental college needed his Social Security number. He would have dropped the intake forms and walked out were it not for the escalating pain in one of his remaining natural teeth. They replaced the filling. The Social Security number stayed in a file with the rest of the information the red-headed man had sold him and the file was in a drawer or a box somewhere, forgotten. He applied for a

job at the university library. Full benefits, rent and groceries at the same time. First and last name, date of birth, place of birth, Social Security number and high school. He signed the consent for background check, filled out a W-4 and went home with his stomach twisted in panic. He took a reluctant drag from a joint with his housemates and his panic mushroomed into paranoia. Human Resources rang during a coughing jag and said he could start Monday. He filed the first 1040 of his life the following spring and let his private theater of dread run its showcase without help from a joint. He received two refund checks, State and Federal, for a total of sixty-three dollars. Funds were cut back and library employees were cut loose, so Lyle went back to painting houses and soon picked up demolition work. He stayed on where he was needed, when framing or drywall crews lost people to injury claims or too-frequent hangovers. By the time he'd acquired all of his own tools, he had enough steady work for another W-4.

Credit card applications, HMO enrollment, night classes.

"Edison? Like the inventor?"

"Yeah." Exactly like the inventor. Nobody else.

Checking account. Auto loan. Vehicle registration.

"People ask if you're related to Thomas Edison all the time, I'll bet."

"Not always. I'm used to it."

A P.O. box. A rental agreement for a new apartment.

Three traffic stops in eight years and his name came up clean each time. One of the officers aimed a flashlight at his eyes and told him to wipe that goddamned smile off his face.

The passport application was a private dare to himself. It required the certified copy of the Lyle Edison birth certificate he had bought from the red-headed man. Crippling insomnia followed, then dry mouth and heart pounding from the government plates in his rear-view mirror one afternoon. The Priority Mail envelope arrived from the State Department after seven weeks and he slept again.

But he never stopped looking over his shoulder, always ready to disappear again. Month-to-month leases, mattresses on floors. The itinerant nature of construction work suited him well, and he never owned more than he could fit all at once into his truck. He saw the future as an abstraction but spared no expense on the present, so he managed his money no better than he had in high school. But he was still alive because of it.

Years later, he met a woman and at last wanted to stay in one place for good.

NEW BRAIN

Icarus fell.

Three-hundred pounds of freshly incarnate flesh and bone with nothing to break his freefall but the grace of the same god who had just given him the boot. Wind stretched his cheeks into a rippling skeleton grin, flames snapped from his wings and a black ribbon of smoke plumed grey in his wake.

Twenty seconds to impact if the fire didn't take him first, the smoke trail stopping midair in a burst of blood vapor and smoldering feathers.

Ten seconds.

Wing stumps burned off clean.

Five seconds.

Insects peened his chest and teeth. Last chance to speak his name out loud, make it official.

"Icarus," he said, and a bug hit the back of his throat.

Zero.

A rain of shattered high-rise glass and a geyser from a ruptured water main beneath a steaming crater in the asphalt.

Someone shouted, "Man down!"

I guess that's it. I'm a man now. Shit. I got to breathe and bleed and remember to put the seat down. I got to use stairs. Goddamned stairs.

Icarus opened his eyes to the naked sky.

So, that's blue.

He knew the frequency, a dim twitch of a signal now regarded

17

with his tender new eyes, pockets of jelly skinned with a clear membrane and blind to all but a sliver of the Mother Howl's full transmission.

"What do we got here?" Four shapes ringed his vision, men silhouetted against the blank whimper of blue. "Sir, can you hear me?" They wore badges and their belts were laden with all manner of hardware and they had no sense of urgency whatsoever. "Blink once if you can understand what I'm saying."

"Icarus."

"Icarus? What's that mean?"

"My name."

"Sure thing. Where are your clothes, Icarus?"

"Clothes are for primates."

"So's identification. You have an ID on you, Icarus?"

"Got no pockets, Captain. You guess where I'm holding an ID, you can pull it out yourself."

Icarus gauged their manner and reckoned these men begrudged their occupations. They secured him upright and took him to a place without windows where he clocked the days by his meals and the appearance of a man in grey who dragged a mop over the floors, to no visible effect. The humming lights leached the color and shadows from everything. The walls, floors, patients, staff, bathrobes and lab coats drained of distinction.

One day they ushered him to another room, one with a window. The walls were empty but for a coat hook and a framed certificate hung from a nail shot into the brick. A man stood from his seat in greeting.

"You seem to have bounced back rather well, all things considered," he said.

He wore a two-day growth of beard and looked as though he'd been awake for both days. He directed Icarus to a couch. Brown vinyl with yellow foam swelling through the cracks, and swaths of silver tape patching the armrests.

"Please," he said.

Icarus stood with his feet apart and his hands folded behind him, a full head taller than either of his escorts. He was bald and the light cut a hard band of shadow across his eyes. He didn't blink and he didn't appear to breathe.

"All things," Icarus said.

He stepped onto a sofa cushion and its brittle skin snapped like tree bark. He crouched atop the armrest and curled his toes over the edge, draped his arms between his knees and stared forward, perfectly still. A weathered stone gargoyle.

"Excuse me?" The man dismissed the orderlies with a nod, then seated himself in a chair likewise leaking and leprous with neglect.

"What things exactly were you considering, Captain?"

"It's just an expression," the man said.

"*All things*. You have no idea, Captain."

"I suppose not. Though nobody's ever addressed me as Captain before."

"You ever hunt whales?" said Icarus. "Fly a plane? Like one of them jumbo jets what has those little dollhouse bottles of whiskey?"

"I can't say that I have."

"Then I would venture to say that's why nobody ever calls you Captain."

"What about you?"

"Nobody ever calls me Captain, either."

"No, I mean you. Why do you call me Captain?"

"Because I'm depressed. Because my daddy beat me and my momma left me. And the world keeps getting hotter, Captain. All them antioxidants and corn syrup and polyester melting the polar caps. No more condors or pandas or grey whales or eight tracks. Bringing me down to where I just want to end it all."

The man nodded. He reached for a legal pad on his desk and turned to a clean sheet.

"That was a joke," said Icarus.

"Of course."

"But you're going to write it all down, anyways."

"I'm obligated."

"Not to me, you ain't."

The man returned the pen to his pocket, set the legal pad aside and stood. "What do you say we start over?" he said.

"It's your show, Captain."

"My name is Dr Finn." He extended his hand and Icarus took it from where he perched. "You may call me Walter. I'm a psychiatrist for the State Department of Mental Health."

"The System."

Dr Finn returned to his seat. "We can agree on that," he said.

"I am pleased to make your acquaintance, Mister Doctor Walter Finn. Mind if I call you Captain?"

"Not at all. And what should I call you?"

"Icarus. First thing out of my mouth. Told those men what brought me here so it might ought to be on your chart there, someplace."

"Icarus," said Finn. "The man who flew too close to the sun and melted his wings. Mind if I ask your last name?"

"You may ask, but I can't oblige you with an answer."

"You don't have a last name."

"Indeed, Captain. You most definitely earned that sheepskin."

"I did, yes." Finn smiled and said, "*Sheepskin*. Know where that term comes from? They once used sheepskin to make diplomas. A long time ago, not anymore."

"They use it for condoms now," Icarus said.

"Actually no, they don't. They use, I mean, they're mostly latex now. Safer."

"Bet the sheep feel elsewise."

"That's not what I meant."

"You're well informed about these things, Captain."

"I'm in public health, Mr Icarus."

"Just Icarus."

"Icarus. Yes. Why is that?"

"Greek names were fashionable for a stretch. Just like y'all with your Jennifers and Lisas one year and your Brittanys and Courtneys the next."

"I don't recall Greek names ever being fashionable during my lifetime."

"Wasn't talking about your lifetime."

Finn stared at his notepad, then took a deep breath. "Where are you from, Icarus?"

"Long story."

"I've got time."

"Not near enough."

"Trust me, Icarus. I have more than enough time."

"You don't know the meaning of the word. Listen to me, Captain. I don't aim to cause you grief. You have your obligations and I know you're doing good for a lot of folks in this place. But me, I'm just passing through. Y'all patched me up after that spill and have shown me considerable hospitality and I will not forget that. But hear me on this. You can set me up in a five-star suite if y'all want. Have me dining on lobster humidor."

"Thermidor."

"It don't matter. I'm just saying, I get my marching orders, Captain, I march."

"Orders from whom?"

Icarus remained silent.

"Does God speak to you, Icarus?"

"You mean to ask if I hear voices, Captain?"

"I wasn't trying to ridicule you, Mr Icarus."

"Icarus."

"Icarus. I'm sorry if I sounded flippant. But my question is, yes, do you hear voices?"

"Got my ears from the same place you did, Captain."

Finn set his notepad aside once more and closed his eyes for

a moment. "Icarus. If you don't want to answer my questions, I will respect that. Just say so and trust me, I'll understand. I've got more patients than hours in my day. Otherwise, the more honest you are with me, the more I can help you. And I do want to help. Do you understand?"

"Clear as shrink wrap."

"Now then, tell me, Icarus, why did you try to kill yourself?"

"Only thing I tried to do, Captain, was land on my feet."

"I have the police report right here. Says you jumped from a ledge, and that a canvas awning and a discarded couch broke your fall. Which makes you about as lucky as winning the lottery twice in a row."

"Whichever ignorant donut hole wrote that there report didn't roll up until I was ass-to-asphalt looking back at the sky. Man couldn't be bothered to scribe my name down proper after I introduced myself."

"Says here several witnesses saw you jump."

"They saw me hit the ground. Your witnesses got my trajectory upside-asswards."

"Help me with this, Icarus. You hit the ground but you didn't jump. Were you pushed?"

"My own free will."

"So, you what, fell from heaven?"

"In your quaint manner of phrasing, yes."

"You telling me you're an angel, Icarus?"

"I don't much care for that term. *Angel.*"

"What term would you prefer?"

"*Icarus.* Thought we'd moved on."

"Okay, so you're one of those messengers from the Bible?"

"I'd appreciate you keeping your agenda clear of my mouth, Captain."

"My only agenda, Icarus, is to make an honest assessment of your psychological health. Whether you follow the Bible or not isn't my concern. But the Bible describes others like you claim to be."

"I believe it does," said Icarus. "And while I'm walking this sodden clump of dirt, I just might have occasion to wipe my ass with a page or two but elsewise I got no use for it. Your people wrote that book, Captain, not mine. Me, I didn't have a set of balls or a place to hang them until I showed up here, and I'll be rid of them when my job is done."

"So, when you're done with your mission here on earth, you'll fly back to heaven and become an angel again?"

"Told you not to call me that."

Finn held up his hands.

Icarus said, "Captain, me and my crew cooled the earth. I've crumpled suns in my bare fist. Made those black hole things, pockets in space so dark they bend math. I watched you monkeys climb down from the trees, sprout thumbs and figure how to sharpen sticks so's to roast marshmallows in front of cave paintings. And I'm just one of the clean-up guys. A clock puncher."

"And what brings you to our little planet, then? What can you tell me about your mission?"

"Orders ain't come down, yet."

"But when they do, how will you know what God is saying?"

"I just decide what I want to hear. That's been working for y'all down here for some time."

Finn picked a stray thread from his trousers.

"Another joke, Captain. When word comes, I won't have any choice but to hear it. Believe. And once I wrap up this gig, I'm gone."

"You get your wings back."

"Laugh all you want."

"I'm quite serious, Icarus. How about telling me why you took on an unknown assignment?"

"Why did you take this gig, Captain? You really want to be here with all these foilheads?"

"It's complicated."

"Indeed. That's the System. But there are better gigs than playing foreman to this clown car wrecking yard."

"No question. I'd love a more, let's say *comfortable*, position. But it's not that simple."

"You said that. What you mean is it's political. And you've got certain obligations to the System."

"You've got me, Icarus. That's the sad truth. The System, like you said. It's all about who knows who."

"Whom. And that's all I'm saying, Captain. I got this bum detail same way you did."

"Hold on. All of you *non*-angels, you *beings*. All of you, up there, you have politics? I thought you were all perfect."

"Ain't nothing perfect, Captain. Ain't nothing imperfect, either. Things just are. As for me and my crew, you got more than one way to do things and more than one voice saying how they should be done, you're going to have some hollering across the table. Fact of life. And I don't put ceremony before my opinions. Sometimes, I pay for that."

Finn checked his watch, twisted the dial.

"Icarus, I think we're finished for today. But I'd like to speak with you again. That sound okay to you?"

"You're the man with the sheepskin. I'll talk as much as you want while I'm here. But like I said, when I get word, I'm gone."

"As long as your word comes after I've signed you out."

"Captain, I mean you no disrespect. You got your people to report to and I got mine. Thing is, someday after your sun's turned black and the last bones of the last monkeys have crumbled to dust miles below the miles of ice, I will still be humbly serving at the beck and call of the Mother Howl. When word comes, I am walking out of here. With or without your signature."

Icarus unfolded from his gargoyle crouch. He stood above the doctor and put his fingers to his brow as though tipping his hat.

"It's been a pleasure to make your acquaintance, Captain. Have a pleasant afternoon."

~

Icarus perched with his knees to his chin, gripped the cot frame with curled toes and rapped the back of his head against the wall. The room swayed and color spots flared. Burning vapor trails and electricity arcing between ghost points. He put his thumbs to his eyes and they held firm. He tapped his teeth with a fingernail and pressed his fingertips to his head, harder, harder, then his palms to both ears harder still and listened. Nothing but the whispered ocean hiss of his own blood. His new flesh came with joining the ranks of glorified monkeys. It was exemplary from the neck down, had survived an entry into the world that would have killed any other man.

But he considered his new brain but a wet simian machine. A deadbolt on the doors of perception, blind and deaf to all but a few crude frequencies split between his eyes and ears, those meat scraps tuned to the slag pooled on a derelict dirtwad. His new brain was ill-suited to house the preceding eternity, and everything prior to his arrival was draining from memory as he passed the days in his bloodless surroundings.

He had witnessed the birth of time, and the universe expanding and collapsing in measures too vast for any clock. He had watched the monkeys leave the trees, stand upright and make tools and fire. From hunting and gathering to sowing and reaping. They made words that twisted the universe to their understanding and with barely a grunt they expressed eternity and everything within it: *God*. The monkeys had reduced the boundless frequencies of the Mother Howl to crude symbols and self-serving morality tales whose rival faithful were known by their violent allegiance to a trinket. And now Icarus was marooned among them.

The signal was strong, his surroundings broadcast clearly. The floor and ceiling, the texture of his clothes and skin all maintained fidelity regardless of shifting sunspots or local interference. Plumbing droned and shook the walls. Telephones

rang, intercoms crackled, pagers chirped and security doors buzzed. Patients coughed, cried, sang and screamed above the television playing cartoon music. Every sound sustained by its echoes from painted brick and bank teller's glass.

"Got monkeys what had their brains wired wrongwise at birth. They hear this white noise twenty-four seven with no source but their own ears, yet they're brought here for sanctuary."

Icarus checked himself. His thoughts were best kept clear of his tongue. Solitary mutterings begat screaming at phantoms and a fear of black helicopters.

The most far-gone patients shuffled about in secondhand bathrobes, observing each step as though walking for the first time. Others were poorly tuned, their brains and bodies dialed to some netherpoint of noise between their common frequency and the full bandwidth of the Mother Howl.

The old woman appeared first, her face seized in pain and her wide eyes fixed on some private bygone loss. She clutched her breast to keep the pieces of her heart from scattering. She never ate, never moved from her corner of the dayroom and no one attended to her. Whatever horror had driven her to the care of the System remained beyond its reach but inseparable from her, and her faulty tuning made her smallest movements stutter or freeze and then skip. The old woman wiped her eyes, then locked motionless for a moment, flickered like a weak candle flame, and then she blinked from view. Empty chair. Scuff marks on wallpaper. She reappeared in a sandstorm haze of static, still mourning.

The other Untuned likewise moved in bursts without apparent effort or choice. A man kneeling in prayer froze, shimmering and limpid for the length of a sigh, then disappeared, reappearing at the far end of a hallway or on the opposite side of a window but always mid-motion, the seconds between clipped from the sequence. The Untuned were men and women of every age. Their clothes were dated, some

formal and resplendent, others torn or violated with dark stains and their eyes were filled with profound sorrow or a pure and prolonged animal fear. They carried Bibles, prayer beads and ragged toys. They stared at photographs or re-read the same grim letters, day after day.

The System remained ignorant of them, and they remained in the System, wards of nothing and no one. The Untuned, the ignored, the abandoned, and the forgotten, all had a part in the Mother Howl's infinite machine and were it not for his new brain, Icarus could comprehend its grand design and each thing's place within it.

"Please don't leave me here." His prayer echoed and faded, heard by Icarus alone but swallowed by the surrounding noise, and the hollow in his heart grew.

~

The tremulous form of a dark suit like the reflection in a shimmering pool. The transmission cleared and there stood a man, his gaze cast groundward, holding a wide-brimmed black hat in one hand and a cone of newsprint wrapped about a bouquet in the other, the fingertip below his wedding ring missing at the second knuckle.

"Good afternoon, Icarus," said Dr Finn.

The Untuned man stood behind him, outside the reinforced windows where the sun streamed through and wrapped the office in a lattice of light and shadow.

"Captain," Icarus said, assuming his perch on the sofa. "Your man with the pink flowers, there at the window, he inmate or staff?"

"This hour," Finn said without looking, "staff. Probably one of the landscapers. And we don't have inmates here, Icarus."

"Somebody might ought to savvy him on some softer soil elsewhere for them carnations."

"He's a gardener. I'm sure he's given it plenty of thought."

"Looks to me like he's still thinking on it, and he's a dog's light year from making up his mind. And planting stems what ain't got roots seems rather unschooled for someone on your payroll. Elsewise, you got one despondent groundskeeper on your hands. Got a face of a man what's tired of planting his own kin."

"Icarus, let's talk about you. How are things?"

"You and your things, Captain."

"They treating you well here?"

"Still waiting on the lobster."

"Budget cuts hit the cafeteria. We're doing the best we can."

"Food's fine," said Icarus. "Except the pears."

"And what's wrong with the pears?"

"Nothing, long as they stay out of my mouth. Pears just ain't right."

"You don't have to eat the cafeteria's pears if you don't want to, Icarus."

"Ain't that a load off."

The man holding the flowers looked to the sky, then back to the ground, buried his face in the crook of his elbow while his shoulders shook briefly and then he was still again.

"You mentioned someone, last time we spoke." Finn flipped back through his notepad. "Mother Howl," he said. "Want to tell me about her?"

Icarus pressed a thumb to his forehead and squinted as though keeping a headache at bay. "Ain't no *her*," he said. "Or *him*. Ain't no nothing. Except everything."

"I don't get your meaning."

"Don't be too tough on yourself, Captain. Like you said the other day, it's just an expression. Another one what you got no idea, and ain't no way any one of y'all can fit that much meaning into one of these." Icarus pointed to his head.

Finn waited.

Icarus sighed. "Y'all said it, in that book of yours. *And darkness was on the face of the deep.* Good enough description of things before there was things, I reckon. But jump cut to

where y'all went all bovine on the glassware, *In the beginning was the Word*. More like a Scream."

"Or a Howl," said Finn.

"Indeed, but even that don't make the mark. Ain't just noise or color we're talking, but everything. Ocean waves, radio waves, and all them humming particles what you call your Silly String Theory. Everything around you ain't but a piece of a single transmission what begat the universe."

"You have an unusual manner of speech, Icarus."

"That a question?"

"If you have an answer."

"Got lexified on my departure, Captain. Same way a spaceman gets his Sunday barbeque in one of them little pills, but without the pill. Aardvark to Zzyzyx, Oxford-style, and I cherrypick my meanings as I see fit."

"Okay then. Has the Mother Howl, I don't know, spoken to you yet?"

"You'd be talking to an empty seat, if it had."

"You sound pretty certain of yourself."

"*Sound*," said Icarus.

"What about it?"

"Thought that sheep condom on your wall meant you could reckon that for yourself."

"Care to tell me what's on your mind?"

"You got to show me a stack of diaper-stain pictures, first. Ask me what they look like and then tell your people I'm a Type II BLT. Elsewise, I tell you what's wrong, Captain, then your people got to start paying me. Then I get to drive your fancy car and violate your sheep, and you can stay locked in a white box, watching cartoons with talking farm animals and eating pears with Nixon and Elvis."

"It sounds to me like you're feeling confined."

"You keep saying *sound* like you got more than a gnat's notion of the word. I'd draw you a diagram but y'all won't let me have a pencil in lockdown."

"Nobody's put you in lockdown, Icarus. This is not a prison."

"That one of your jokes, Captain?"

"No. I thought you could leave whenever you wanted."

"After I receive instructions, then I may leave. I get firm orders before that, say I got to enjoy the wait and like where I'm enjoying it, you'll see a whole different side of me. A smile on my lips and a spring in my step, Captain."

"Okay, still, you're feeling caged up. Am I correct?"

"Getting warmer, Captain, but you're still miles from hot."

"I can authorize more free time for you, Icarus, more outside privileges. You could help with the gardening."

"You say to my face you ain't running a prison, then you tell me that being outside is a privilege. Shit. Forget it, Captain. Wrong cage, anyways."

"Which cage, then?"

Icarus rapped his chest. "This one," he said.

"Your body."

"Check your notes, Captain. This here monkey leather's on loan."

"Okay. But you feel trapped in it."

"Indeed."

"That why you attempted to take your own life?"

"Won't let that go, will you?"

"I have a duty to your safety, Icarus. Once I'm convinced you're not a threat to yourself or anyone else, I can have you discharged. There are programs to get you temporary shelter, some assistance from the State. But I need to believe you."

"Captain, your beliefs are your own choice. Don't matter if I want to die. I can't. And I'm good with that, long as I ain't stuck here. But savvy this: imagine waking up one morning and you're an insect. You got to look at the world through your little bug eyes. You eat scraps off the floor and hope you don't get stepped on or cut up for a science project. Light bulbs and shoes are the enemy, and you got these kids what popped out of eggs some lady roach shat out behind the baseboards,

some sweet bug thing you don't recollect tipping your hat to. And the whole time you're living your insect life, eating your own dead and sleeping in cracks in the floor with the whole world hating you, all you can think about is what it was like before you were a bug and how much you miss it. Every day you spend being a bug is one more day you don't spend being a man. And bit by bit, your old man-self gets squeezed out because it's all too big for your little bug brain. But the men who made you a bug said, Don't worry, we'll bring you back when it's time. And you believed them. But their word and your trust, those are just more of your old man-self draining away. Forgetting them is nothing. It's knowing you'll forget them, that's what you can't take. All you can do is watch it happen because you ain't nothing but a bug." Icarus tapped his forehead and said, "I got your prison right here, Captain."

"From angel to ordinary man," said Finn. "I forgot, not an angel. My mistake."

"Forget it. If that word's easier for you, go with it. But that's what's happening. And the bitch of it is, I know I'm wrong, just because I do. Been around a few times, you know? But I can't see things like I used to. I can only see one outcome because now I got the same monkey brain you do. You'd think maybe the Mother Howl's crew would have tricked it out some, given me proper tools for the job."

"Such as?"

"Like x-ray vision. Or making it so's I can pretzelize a fork by staring at it. I don't know any *such as* like you say, but near as I can tell, I came off the same assembly line as you and your gardener there." Icarus addressed the man in black. "Keep staring, my man. Maybe the hole will dig itself."

Finn twisted in his chair for a view of the sunlight lattice projected over the corner of the office, then turned back around.

"Icarus, describe the gardener for me."

"You blow an optic fuse there, Captain?"

"My eyes are fine. Tell me what you see."

Finn's pager chirped from his belt and the gardener strobed in and out of sight. Finn switched it off and the gardener's frequency steadied.

"Life or death business, Captain? I can wait."

"Not at all. I'll get back to them."

The doctor once more traced the line of sight from Icarus to the sunlit corner behind him.

"What do you see, Icarus?"

Icarus smiled. *New Brain, indeed. Solid state.*

At seven million colors and twenty-thousand hertz, the monkeys were pure Old Brain. Their receivers redlined at the gulf of radio silence where the Untuned lived on the opposite shore, yet they were still fool enough to claim communion with the Mother Howl.

"I see same as you do, Captain."

"You don't see a man in the corner?"

"Nope. Do you?"

"You mean the gardener?"

"He's long gone, Captain. Must have found a better place for them carnations."

"And there's nobody here except for you and me?"

"Captain, I know you think I'm just another foilhead what thinks Elvis shot Kennedy or some shit. But I ain't seeing things."

"Consider my dilemma, Icarus. I have a patient who claims to be a messenger sent from Heaven. But according to witnesses and the police report, this patient is a homeless man who attempted to take his own life. What would you do in my position?"

"What I'd do is I'd get my science on it. Skepticize the situation and get some proof."

"All right, then. I need proof that you're an angel."

"Like something in a plastic bag you can flash to a jury?"

"How about a miracle?"

"Captain, I could show you a miracle, turn a blind man into wine or make loaves and fishes walk on your bath water. Won't stop all y'all from watching your own kind eat out of garbage cans, or telling some woman with a black eye she should have turned the other cheek. Y'all want a magic show when the real miracle is pulling four billion heads out of four billion asses all at once. Where I'm from, y'all look like walking donuts. Damn shame is what it is. You want a miracle? How's about I write my name on these walls with a blood slug trail leaking out of the back of your brainless skull? Magic enough for you?"

Dr Finn slapped his palm onto a plastic button fixed to his desk and his office door burst open the same instant. The orderlies seized Icarus from where he perched and secured him to a wheelchair, and Icarus did not resist. They bound his wrists and feet with heavy belts and took him away.

Finn's pager sounded again but he ignored it. He sat wrapped in a lattice of light and shadow, staring at an empty seat.

THE SYSTEM

He met her in his sleep. A veil shrouded her face and she spoke in a voice other than her own, dream words that made no sense but he nonetheless understood. He knew with the certainty dreams sometimes bring the sleeper that it was her. She kissed him and he held her lower lip between his teeth. Then her veil was gone along with everything else she wore and the dream went dark. He awoke wrapped around her and she around him, moving together slowly beneath the covers. It was the first time the woman of whom he'd been dreaming was the same woman who slept beside him.

"I love you." She looked away from him in the dark and he heard the soft tremor in her voice, her words buckling beneath the weight of her confession.

"And I love you." He'd never said this to her before and now his whisper came as a relief.

~

One late afternoon she locked herself in the bathroom. Neither of them had ever closed that door completely since they'd moved in together. A crack of light in the dark of the bedroom but never anything less. He sat on their bed with their cat curled in his lap and listened to the rustle of cellophane and plastic, her bare feet on the tile. He shifted his weight and the

34

bed frame groaned like a barn door and he felt her eyes on him through the wall.

The doorbell rang. Their building played host to a steady parade of solicitors. Newspapers, raffle tickets, cookies, salvation. He set the cat gently onto the bed and stepped into the living room, where the visitor had already entered, uninvited.

"It was unlocked," the visitor said, and handed him a plastic beaker with a white cap and a marker on the unbroken seal. The label bore a serial number and a name: LYLE EDISON.

"Mr Reid," said Lyle.

"Officer Reid."

"Officer."

"This a bad time, Edison?"

"It make any difference?"

"Not to me." Officer Reid closed the door behind him, surveyed the tiny apartment and made a face as though he were smiling in spite of some rank smell. "You want to cop an attitude, Edison, have at it. See if your act works in the tank for a night."

"I got called in yesterday for screening," Lyle said. "And two days before that. That's already twice this week."

A small notebook held together with an elastic band lay atop a speaker cabinet. Lyle removed a card the size of a passport wedged behind its cover and offered it for inspection.

"All my signatures are up to date," he said. "Not to mention I've got group tonight, and every night this month."

Reid ignored the card. "I know when you've got your court-ordered circle jerk. And I know when you pissed, into what cup, and how much."

"Of course you do. Because I've been compliant with the court, every step of the way. Why would I be using the day after a random screening with group the same night?"

"Because that's when you think nobody's got an eye on you. And because I'm not asking." Reid scooped the mail fanned

across the coffee table with a single sweep of his hand like a seasoned card dealer. He read each envelope and dropped them to the floor one by one. "Court also says I can search your place if you're being uncooperative," he said. "Are you?"

"No." Lyle slipped the card back into the notebook.

"And I can take your copping an attitude as a sign that you're being uncooperative. You copping an attitude with me?"

"No."

"No, what?"

"No, sir."

Lyle had heard the stories about Reid. The young man living with his grandmother, getting back on his feet. Reid took a knife to the woman's furniture and gutted every last cushion and mattress based on an anonymous tip the kid was moving product again. He violated his probationers who couldn't find work and made anonymous calls to the Health Inspector and Fire Department on the places where they did. He lost urine samples and broke tail lights.

"I'm going to check your bathroom," Reid said. "To make sure you got nothing stashed in there. Once you do your business, I'll be out of here and you can act like a prick all you want."

"My girlfriend's in there. Give her just a minute. Please."

"Stashing a clean sample for you?"

"No, sir."

"What's this girlfriend's name?"

Their mail lay scattered at Officer Reid's feet. Utility bills, credit card statements, a notice of rent increase, either in Sera's name or Lyle's but never both. The sweeping seizure of his assets looming at the start of his troubles had never been realized, but Lyle had taken every measure to insulate Sera, to keep her life separate from his in the eyes of the court. His lawyer had met her only once and Lyle had never before mentioned her to Reid. Sera had offered to accompany Lyle to one of his hearings but he'd refused, though reluctantly conceded to let her drop

him at the courthouse on two occasions. The apartment they shared listed only Lyle's name on the rental agreement, thanks to an oversight by the building manager.

"I asked you a question, Edison. So far all you've given me is a reason to kick your bathroom door down."

"Her name is Sera. Please. She'll be out in a minute."

"She over eighteen?"

"Yeah."

"Yeah?"

"Yes, she's over eighteen. Sir."

"Just making sure. I know how you dealers like to start them young."

Sera burst through the bathroom door, through the bedroom and with a few rapid strides stood between the two men.

"Lyle is not and never has been a dealer," she said. "And I'm thirty-one."

"Sera. This is Officer Reid. My probation officer."

"You can call me Nestor." Reid smiled.

"Random screening," Lyle said.

"You went yesterday." Sera kept her eyes on Reid.

"Won't take but a minute, Miss. Unless it takes your boy here time to work up a trickle. Or unless you want me to stay for dinner."

"Lyle didn't tell me how much you enjoyed your job, Officer Reid." Sera wore a pair of sweatpants that hung loose on her hips and a t-shirt cropped above her belly.

"Please, call me Nestor."

"Officer Reid. This is a bad time."

"Sera," said Lyle. The cuffs cutting into his wrists loomed in his memory.

"It's never a good time, Miss. I'll just be a moment." Reid stepped through their bedroom and into their bathroom, startling their cat who bolted out and ducked beneath their bed. Coal black from head to toe, Scissors was but a pair of eyes floating beneath the bedsprings.

"I've found clean samples stashed in all kinds of places," Reid said. "Other things, too. Catheters and stuff. They got that special shampoo now. People use it when they need to get their hair tested, instead of urine. Believe it or not, every now and then somebody's not hiding anything." Reid raised his voice above the clatter of toiletries and makeup swept into the sink. Lyle heard lids snapped open and cast aside, boxes and jars hitting the tile, the medicine cabinet and shower door flung open, then slammed shut, the toilet tank lid dropped back into place. The garbage pail toppled over, used razors and empty plastic bottles rattled across the floor.

"Well, shit. What do we have here?" Reid emerged holding something like a thermometer. "What's blue mean? That good news? Anybody?"

"It means I'm pregnant."

Reid lobbed the plastic stick to Sera. "Never actually seen one of those before," he said.

"I'm not surprised," said Sera.

"You sure it's his, honey? Hell of a day, Edison. Now get your ass in there and fill that cup. Any extra, try one of those little sticks yourself. I wouldn't be the least bit amazed if you turned it all kinds of blue."

When Lyle returned he exchanged the hot specimen cup for a carbon form with two lines marked for his signature.

"I'll contribute to your baby's college fund by not tearing your place apart," Reid said. "And don't sweat this, kids. Assuming it's your first, there's a good chance you won't make it past the first trimester. Give everyone in group tonight a big kiss from me."

Lyle shut the door behind Reid, turned the deadbolt and then sat down beside Sera. He rested his arm on her thigh and took her hand. She leaned her face into his chest and Lyle could smell her hair.

"Hey," he said. "If it's a girl, we'll name her Nestor."

Sera laughed once, almost like a cough. "Please, Lyle, not now."

Two days earlier, Sera had said she was late. They catalogued

their precautions aloud while Lyle silently ran odds to the contrary. What he knew of her cycle and how seldom she remarked on it. The night she'd returned from her book group and roused him from sleep, her breath hot with vodka. And for those two days nothing existed more than thirty minutes beyond the moment for Lyle, his future bent through a lens into a concentrated point of panic deep in his gut. The end of his two days marked the end of her fourteenth, when she had locked herself in the bathroom.

Sera looked at her watch, an anniversary gift from Lyle. In return, she'd given him a silver ID bracelet that she hadn't had time to engrave. Lyle left it that way.

"You should go," she said.

"There's a number I can call if I've got an emergency. I'll have to jump through some hoops, but I can get a pass on group tonight."

"I don't need you to babysit me, Lyle."

"That's not what I meant."

"I know you didn't mean it that way."

"So why don't you want me to stay?"

Sera said, "Lyle." She spoke his name with the same firm but dispassionate tone the medics had used when he was younger. *Can you hear me? Do you know who you are?* Not an address but a test of cognition. "It's not what I want or what you want. It's a matter of you not violating your parole because you missed a meeting."

"Probation."

"It's neither if you go to jail. That asshole, Reid, just wrecked our bathroom. You want to give him a reason to come back?"

"Sera, I can call. I said that already."

"I'm not going to give birth tonight. I just need a couple of hours to get my head around this."

Lyle stood and went to the bedroom for his jacket, came back for his attendance card and notebook, fished his keys from the bowl of change by the door.

"I'll be back later. Want me to bring anything home? A movie?"

Sera shook her head. Lyle had his hand on the door when she said his name again. He turned to her but she said nothing until he walked back to where she sat.

"I love you," Sera said. That insistent, unwavering tone again, probing for life.

"And I love you." Lyle bent and kissed her. "One day I'll beat you to it."

"I doubt it." Sera kissed him again. "Now get out of here."

~

The Untuned hummed at the room's edges like projections on lace. No telling if the Untuned were Old Brain or New Brain, and Icarus knew better than to test the signal gap while still pickled in monkey blood. With no evidence they could clock his presence let alone his intentions, addressing the Untuned might look like talking to the walls, and little prosperity could come of that. The whole place made his skin hurt and he didn't like having skin.

"Afternoon, Captain."

Finn spoke through a muzzle of boreholes in the thick window. "You threatened me," he said.

"You believe I would actually hurt you, Captain?"

Finn had spent years reading patients' signals, the tics and eye movements that spoke volumes more than their words. But Icarus had the face of a man sleeping with his eyes open, without so much as a day's growth of stubble or the restless, reddened eyes of the newly incarcerated.

"My job, Icarus, is to assess and evaluate, to make a diagnosis and recommend treatment. I don't make split-second judgments in combat. If I believe that I or a colleague is in imminent danger, I will act accordingly."

"Captain, I am here at the pleasure of the Mother Howl. And while I remain unburdened by your social graces or rules of civility, I do not and will not hurt people."

"What if you think they deserve it?"

"Ain't for me to decide. Y'all favor sharpening sticks for each other's tender spots more than for roasting marshmallows, Captain. Ain't a single tick of time in history's got more monkeys dying of old age than at the hands of another."

"What if someone threatened you?"

"People don't threaten me, Captain. You got more questions, maybe some picture puzzles, might you want to consider reclaiming the upper hand of a home game?"

"I'm happy to see you back in my office, Icarus, but I need to understand why you threatened me."

"You asked for a miracle."

"I'm listening."

"You still don't believe, do you?"

"I believe you're being obtuse, so you're not being fully honest with me."

"Likewise, Captain. Full disclosure goes both ways."

"Icarus, please."

"Captain, y'all did everything in here but take a stool sample, never mind I got this set of bones not just a few days ago. But I reckon you made some calls, right, Captain? Reeled in some favors?" Icarus held his hands up and fanned his fingers wide. "Now I know what you found, Captain. But do me the courtesy of explicating on what those outstanding favors brought to light." Icarus lowered his hands.

"You had no prints on file, that's all I know. I didn't hire an investigator."

"But you made some calls. You know people who know people."

"You've never been arrested, driven or tried to pass a check in this state. That's all we know," said Finn.

"There's your miracle."

"What? You've never been fingerprinted is proof you're an angel?"

Icarus held up his hands again. "Brand new, Captain. You not believing don't make it untrue."

"Icarus, I'll remove you from secure housing, but will you submit to some therapy with me? I think I can help you."

"Indeed. I get my old room back, Captain?"

~

He was granted time in the courtyard daily, the first natural light on his skin since he'd arrived. The Untuned surrounded him but with each passing day their signals became further scrambled, their transmissions bent further to the edge of his eyesight. When Icarus turned to them directly he found a cluster of leaves he'd mistaken for a face, a bag of lawn clippings that had taken sleeping human form before closer inspection. A shock of white hair in the corner of his eye became a pale, fluttering pigeon perched near the metal door to the courtyard. Layers of paint had long ceded to enormous Rorschachs of fiery rust, and as Icarus regarded the bird, the rust became fluid as though refracted through bent glass, and a dull wave of vertigo struck him. A patch of color, high as a man's shoulder, dislodged from its backdrop and drifted, shimmering as though seen through a heat wave and capped with the mad flapping of the albino pigeon that once more was a shock of white hair and a beard of frost. The shimmering stilled and the shape faced Icarus with a face of its own, a man who looked nearly a century old before his signal had been Untuned.

Icarus steadied himself, then stepped closer. The Untuned man appeared frightened and Icarus turned around to see the bad news for himself but there was nothing. He fully expected the old Untuned man to be gone when he looked back but he remained, and when Icarus took another step the man was visibly trembling.

"You can see me," Icarus said.

The man nodded. Then he was gone. The pigeon flew away and the mottled metal door opened from inside and an orderly called the patients in for the day.

~

Seventeen people snapped from view the instant Icarus went deaf. First came the stuttering of a short from the floor of his New Brain, then the pop of a blown switch. The intercom pages, shouts of distress from other patients and every other signal within range went dead.

"Hello?" Feedback pierced his ears when he spoke.

Icarus swept his palms through the vacant space like a magician dispelling suspicions of fishing line. He drifted through the empty hall where the Untuned had stood seconds before. A boy in his Sunday best standing vigil with a rusted shovel. A woman crouching with her knees to her chest and her hands over her ears. Gone.

The nurse had been checking his pulse and blood pressure and listening to his heart twice daily every day for two weeks. He looked into his eyes and ears with a small light and murmured his approval, then selected a paper thimble of capsules from a metal trolley and gave it to Icarus with a cone-shaped cup of water. Icarus had asked about the medicines but couldn't remember their names. The nurse said something about a type of salt and monitoring his electro-somethings. Lights, it was. His electric lights. Two pills twice a day, four pills every day for fourteen days, fifty-six pills in all. Finn's scattergun tactic had the allegiance of time. It would eventually land upon the right wattage to jam the New Brain's receiver and today was that day.

"Finn," Icarus said, his voice a distant broadcast blown to static. His heart swung between certainty and doubt.

The Untuned had spontaneously corrected their flawed signals.

Finn was jamming his New Brain's receiver, intercepting orders meant for Icarus.

Finn was a monkey and couldn't possibly outwit Mother Howl.

The hospital was a fortress and its walls were already blocking transmissions.

Icarus was an anomalous pinpoint blink on the radar. A flock of geese, a weather satellite or a meteor bursting into superheated dust. There one second, gone and forgotten the next. Skies clear, cancel priority alert.

Old Brain, New Brain and back again.

~

Icarus lay beneath the warm afternoon sky, a sheet of luminous blue unbroken but for a single monstrous cloud overhead like a snow-covered mountain. A hundred million tons of rock and ice stretching to an airless peak, all at once uprooted and suspended above the earth, light as a whisper. The ebbing breeze rose again and carried white tufts up from the grass and rushed through the trees, where the rustling leaves sounded like rainfall. Icarus couldn't recall when or if he had ever felt a breeze. Flutes and shafts like rat mazes funneled spent air throughout the hospital, but every breath out in the open was his and his alone.

Small birds no larger than a man's thumb flocked among the branches. Their wings had the hue of the surrounding leaves and their bellies were the color of the sun, and they hopped madly from limb to limb, pausing long enough to emit a short burst of sound from their small beaks, like a fingertip slipping across wet glass.

The anxious feet tapping at the edge of his sight became shadows thrown from rustling leaves when he looked at them directly. The Untuned moving about his periphery were ultimately window reflections of patients or staff, more shadows or the darting movements of small wild rodents. His head lolled to one side, then sank forward and he floated in a half-sleep with the sun glowing through his eyelids. The excited bird calls were all that kept him from dreaming completely. A nurse woke him and said it was time to go inside. Icarus stood and stretched, feeling rested for the first time in his life.

~

"You can speak the truth with me," Icarus said. "Bad news is best served out loud."

The nurse checked his pupils but said nothing.

"I knew it. How long before my flesh and bone clocks out?"

"Hard to say," the nurse said. "Forty years, maybe. Fifty, max. Problem is, you're in top physical shape, which means there's nothing we can do for you. It's out of my hands, I'm afraid."

He handed Icarus his pills.

"Notice how you said *physical* shape," Icarus said. He swallowed his pills and drained the paper cone of water. "Meaning to say that I'm batshit crazy."

"Oh no, you're fine on all counts."

"That so? What's with the brain candy?"

"Micro transponders," said the nurse. "CIA, FBI, NSA and, give me a second, I always forget the other one."

"PTA," said Icarus. "Been after me for years."

The nurse's smile cracked first, then Icarus followed with a blast of laughter that felt better than sleeping beneath the sun.

"See you tomorrow morning, brother." The nurse clasped Icarus on the shoulder and added, "Bright and early."

"Have a good evening yourself, sir."

The nurse's touch lingered after he'd left, the first hand Icarus could recall that wasn't forcing him into or out of a room, strapping him to a chair or gurney or slapping his inner elbow for a vein. He slept that night and dreamt of warm sunlight and birds.

~

Dr Finn's lips moved but no sound came. He stopped speaking and his disembodied question followed moments later.

"How is your hearing now?" Finn's voice played back out of nothing.

"There's a delay," Icarus said. He sat with his feet on the ground, both hands in his lap. Finn had the windows open to let in the breeze and the whitewater sounds of fluttering leaves.

"How, exactly?"

"Like I don't hear a person's words until after their face quits moving."

"How long have you been experiencing this?"

"Since wake-up o'clock. It comes and goes. Most of the time everything's synced, but the tracking slips now and again."

"What else?"

"Not much. I mean, my hearing just comes and goes in general."

"Since this morning?"

"Yeah. I'll hear all the sounds, you know, on either side of me."

Icarus shut his eyes and pictured the source of the noise. "Television set overhead," he said. "Phones down the hall, door behind me. Little motor in the drinking fountain kicked on, I guess it keeps it cool, I don't know, but I'd never heard it. Startled me, believe it or not. All these sounds coming at me, then they'll just stop. Like God just pulls the plug on all the noise and I can't hear a thing for three or four minutes. Then it comes leaking back. Everything's out of alignment for a while, like I said, then it all slips back into gear on its own."

"Before this morning, how was it different besides being out of sync?"

"I heard everything."

"Everything?"

"More or less. It was in earshot, I heard it. But I couldn't tell you where it came from. All sounded the same, like one big noise locked on one volume. I guess this could be an improvement."

"Very possibly. What about your vision?"

"My eyeballs are team players, so far." Icarus examined his folded hands, scraped the dirt from beneath one fingernail

with another. "I'm seeing everything that's there, and nothing that ain't. Same as y'all, not like the other day. But I reckon you figured that out."

"I did," said Finn.

"You understand, I couldn't let my crazy out unsupervised until I got a clear read on you."

"Of course."

"I don't suspect you got reason to believe me now."

"Icarus, I believe you. That's part of my job, to know when a patient is telling the truth, even if they believe they've seen flying monkeys."

Sunlight streamed through the windows, and Icarus watched the shadowplay of patterns across the wall. He recalled the man standing in solitary contemplation with a bundle of flowers, the grave at his feet visible to him alone. Icarus had first been as unmoved by the mourner's loss as by the plight of any fellow patient. But his treatment had awakened a deep sadness at the thought of the man, whether he had been real or imagined.

Icarus said, "What now?"

"We stay the course. Seems your treatment is working, so we keep monitoring you. I'm pleased with your progress so far, to say the very least. So, I'm optimistic about a long-term plan for you presenting itself very soon. In the meantime, I've asked an old friend for a records search on you with what little we've got."

"How does that work?"

"I don't know. But she's a pro. It's what she does."

"What happens when you cut me loose?"

"We work with other agencies, nonprofits. We can get you set up somewhere, at least short term, and connect you with a counselor for job placement. But filling out an application as *Icarus* won't help things. You need a last name."

Icarus stared at his hands.

"The good news," Finn said, his voice and his words paired at last, "is you're not in any trouble. We can be certain of that. FBI's never heard of you and the cops aren't looking for you

either. Somebody knows you, Icarus. Doesn't mean they miss you, but they do know you."

"How do you mean?"

"Could be somebody's worried sick about you. Or could be you owe child support or back taxes. People don't just drop out of the sky." Finn smiled and Icarus likewise cracked a wide grin. "Second time I've seen you smile," Finn said. "Nurse told me you two had a good laugh yesterday evening."

"We did."

"Sounds good. We'll maintain your dosage, then. But tell me if your hearing doesn't improve soon, and let me know immediately about any further changes in your hearing or anything else. We'll find whoever's out there that might be looking for you, Icarus." Finn tapped him on the knee with his file. "Rest easy," he said. "For better or worse, somebody, somewhere, knows who you are."

"God only knows," said Icarus.

~

Icarus took his medicines and his meals as scheduled. He leafed through magazines stacked about the dayroom shelves. Travel, nature, and celebrity gossip rags donated by the heap. He sat beneath the sun and listened to the birds, to the roar of jets overhead or the distorted nursery song of a far-off ice cream truck. He saw nobody but flesh-and-blood staff and patients, and he heard every word the instant it was spoken. Before he slept each night he thanked the Lord for delivering him to the good care of his keepers, and humbly placed his trust in God that he would be an honest working citizen in the Lord's own due course.

The scriptures came back to him like bits of polished glass beached at low tide.

And I will show wonders in heaven above, and signs in the earth beneath; blood, and fire, and vapor of smoke.

And let it be, when these signs are come unto thee, that thou do as occasion serve thee; for God is with thee.

Brushing his teeth or dozing off beneath the trees, something small and bright on the muddy floor of his memory caught the light and the words flashed to his mind.

Be not faithless, but believing.

Blessed are all they that put their trust in Him.

His nightly prayer grew as what he was grateful for compounded by the day.

~

The silence struck Icarus with the force of a wave and nearly knocked him to the ground. The slide whistles and falling anvils of the television's cartoon animals, the paging system, intercoms and the din of the dayroom were all gone at once. He followed the second hand's sweep around the wall clock for a full minute. Two minutes. Five. An hour. Deep-space quiet for ninety minutes before he heard another sound.

Aye. A clip from a single word, then more silence. The lone sound looped in his mind like a distorted dial tone for thirty minutes before the next sliver of speech: *Well.* Very well, thank you. Well, isn't that thoughtful. Well done. Maxwell. Cromwell. *Well* and *aye* pooled together and stretched apart, sustained and reverberant. *Ayewell.* By lunchtime Icarus feared the delay in his ears would cease that night and the entire day's noise would commence cruel playback when he tried to sleep. He briefly bowed his head in thanks for his meal when the word *bring* sliced through the quiet. *Briiing.* Resonating like the chime of a wine glass until a pulse of breath cut it short. *The.* Icarus repeated the sequence as it grew, conjoining the sounds into a mantra to fill the quiet until the understanding burst through him with all the force of that first silence:

I will bring the walls down and show you the way out.

~

Icarus prayed and the full weight of his humility bore down upon him, his eyes cast downward while he laid his gratitude at the feet of his Creator. He now believed that the care he had received, the food, shelter, and Dr Finn's therapy had together pried loose the Devil's grip on his brain. But for the first time he asked God for more, for the wisdom to discern the Lord's word from his own dementia.

I will bring the walls down and show you the way out.

God had told man not to eat from the Tree of Knowledge but had nonetheless given man free will to do so or not. He never made that mistake again. God ordered Abraham to sacrifice his son. Abraham played chicken with God. Abraham lost. God ordered Lot to flee Sodom and Gomorrah. Lot spun childish excuses and dragged his feet. God dispatched a crew of specialists who'd learned a strong-arm thing or two since Jacob. These jackbooted, winged goons did their midnight, black bag, snatch-and-grab, pulled Lot's lagging ass from the fire and brimstone, but not before Lot's wife made their unmarked van from two blocks out. She gave it her best run, got two steps and never moved again so Lot, heartbroken and single, was back on the market.

God told the Pharaoh to find his own cheap labor and the Pharaoh told God to kiss his ass. God could have capped his firstborn then and there, changed the Pharaoh's mind out of the gate with none of the counteroffers and negotiations and plagues. God, being all-knowing, all-present and eternal, had seen it all. God was bored. So He amused himself and indulged the Pharaoh. The Pharaoh muscled through it all – frogs, blood, locusts, the works – gauging his manhood against each vanquished scourge until he finally snapped. History maintains the Angel of Death broke him, though some say it was the boils. Job proved even more stubborn and by the time Jonah tried the duck-and-dodge, God was through playing around. God issued directives and didn't accept *no*.

Then God changed.

The new God abandoned the special effects and prairie fires. He spoke to man through his fellow man. The new God broke bread. The new God hung out. The new God decided man should take free will for another spin.

I will bring the walls down and show you the way out.

This was no command. Icarus reasoned it was the word of God if indeed the walls came down and only then. But taking the way out would be his choice alone. He offered one last prayer before he slept. He asked God to take away the choice.

~

He awoke to the sound of horses charging through the ward, a stampede of wild unshod hooves in the hallway and on the floor above, shaking the building from its foundation. The lights surged, then died, then surged again, faster, faster, until the debris trailing from the crumbling ceiling appeared like icicles hanging still in the flickering dark. Then a heartbeat of black silence before the walls shifted with such force Icarus was thrown from his bed. The metal frame clamored against the floor and then everything went still.

Backup lights flooded the ward. Hard glare, harder shadows and alarm bells to crack a man's thoughts midair. Chaos to his left, where the panic-stricken patients outnumbered the orderlies. The door to his right said DO NOT OPEN – ALARM WILL SOUND. The alarms were already sounding and the door led away from the mayhem so Icarus opened it.

He stood in the room where he had first been interviewed after they had treated his leg. He remembered the intake nurse, a stocky man whose left eye had run out of juice. It pointed groundward beneath a sagging lid while his right eye did all the work. The nurse had repeated the same questions Icarus answered in the ambulance. *Do you know where you are? Can you tell me who the president is? Are you intoxicated? Have you ever used*

drugs? But the room was empty now. Icarus pushed through the double doors and stepped outside.

A blown transformer pulsed behind a roofscape silhouette and then died, a wave of blackness breaking across an ocean of car alarms and frightened dogs. He clocked a siren far off to his left and followed the sound in a wide arc until it faded. Glass and gravel crunched beneath his feet. He approached a hot pinpoint of orange hovering in the air like someone smoking in the dark. A police chopper cut a swath of daylight across his path and Icarus saw the severed end of a utility line hanging in front of him. He stepped clear and looked about. A car crushed beneath a heap of bricks. A gurgling fire hydrant flooding the intersection. Storefront windows shattered into jagged glass drifts along the gutters. The chopper flew on and left Icarus in the dark. He crossed the intersection ankle deep in water and kept on, looking for lights and listening for voices.

His eyes burned from the smoke and the razor dust of whole buildings collapsed to powder and thrown back into the air. Faint shapes of men were visible in the light from the distant fires. Dark ghosts scurrying from the wreckage with whatever they could carry. More water gushing through the sidewalk. Fire sprinklers trickling onto showroom floors. Accordion gates pried apart with tire jacks, cash registers opened with crowbars and claw hammers.

"Hey, no," someone shouted. "No, no, no. You put it down. You put it down now."

A flashlight panned the street and flared in Icarus's eyes, the piston clatter of a shotgun pumping a shell to the ready.

"Put it down. Go. Get out."

Portable stereos, televisions and video games slammed onto the pavement and the ghosts scattered. The light stopped on Icarus.

"You go away."

The entreaties flew through his head – *I'm not stealing from you. I'm lost. I'm not going to hurt you* – but the man's broken

English would only catch the words *steal* and *hurt*, and his whiteknuckle grip would have already drained the feeling from his bloodless and trembling trigger finger.

Icarus fanned his arms and took a step backward, slow as drifting dust. He took two more steps, then turned his back on the light. More sirens, burglar alarms and smoke detectors. More looters and fallen debris. He stooped for a shard of glass, found one large enough to cut off his hospital bracelet and as he stood back up, he heard a crack of thunder and felt fire on his legs but there were no flames. Icarus ran, his lungs burning and dust scraping his teeth with each breath.

A cyclone fence topped with a coil of sawtoothed wire blocked the mouth of an alley. The ground shifted, righted itself, then fell sheer beneath him. Icarus hooked his fingers through the chain link and observed his hands as though seen from the far end of a tunnel that stretched further until the opening was but a star point as he fell through empty space.

~

The sound of Lyle's engine echoed from the mouth of the parking garage, then flattened out as he pulled into the street, the pitch swelling, then Doppler-fading up the block and then Sera was alone. The web of potential circumstances and choices, of alternate possibilities and actions had been scattered and frozen the second the test turned blue, leaving the pieces of the future suspended in her shock. Whether it was her future alone or theirs together was not solely up to Lyle, but until he returned for good it wasn't solely up to Sera, either. He'd disappeared before. He'd told her so.

This was different. This was a responsibility, not a threat. But she'd loved men in the past who'd made no such distinction. Sitting alone in their apartment with Lyle's child growing in her belly, she wondered if she'd hear the sound of his pickup coming down the block that night or ever again.

~

The early arrivals stood in circles, smoking in the church parking lot and greeting each other with their arms spread wide for long, firm hugs, friends and strangers alike. Lyle ducked inside and dropped his attendance card with the monitor. He'd get it back, signed and dated, at the end of the meeting. After his arrest, the booking officer had photographed him with a handheld passport camera. No tripod or ducking from a sulfur flashpan beneath a black shade cloth. The fingerprinting had been inkless, with Lyle rolling his fingertips across a piece of glass that looked like a miniature grocery scanner. But the court-issued attendance card seemed antiquated, with its list of stamped dates and hasty signatures like a turn-of-the-century library record, an administrative measure unchanged since the days of chain gangs in striped jail pajamas. Lyle measured his days by the System's requisite signatures and stamps, each the hard-won product of petitions, forms and requests submitted in writing, of hours spent on hold or in a plastic chair with a numbered ticket. The legion of officers, agents, clerks and trustees had become a faceless blur.

"Lyle, hey."

It was Dana, opening her arms to him. They hugged and Lyle said, "Dana, yeah. Hey."

Dana was the facilitator. She didn't wear a plastic ID badge or carry a dossier with Lyle's name and mugshot. She was only a few years older than Lyle but had lived them to near-lethal excess. She was fond of saying, I got the face I deserved at fifty, but fifteen years early. And when Lyle had introduced himself on his first night, he told the group, I rarely drink and I've never used. My lawyer plea bargained on a bullshit possession charge for shit that wasn't even mine, so here I am. Judge's orders. Lyle hadn't participated since. Neither Dana nor the group challenged Lyle's story. Dana's was the first face of the System who took Lyle at his word.

"Lyle, you there? You keep drifting away."

"I'm here. Lot on my mind."

"Maybe you can share some of it tonight. Still haven't heard from you. If you feel up to it. Your call."

"Thanks. Maybe." Lyle glanced at the coffee.

"Fuel up," said Dana. "We're starting in a few."

Every meeting had a speaker who told their story, and every meeting had time allotted for anyone in the group to share. The members obliged with their own blackened and shattered pasts, the attending silence unbroken but for an empathetic chuckle or stifled sob. The combined confessions Lyle had been privy to since his first day formed a Biblical epic of wrecked lives, and each member stood witness without judgment to the others' private Armageddon and thanked one another for the chance.

Valerie had been a stripper, had worn elbow-length gloves to hide her track marks. I had my looks, she said. All natural. I was earning so much for the club they were bumping other girls from prime shifts, girls who'd been doing Fridays and Saturdays forever. One night, this guy offers me a grand if I take off my gloves. He'd seen everything else, but it wasn't enough. But he stiffed me, walked out in the middle of a private dance. I yell after him and go chasing him through the club. Left my clothes, my tips, everything, behind to keep him from leaving. And my gloves. The bouncer stops him and the manager comes over. Turns out one of the dancers who'd lost her weekends to me, that was her boyfriend. Ratted me out. The manager saw my arms and kicked me loose on the spot.

By the time she had run out of room on her arms, Valerie was shooting between her toes and tricking for an agency.

Arthur fractured three of his wife's ribs but she didn't press charges. He lost his job and told her he had interviews lined up, that recruiters were calling. He'd lied. She confronted him with the foreclosure notice and he broke her wrist. She finally left him. Arthur relapsed after two years clean when

the divorce papers arrived. He received his second thirty-day chip from the group on Lyle's first night.

Kenneth attempted suicide after his engagement died on the vine, the wedding date postponed again after his last arrest. He awoke to his fiancée beside him at the hospital, her voice silent but her eyes howling with relief and resentment.

Paul had stolen everything from his business partner and Donna had crashed into a school bus.

They had all served time.

Ray was the speaker that night. Lyle had seen him at every meeting but had never met him or heard him say anything. Ray wore a grey beard like an Old Testament prophet, and the lettering on his neck and knuckles had blurred to the dull green of rotten fruit since their inscription.

"I hit bottom," Ray said. "More than once. You could shingle a roof with all of my one-year chips. All I got to say on that. No sense dragging out the details because we all got our own different Hell and I see no reason to make it a pissing contest. They say you forget the past, then you're doomed to repeat it. But I think you dwell on the past, it means you never left it. And that catchy tidbit, friends, is all I got from my palace of wisdom."

Ray spoke without resentment, self-pity, anger or regret. He hadn't split from some destructive alter ego and he didn't speak of his addiction in the third person. He didn't talk about baggage or scars and he never mentioned demons. There was no change or rebirth or new person with Ray, but the same person making profoundly different and more difficult choices daily. Whatever his turning point had been, Ray kept quiet about it. Ray talked about the future and about God. A hard man determined to be a better man, to keep living despite having witnessed every reason to the contrary.

The group broke for fifteen minutes, then reconvened for announcements and readings, and finally Dana opened the floor up for anyone to share. Hands went up and Dana called them one by one. Each member stated their first name and said they were

an addict and the group responded with a collective greeting. Members thanked Ray and shared their own stories. Lyle's attention drifted. He caught Dana's eyes twice and looked away both times. His wandering gaze landed on Ray and Ray looked back. A long half-minute drifted past and Ray gave a solemn, leaden nod. Lyle held up his hand and Dana called on him.

Lyle stood and faced the room. "My name's Lyle." He didn't offer a count of days clean, and after a long pause came a disjointed chorus: Hi, Lyle.

"I said I didn't belong here, I know." He paused again. His ideas broke apart before words came together. In the silence he heard his ears ringing. A puddle of coffee hissed on the burner, someone cleared their throat. Lyle pictured Sera at home by herself and pushed himself onward. "Got a visit from my probation officer. Couple hours ago. Guy's a real storm trooper." Lyle stared at his fingers, then said, "Looks like my girlfriend's pregnant."

The air in the room shifted but nobody spoke. Lyle heard ringing in his ears, louder.

"It's like, I'm somebody else and I'm watching me from three feet away. Everything I'm saying and doing is this other guy, this *me* that's over there. Been like that the last couple of hours. We found out, about the, her being pregnant, right before I had to come here. We didn't really have time to talk. A few minutes. I think she's got a better head about it than I do. But we're not married. She doesn't have insurance and my coverage is for shit. Still a year and six months left on probation. Got to make these court payments. Jesus, I still owe my lawyer."

Lyle stopped. He'd confessed enough without itemizing the full weight of his debt for the group. Credit cards, back taxes, and auto repairs. White statements, pink late notices and collection letters rubber-banded into a dozen fat bundles piled into a grocery bag.

He didn't recall finishing. He was in his seat with a stranger's reassuring hand on his back and Dana was wrapping up the

meeting. The group formed a circle and said the Serenity Prayer and then Lyle picked up his signature card and grabbed a coffee for the road. Someone put their hand on his shoulder and Lyle turned to look into Ray's deadpan, resting prophet face. Up close, he had the pale eyes of a snow dog.

"You carry this through," Ray said, "you might be among the lucky few has a kid that'll still speak to him. God bless you, brother."

Lyle drove home, his panic no longer at a distance but with every obstacle to fatherhood in sharp focus. Brake lights flared throughout the traffic ahead and the freeway slowed, a sea of glowing red lights quavering up and down on some strange current. His truck dipped and swayed, streetlights and billboards flailed about like reeds in a gale. Then the city went dark.

Lyle had grown up with earthquakes, but like most non-natives, Sera was terrified of them. Which was perhaps a truly sane response to feeling the earth unmoored for even fifteen seconds. But nothing had collapsed or slid into the ocean. There would be a few fires, a prolonged blackout, and long, identical anecdotes from total strangers for days after, then life would go on.

The trembling stopped and slowly the traffic resumed its pace. Traffic lights were out and freeway signs were unlit, with everyone racing home to their loved ones. Lyle was looking for his off-ramp in the dark, and his thoughts of Reid, Sera and fatherhood were preoccupation enough to numb his reaction time when the driver ahead of him abruptly cut across two lanes without signaling. Lyle tapped his brakes and swerved but the car clipped him. His truck shuddered and a split second froze to a glacial crawl, yellow crash barrels rupturing in a shower of sand and water. The droplets hung in the air, bubbles in glass. His skin hot with adrenaline and the world shrank to a keyhole directly in front of him.

Nadine. If I live and I have a girl, I want to name her Nadine.

TWENTY LONG AND THE
SURGEON BIRDS

Icarus opened his eyes to a cement cave cast in weak orange light. The echo of dripping pipes, the sound of a flaring match head, then more orange light.

"You won't be able to move for a while but it'll wear off in due course. Can't have you struggling now, can we?" The speaker stepped to his side. "I apologize for the medieval lighting but the quake knocked out the power."

The man's hair was crushed into a pile above the miner's lamp strapped to his head. He wore a leather apron over his bare chest and he puzzled over a black box that resembled a transistor radio, clucking his tongue as he did so. Another clucking responded in identical sequence from the bunker shadows.

"I'd be obliged if you filled in some blanks for me," Icarus said. His face felt numb, his words blurry.

"My name, sir, is Twenty Long. Disasters bring looters and looters bring gunfire."

"I was not looting."

"Of course you weren't. Looters don't wear jammies stenciled from the county psych hospital. But whoever locked their crosshairs on you wasn't so discriminating. Took some buckshot in the legs. You may perhaps recall a distinct *kaboom* sound shortly before you passed out?"

"My hearing comes and goes." Icarus felt his words slowly hardening at the edges. "Are you a doctor?"

"Am I a doctor?" Twenty Long scratched at his shock of curly hair and chewed his bottom lip. "Doctor," he said again and fixed his eyes on a point somewhere on the chamber's opposite wall, then repeated the word a third time as though struggling to recall its Latin origins. "The word doesn't ring out like it once did. Was a time back in the day when a man relied on hard work and horse sense. You had to improvise with what tools you had and there was no substitute for elbow grease. Nowadays anybody can mail order hisself a piece of paper with his name written in fancy curlicue letters that says he's a doctor. So you write a book, *Outer-Body Feng Shui for Your Inner Child*, or some such thing. You slap your name on the cover after the word *Doctor* and you're golden. Buy a turtleneck and hit the talk show circuit, then you retire."

Icarus felt a panic blooming.

"Not my style," said Twenty Long. "I know my way under the skin. Not as good as some but better than most. I get my share of repeat clients who pay for my services, plus a little extra to keep quiet about what brought them to me. Not that I ask or care. Money or not, I will never turn someone away. And what else I will not do is further sully the sanctity of the Hippocratic Oath by abusing the title of *Doctor*. Now relax, good man. You got hit by a longshot. Skin deep. You'll be sewn up, directly."

"With all due respect to your ethics, sir, I'd much appreciate you wiring my legs back to my free will and directing me to the nearest hospital. The kind where they have diplomas. And soap."

"Nonsense. Bunch of know-nothings who can't abide by a cotton ball that isn't boiled and shrink-wrapped before they use it. No, trust me. We've got you covered. This is all smoke and mirrors."

A sound like the spastic flapping of shoe soles echoed from

the walls. The air pulsed and an enormous grey bird thrashed out of the darkness and landed beside Icarus. Its scorched bone-colored beak hooked to a stout point and short round feathers like scales covered its head. A second bird landed beside it, identical but for being slightly larger. They looked to Icarus like twin cemetery markers and the pair regarded him with half-lidded eyes, as disinterested in his condition as he was distressed.

Twenty Long snapped his fingers and the birds climbed atop Icarus, settling onto his legs, their feet like thongs of tough hide clamped to his bare shins. He craned his head forward, discovered his pants were missing. He tried to move, to startle the creatures away but was inert below the neck. Twenty Long stood over Icarus and passed the small black box over his legs. It beeped like a watch alarm and the smaller bird responded likewise. Twenty Long stroked its nape, then placed a lidless coffee can gummed with glossy black paint beside Icarus's blood-covered knee. The bird lowered its head and issued the briefest stab of pain, then spat a shot pellet into the coffee can. It dipped its beak twice more and spat out two more pellets in the space of a blink.

"Good girl, Smoke." Twenty Long rubbed her neck again. "She's got the gift. Taught Mirrors everything he knows. Lucky for you it's steel shot. Had it been lead, I'd be pulling it out myself and I'm all thumbs with this sort of thing."

Smoke cleaned her beak with quick swipes against her wings and resumed work. Mirrors followed suit with the other leg. Icarus lay paralyzed while Smoke and Mirrors foraged through his open skin with their black beaks extracting the buckshot spray, pellet by pellet. They crept upward and adjusted perch with each step. They paused to wipe blood from their beaks or preen the odd pinfeather, then resumed the task at hand without a prompt. Icarus felt the occasional stab or sting but little else. Mirrors probed more firmly when a shot pellet slipped deeper beneath his skin and Icarus braced himself

for the shock to come but it never did. The bird spat out the wayward bead and continued. Icarus squeezed his eyes shut and measured the crawling time by the rhythm of buckshot striking the metal can. When the foraging and spitting ceased, Icarus opened his eyes but Smoke and Mirrors remained.

"I'll clean you up just as soon as they move," said Twenty Long. "And they'll move just as soon as they get a reward. Got some pine nuts around here someplace, ought to do the job. Some fresh threads for you, too. I'll return in due course."

Alone with Smoke and Mirrors, Icarus's panic subsided. He could lift his head higher now and sensation was returning to his fingers. The surgeon birds regarded him from their perch atop his hips. Feeling as much foolish as grateful, Icarus smiled and said, "I suppose I should thank you two."

"Think nothing of it," said Smoke in a flawless mimic of his own voice. She scrabbled her way to the top of his chest and held her black beak to his eyes. "We have a message," she said, "from the Mother Howl."

~

The house is alive. The boy stands alone staring down the dark hallway, where the sounds from which he hides beneath his blankets at night have all been loosed at once. Tapping overhead, scraping, something shifting its weight and dragging itself across the attic floor. Wooden wheezing from the staircase bearing the slow, leaden ascent of something behind him. Overgrown fingernails scratching at door locks and windowpanes. Restless thumping within the walls from things no longer able to keep still. Breathing from behind cracked doors. Creaking floorboards and a sound like gravel spilling across wood, the scuttle of tiny feet gripping the ceiling.

The boy knows better than to turn around or move but the dream demands it and now he stands before a door at the far end of the hallway though he hasn't taken a step. If he doesn't

open the door, the dream will do it for him. He knows this. He knows he will not find his mother this time, sitting with her back to him on the ocean floor.

Blue light shimmers through the gap at his feet. The television hisses from the other side of the door like wind through a thicket of dead leaves and then a steady shrill tone cuts the static short and the shimmering blue freezes. It's the noise he hears in his head when everything is quiet, the test signal from a dormant channel. A sound he's heard his whole life. His breath hangs in the air like a trail of smoke in a silent film. He hears something clumsy and restless on the other side butting against the wall like an empty cradle beside an open storm window.

The door opens and the boy's skin hums with fear. He stands again at the threshold of his parents' bedroom bathed in deep-ocean blue. The black-and-white television atop the bureau emits a piercing signal, its emergency broadcast screen the source of the underwater light. A dark plastic tarp rolled into a giant black cocoon twists about the floor, bucking against the wall and striking the bed frame. The boy's fear coils around him and slowly contracts, breathing like a slow leak into his ear. He wants his father there to protect him but he hasn't seen his father or his mother in a very long time.

And with that, the boy knows he's standing nowhere but within his own memory. He's asleep somewhere else with a loved one at his side. He musters a furious shout to wake himself that rises from his chest and escapes as a small puff against the pillow over his face. The house with the nightmare noises, the bedroom, the television and its apocalypse distress signal and the person rolled in a plastic sheet and left for dead all at once shrink to a dim point in the dark and then they're gone.

A kink in his neck. Warm, salty rain on his face and in his mouth, running into his ear. He tried to move but couldn't and the warm rain spilled into his throat. He coughed, inhaled more rain and he feared he would drown if he didn't move his head.

"Easy there. You're going to be okay. Keep still."

"I can't breathe."

"You're breathing just fine."

He felt her hands on his face, wiping the rain away. He opened his eyes to the blinding sunlight and closed them again.

~

Icarus dreamed of a cool breeze beneath the afternoon sun and the music of small excited birds. He opened his eyes long enough to take stock of his quarters. A network of pipes and cables on the ceiling. A tube running from his arm to a bag of clear fluid held aloft by a headless mannequin with a bare bulb screwed into its neck. He closed his eyes and dreamed again of lying beneath the afternoon sun but there were fewer birds. Whenever he awoke he found new evidence of Twenty Long's vigil. A bowl of warm soup and a piece of bread, a dark suit hanging from an overhead conduit. Two capsules with a note. *A precaution*, it read. Each time he slept a piece of the dream fell away. First the birds were gone, then the breeze, then the sun moved closer until he could no longer see the curve of its edge. The horizon shimmered with distant arcs of fire thousands of miles high, waves of sound and light twisted into whirling storm funnels tearing at the cold shores of sunspots. Icarus struggled for air and coughed up the broken scraps of some crude machine. Coils of copper filament, glass fuses, conductors and resistors that turned to vapor the instant he spat them out. He could breathe again.

He came to once more. The tube was gone from his arm and the bulb atop the mannequin's neck stump shone brightly, the room feeling smaller for it. Icarus had lost the rhythm of night and day since waking in Twenty Long's bunker. A day or two had passed, perhaps five or ten.

The suit had a vest along with the jacket and trousers and it fit him perfectly but had no shirt or shoes. A cluster of red and

grey feathers lashed at the quills, which he presumed to be the handiwork of Twenty Long, had been fixed to the buttonhole of his lapel. A lone piano sounded from somewhere outside his chamber. The tempo and volume rose and fell without respect to the music itself, as though the pianist were struggling to remain conscious until the song finished.

There was no door, but a gap through the wall wide enough for Icarus if he led with his shoulder. He stepped onto a narrow slope of dirt, the ceiling too low for him to stand upright, and followed the opposite wall to a sledgehammered opening. He crouched through and came to a grand parlor built with the wealth and style of the previous century. A hammered tin ceiling, carpet the color of autumn leaves and everything fashioned from polished wood or red velvet. A wall of books higher than Icarus could reach: *Gray's Anatomy; Index to the New England Journal of Medicine; The SAS Manual of Field Medicine.* Sodden and swollen as if dredged from a flood, their bindings patched with bits of shoe leather or cloth or altogether missing, their pages baled between ragged covers with electrical cord. Enormous charts hung from wires suspended the length of the room. *The Human Circulatory System; The Human Nervous System; The Male & Female Reproductive Systems.* A marble bar strewn with scissors, knives, saws and pliers. An autoclave, portable defibrillators, liquor shelves filled with apothecary jars and unlabeled bottles, a stack of car batteries daisy-chained to a pair of jumper cables. A gurney with a large volume on the headrest, *Manual of Comprehensive Electro-Convulsive Therapy Practices and Procedures.*

The Untuned girl stood barely higher than his knee. Translucent like a reflection in polished glass and as still as the glass itself. Green taffeta dress the color of dark moss, red hair woven into a single fiery braid and dressed with a black ribbon. Then she was gone.

Icarus parted a pair of velvet curtains and entered a cavernous ballroom strewn with crumbled plaster and broken furniture. Beveled glass windows painted black, chandeliers

draped in canopies of white spider thread. Twenty Long sat at a grand piano in the center of the room, the carbide miner's lamp on his head illuminating the sheet music in front of him. His fingers struck the keys as though picking at bits of dried food. The crowded notes fought for space, rebounded off the walls and collided with those few he managed to play without hammering them out of shape. Icarus discerned a melody after a time, the way one sees a misshapen face in a cloud.

"Beethoven's 'Ode to Joy'," Twenty Long shouted above the noise. "Are you a music lover, Icarus?"

"Indeed, I am. And so would be most grateful if you stopped playing immediately."

Twenty Long stopped to sip from a delicate china cup. "I gather you've returned to your former charming self. No longer the trembling jackrabbit I first met."

"I recall you fixed the trembling with aplomb." Icarus stepped across small rocks and wood slivers, a cold puddle up to his ankles, then dry carpet.

"With nothing less than your welfare at heart, sir." Twenty Long reached for the chrome pot atop the piano. "Please, a man in your condition could surely do with some coffee." He filled a second cup and paired it with an equally fragile-looking saucer.

"I may be without manners, Mr Twenty Long, but not without gratitude."

The cup and saucer felt like a child's tea set in his hands, frail and glossy as though fashioned from melted sugar. He raised his cup to his host. "You've done a greater service than you can know and for that I am most sincerely in your debt."

Twenty Long raised his cup in reply, then drank. "Nonsense. Would have done the same for anyone."

Icarus surveyed the ballroom but saw no sign of the Untuned little girl or any others. No telling how many tons of dirt and rubble buttressed the black-windowed walls or how many more overhead were breaking the vaulted ceilings one hairline crack at a time.

"You get radio signals down here?"

Twenty Long shrugged. "Some spots better than others. But even on a good day, the best of those are going to be pretty weak. I gave up trying a long while back. My line of work, I don't have much need for radio."

"However, in mine I do. But I've a hunch your winged beasts have plenty schooled you on the matter."

"Smoke and Mirrors? They're just birds. They assist me in surgery."

"Well, they seemed rather well informed about things. But I suppose my return to health is a tribute to your instincts."

"Didn't take much instinct to see you were bleeding to death."

"Wasn't referring to my legs."

Twenty Long refilled his cup. He added nothing yet stirred it with a miniature silver spoon that rang against the china like the bell on a cat's collar.

"Some of those signals are very important to me, Mr Twenty Long. Most are not. Most are just noise."

"How can you tell the difference?"

"Same way a fish knows how to swim. Thing is, people at the hospital put something in me, jammed those signals."

"They'll do that. And sometimes they do the opposite. Give you receivers, dial all kinds of voices into your head. And I seen what happens when folks don't follow instructions from those voices. Never ends well. Worse, it sometimes never ends at all."

"My misplaced trust in my former handlers was a New Brain glitch." Icarus traced the rim of his empty cup, scarcely thicker than a dry leaf. "Caught a weak transmission back there, halfway between my mattress and this concert hall. You and your birds did something what knocked out the interference, jammed their signal jamming. I'm grateful. I'm also compelled to ask how you moved me to that other room on your own. Even with a funhouse mirror you ain't but half my size."

"A good magician never reveals his secrets, Mr Icarus."

"A good magician also leaves them wanting more."

"I take exception to that rule."

"I am tremendously relieved to hear that."

"Well I'm just gobsmacked, as they say across the pond. You take those pills?"

"I'm not in pain."

"Didn't ask. You strike me as having a damn-near Viking threshold for pain. Those pills are to safeguard against infection. I wash my hands but Smoke and Mirrors aren't so fastidious."

"I'll retrieve them before I make my leave."

"Don't bother. There's a bottle in your pocket. One at morning, one at night. Now, I've got some goulash simmering. Let's get you something to eat before you're on your way."

"Are you a better cook than a piano player?"

"Yes, but not as good a cook as I am a surgeon."

~

The Untuned were legion above ground, the streets filled with silent masses that shifted from view like distant water in the desert heat. A whole new sub-city had emerged from the mud beneath the ruins of highway onramps and the embankments and overpasses that had collapsed unfinished beneath the red autumn sky. The itinerant gathered around scrap wood bonfires, slept in rows beneath plastic tarps or in shelters built from cardboard boxes and wooden skids. Small tribes claimed hollow pockets where great slabs of concrete had broken loose and fallen slopewise into the earth. A grey-bearded man sat in a castoff chair, red leather fixed with brass rivets to an ornate wooden frame sunk into the dirt. He wore a black watch cap and woolen pea coat with the buttons missing, held a plastic grocery sack between his knees from which he extracted a crushed cigarette package that he uncrumpled with great care, shaking the scant remains of tobacco into a plastic

pill bottle. He tore the package apart, checking for stray flakes trapped within the folds and seams, then did likewise with the other empty package from the bag between his knees. An old woman held a single lens from a pair of glasses, the remaining nub of its frame taped to the end of a thin strand of metal. A bicycle spoke or a section of coathanger. She glassed the pages of a Bible and swayed gently back and forth as she read. This indigent city lay in the grip of a bartering frenzy, heated negotiations and seductive pitches for plunder from the night of the earthquake.

"Yo. Yo, Big Man."

Icarus kept on but the stranger called out again, then blocked his path. A wiry man much shorter than Icarus himself, he moved as though caught in some invisible undertow, fighting against the phantom riptide to remain in place.

"My man, I know what it is you're looking for." He bobbed from one foot to the other, took off his crushed porkpie hat, put it back on, tapped Icarus on the chest with the back of his hand. "Got you covered, inside and out, yeah, just what you need." He snapped his fingers and cocked an imaginary pistol. "Most correctly, Big Man, I got just what you need."

"You got a blunt instrument?"

"In a flash, Big Man. Not what I guessed you for, but you wait right here and I'll retrieve the finest of whatever breed of instrument you require, blunt, musical or otherwise. I'll be gone only momentarily."

"You're gone," said Icarus, "then I've no longer call for a blunt instrument."

"Straight to the point, I can see that, so I'll cut to the money shot. The little man shuffled like a half-drunk dancer down a slope of mud and gravel to the foot of a concrete pillar. You won't ever see another one like it," he said, and fanned his arms as though parting the ocean and indicated a large door propped against the pillar. Its top hinge was missing and the bottom hinge remained bolted to a spearhead of pale wood

torn from its former frame but it was otherwise pristine. A broad plank without inlays, bevels or carvings. Glossy red like a toy fire engine, lacquered so smooth Icarus beheld his blurry blood double staring back from its painted surface.

"Craftsmanship," the jumpy little man said. "Old school." He knocked on the bright red door with the flourish of a stage comedian. "They're throwing history out with the bath water. Shit, a few bricks shake loose and next thing you've got FEMA rolling in with their wrecking balls and auctioneers. Brother, I've got toilet handles all the way from wherever Germany and all that shit is. Doorknobs from before we had electricity." He shuffled up to Icarus once more, bobbing and weaving like an underwater boxer. "I'll bet you, in fact I'm sure of it, Wyatt Earp himself knocked on this very door. Now, I know what you're thinking."

"You're standing far too close for a man who knows what I'm thinking."

The man stopped shuffling and twitching and his face went slack.

"Now, this door of yours," said Icarus. "Where might it lead?"

"Lead?" The man bent over and belly laughed for nearly a full minute, pointed at Icarus and shook his head. "It's just a door, Big Man. It don't go anywhere."

"And what would I want," said Icarus, "with a door that goes nowhere? Step aside, puppet."

Icarus went on and the man called after him. "Think on it," he shouted. "I'll be right here."

Further ahead, Icarus heard the sound of the end of the world.

~

Sera woke up married but alone on the morning of her twenty-second birthday, four floors above Fremont Street in downtown

Las Vegas. Moisture from the sweating ice bucket puddled on the nightstand and seeped into the marriage license, blurring her name. Her husband had left a note beside a travel packet of aspirin and a bottle of water. She swallowed the aspirin and threw the wrapper away with the note. She didn't need to read it. She knew what it said, where she could find him.

He was downstairs with another pile of chips, certain he had it all figured out this time. If he was losing, he blamed a cold dealer or an amateur player shaking the table. If he was winning, it was never enough. He had to get back everything he'd lost – *invested*, as he called it – but his luck was never that good for that long. The house switched dealers or some beginner took a seat at his table. And luck, he insisted, had nothing to do with it.

He knew the system, he told her. He knew the math behind the system and how the house rigged it against the player. He said she couldn't possibly understand, but then he never stopped trying to explain it all, though she never asked. But Sera understood things her husband did not. Like the difference between players who made a living and gamblers who chased a rush. How a gambler could delude himself into believing he wasn't deluding himself.

She gave it her best for seven months. Her husband always had a reason to fly back to Las Vegas or Reno. A bachelor party, a birthday, legitimate business or a cheap promotional flight, and he was gone longer each time. He was gone when their rent check was returned due to insufficient funds. When she spoke with the bank, they informed her their joint account was overdrawn. She was writing a new check to their landlord from her personal account when the phone rang. He was calling from a casino payphone. Collect.

He said his payday was in three days, that he just needed her to cover him until his direct deposit hit.

Sera refused and the line went dead.

The last thing he ever said to her was, *Please*.

The last thing she ever said to him was, *No*.

She paid the following month's rent and filed for divorce. She came home most nights to a blinking message light but no recording. Their lease ran out and she renewed it in her own name, paid the landlord to re-key the locks and left the papers for her husband to sign in a plastic folder tacked to the front door. He didn't come back and she stopped finding empty messages on her machine. When she grew tired of displaying her spite for the neighbors to see, she took the papers down and had the marriage annulled.

Another man cheated on her and left her numb for a year after. She had loved him and they had been happy. When she asked if he loved the other woman he said, *No, of course not.* If he'd said *yes*, she would have been crushed more than she already was. But he'd said *no*, that he did not love her. Sera understood his transgression was one of opportunity and so there would always be others. Like her ex-husband, the keys to paradise lost their luster once they were within reach and he would always be looking elsewhere.

She met Lyle years later, working the café where he read the Sunday paper. She wove among the tables, gathering dishes or offering refills, a bar towel knotted through her belt loop. Men moved chairs and briefcases and backpacks in anticipation of her path, tracked her when she was within arm's reach, then drifted back to their business when she wasn't, their heads moving in delayed unison like high grass bending in her wake. Some of them stared but then looked away when she saw them, pretended they didn't notice her.

The friendly, handsome young regular with the dirty blond hair and thick-framed glasses never gaped at her like so many others did, always rapt with his crossword puzzle or reading. But the split-second Sera first realized she was the one doing the staring, he looked up and met her eyes and she froze, felt the heat in her face. He smiled at her, the scar he obscured with his glasses twisting into view and Sera didn't so much smile

back as try to catch her breath with her mouth hanging open and the handsome young regular went back to his newspaper.

He arrived later than usual one morning and found his customary seat occupied by an old woman in dark glasses, a German shepherd wearing a guide harness at her feet. He passed her, smiling at Sera, then stepped aside for a couple pushing a stroller.

"Excuse me," the old woman said. She reached for him and found his arm, held it. "That would be my foot."

"Well then," he said, "I guess that would be my dog."

The blind woman smiled and gave him a playful slap. "Mind yourself, young man."

Sera tried to snuff her laugh but made a snort, then laughed louder. She would sit with him if he was still there by himself when her shift was over. He was and she did.

"Kind of quiet, aren't you?" She dropped into the seat across from him and nudged his chair with her boot.

"Wasn't anybody else here to talk to until you sat down," he said.

"I could see that."

"Right. If I'd been mumbling out loud to nobody, I doubt you'd have joined me."

She smiled. "What's your story?"

"I don't have one."

"Yeah. You've got that just-appeared-out-of-thin-air look."

He extended his hand. "Name's Lyle."

"I know," she said. "I've seen your credit card, remember?" Sera put her fingertips to his upturned palm and introduced herself, then said, "So, Lyle. Ever think about getting one? A story?"

"Eventually. Maybe. I like not having one. It's simpler."

"Mr Mysterious."

"Just Lyle."

He took to having coffee on other days, whenever she was working. Then they met for breakfast on her days off, or he

lingered until the end of her shift and together they browsed bookstores and record shops. They met later and later in the day, weeks passing before they went out after dark. When Sera first suggested a movie, Lyle was reluctant. She pressed him. He said he didn't want to spend time with her staring ahead at someone else's imaginary life and not speaking with each other for two hours.

And with that, an urgent heat coursed through her like a passing comet and the longer she stood smiling at him and not saying anything, the more she felt the heat in her face and the more certain she became the whole world could see it. Sera turned and took Lyle by the hand and led him into the nearest bar.

They found a table near the stage, a plywood riser where a musician with the brutish girth of a piano mover worked a bottleneck slide over a hollow body electric guitar the color of smoke and blood. First, a steady keening as though he were dragging a razor over the strings, then the sound opened up as it sank through the floor, the long leaden notes pushing against the distortion and the distortion pushing back. The music of sex under hot rain, of losses and regrets tallied in a dying breath.

Her knees brushed his beneath the table and each time one of them left and came back, their chairs were a little closer until they were leaning into each other, from shoulder to ankle, fingers knotted together in the nook between their legs.

The guitar player said, "I'm just about out of here. Thanks for coming out tonight." He grinned at Sera and Lyle, then leaned past the microphone. "Come on, you two, make your move. This is the end of my set."

~

They sipped tart red wine from cracked mugs. Hers was dark blue, his was bright green with daisies. Sera changed into her old bathrobe, then opened another bottle, stopping to look at

him, the way he stood as the room swayed beneath him, lost in the glow of the candles flickering in her fireplace. She refilled his cup, then hers. She set the bottle down, reached for his face and removed his glasses, then let her robe slip to the floor.

She awoke later to a furious rain hammering at the window and opened her eyes to a weak, tin-colored glow from behind the curtains. The outline of a door, bookshelves and picture frames. Grey shapes in the dim break of morning. She lay with her leg slung over his and the blankets pulled to her chin, trapping the heat between them. The rain fell harder and she listened to the rattling against her windows and roof, watched her breath cloud in the air, and felt the rise and fall of his chest and then drifted back to sleep.

~

Sera awaited the inevitable revelation, something that would fundamentally change him in her eyes. A past addiction or one present but hidden. A violent record. A wife, or a child from a previous marriage. But Sera knew in her heart it was none of those things. Whatever she was waiting to hear was about his family, because Lyle never spoke of them except when he'd said he had no siblings and wasn't close with his mother or father. Sera never pressed him. She was an only child herself and like Lyle, had drifted apart from her parents without regret.

Sera had given her reasons over time – a father so disinterested as to be invisible, a mother whose weapon of choice was a leather belt before Sera was old enough for school – but Lyle had not. *We're just not close.* She knew nothing about his life before their first date, as though he had fallen from the sky the day she met him.

They had talked about living together. The day Lyle discovered the apartment listings she'd circled in red, he set the newspaper down, then took her hand and held it for a long time without speaking a word. Sera sensed the confession

taking shape. He was backing out, wanted to keep separate apartments. Or he was breaking up with her. She waited.

With no preamble or nervous stammering, Lyle told her his last name was not *Edison*. He said this slowly, then paused, giving the words time to sink in. But before she could phrase her question, he leaned in close and, as though they might be under surveillance, he whispered his birth name.

A news story floated to the surface of Sera's memory and she smiled, thinking he shared a killer's name by some dark coincidence. Looking back, she hated herself for smiling even though Lyle remained impassive, staring through her eyes to the wheels turning behind them. When the wheels stopped, Lyle told her the rest.

His father was doing multiple life sentences. He had been a hard-working, stern but kind man who had never raised his voice or hand to either Lyle or his mother. Sera's childhood had been a physical and mental war zone and was all but science fiction to Lyle, something he could barely fathom next to his own storybook upbringing. But it had been a lie. His father was arrested for killing a young waitress, someone Lyle had met. His father, Lyle Sr, had been preying on young women for a very long time and after his arrest, he confessed to nine.

Those nine victims served both the prosecutor's ambitions and Lyle Sr's ploy to avoid execution. But in the court of public opinion and the leaked statements of unnamed law enforcement, there had been far more.

Sera had been waiting for a revelation and now she had it. Lyle had been outcast and nearly killed because of his father. So he'd changed his name, moved away and started over. He was still guarded about his past, but Sera didn't need to know any more. Sera had thought briefly about his mother, what happened to her, why Lyle had disowned them both. But she never asked. She was already in love with him, and he was with her. Lyle hadn't been hiding a secret from Sera, but from everyone else.

~

When Lyle opened his eyes again, Sera was sitting beside him with her hand on his arm. The sight of her sent a warm wave through him but her face did not match the name in his head. He reached for it but the name slipped away.

"Hey," she said.

"Is it still raining?" He could only whisper. He coughed dry as dust and something stabbed in his chest.

She held a straw to his lips and he drank. "Better?"

He nodded.

"Sweetie," she said. "Lyle."

"Yeah." His throat felt like bark. "Right, Lyle."

He repeated his own name and the rest surged through his mind that same instant. It was Sera holding his hand. He said her name out loud.

She wiped her eyes and smiled and Lyle's memory righted itself. Events floated to the surface and drifted into sequence. Those first blank moments of unknowing loomed above the rest, the size of whole days, then turned to vapor and everything was clear. He moved his toes, both feet, felt the sheets brush his legs when he shifted his heels and the relief was sweeter than any drug the hospital could give him.

"You had me worried." Sera brushed his cheek.

"What's the story?"

"You punched yourself in the face when the airbag went off." She laughed.

"Hilarious." He coughed again.

"I'm sorry," she said. She smiled and wiped her eyes again. "I'm just so happy you're okay."

The Highway Patrol had called it a hit-and-run. A witness reported a white, late-model Taurus driving erratically that had hit Lyle's truck but didn't stop.

A doctor entered but gave no introduction. He said *Lyle Edison* as though making roll call and tallied Lyle's injuries

without a breath. Dislocated shoulder, fractured kneecap, two broken ribs.

"Like I'm hearing a cattle auction," Lyle said.

"None of this is news to you, I imagine," said the doctor. "What haven't you broken so far, Mr Edison?"

"I was a stuntman in a past life."

Sera left his tape player and headphones and Lyle fell back asleep to Mississippi John Hurt singing "Stagger Lee". He was fitted for a leg brace that afternoon and Sera pushed his wheelchair to the nurse's station for his discharge paperwork. Lyle fumbled with his wallet, his hands like gloves full of mud. One of his credit cards had a pink late notice and the other did not but he couldn't recall which. He handed the first one over and waited. He stared at the floor and saw a spray of brown and silver coins flash across the tile, heard the drone of an ice machine.

"I'm sorry," the nurse said. "But this one's been declined."

Lyle gave her his other card. "It's my father's," he said.

"Lyle?" Sera touched his shoulder.

The nurse smiled. "He just needs to sleep it off," she said.

Sera drove them home in a rental car. The painkillers receded and his life came into focus: Another credit card charge for his hospital deductible. His insurance company's inevitable scripted refusal to cover certain line items on the bill. The claim that would barely pay his outstanding truck loan. Another loan and higher premiums. The lingering opiates would blow his next drug screening. He would have to forward his medical documents to Reid in advance, who would likely insist on a confirmation screening and then request a hearing to review Lyle's case. He was going to miss group that night and work for at least a week, and would spend much of that time on the phone repeating his date of birth, Social Security and driver's license. Policy number, claim number, accident report, probation and case number recited every time his call was transferred or dropped. The System would serenade him

with computerized bubble gum music engineered in a hidden bunker and tested on violent offenders, war veterans and rabid mice.

"Hey, you." Sera touched his face. "You in there?"

"Yeah. Drugs are wearing off."

"We can fix that." Sera tapped the white paper bag on top of her purse.

"Where'd that come from?"

"The hospital pharmacy. Maybe they're not wearing off as much as you think."

The bag was large enough for a half-dozen bottles. "All that's for me?"

"Some, not all."

"What're the rest for? Are you okay?"

"I'm fine, they're prenatal supplements. And I've got an OB-GYN appointment tomorrow."

"What's wrong?"

"Lyle." She slowed down, stopped at a red light and turned to him. "I just said *prenatal*. I'm pregnant. Remember?"

"Yeah." He closed his eyes and leaned his head back. The pain returned to his joints and his stomach twisted into a familiar knot. "I remember now."

~

A single furious violin played as though the player were chasing an insect over the strings. One note held its own against the others, straining for a full three seconds before the noise resumed. The distress signal sounding in those last seconds before a dying star buckles beneath its own weight. Icarus swung his legs over the barricade and stood atop the stairs descending into the dormant subway, where the shrieking violin echoed from below. A quake fissure had split the mosaic mural in the stairwell from its sky to its cornfield, the black tile scarecrow stranded from the farm by a frozen

crack of lightning cut from empty space. Icarus walked down into the dark, the red tiles smooth and cold beneath his feet. At the far reach of the dirty grey light from above ground the red tiles came to a slatted metal gate. Turnstiles on the other side, then nothing.

There stood the musician, his eyes squeezed half-shut as though staring into the sun, intent on a cardboard box flap clothespinned to a music stand. A stack of more cardboard bound with nylon cord lay at his feet, with the violin case open beside it, offerings from a transient audience scattered across the fabric lining. A dozen filthy pennies, a three of spades, a cocktail napkin rose, a book of matches, a few pieces of hard candy and a single AAA battery. The musician ceased playing and lowered the violin, squinted at Icarus.

"I call that 'Third Rail Pigeon Spark for Solo Violin'," he said. "You a musician?"

"No, sir," said Icarus. "Are you?"

"A critic, then."

"A messenger."

"And what's your message?"

"Ain't for you."

"No matter," said the musician. "But my muse got to eat. You insist on standing in my light, make an offering." He tapped his case with the tip of his bow. "Or cover your ears. This ain't no elevator."

"Your eyesight's as bad as your playing," said Icarus. "Or you don't pay much mind to your offerings."

"What makes something an offering is a man parting with what he don't want to give up. Stick of gum for one man. Somebody else, it's an instrument they spent their whole life learning to play."

Icarus pondered this, then removed the bottle of Twenty Long's medicine from his pocket and dropped it into the case. The musician set his violin aside and opened the bottle, cracked one of the capsules and tasted the dust.

"These ain't no carnival tickets," he said. "No fun to be had here at all. You ill?"

"Only temporary."

"It's all temporary."

"Indeed," said Icarus.

"But you didn't come here to listen to me play or preach."

"Haven't heard either one, so far."

"You're keener than most," said the musician. "Funny how you can repeat a man's question in reverse, talk in half-sentences, and some folks will stare with their mouths open like you glow in the dark." He took an amber block of rosin from his pocket and ran it over his bowstrings as he spoke. "But my muse," he said, "I can take no credit for that. Shame you can't hear it like I do."

"I heard what I needed. That composition of yours favors a particular note above the others."

The violin man nodded. He picked up his instrument and ran the bow across the strings and played the note, steady and flawless. "Good sound. Mean something to you?"

"The music of a sun's dying breath." Icarus closed his eyes and held up his hand, curled his fingers into a clench as he spoke. "When they're too old and too tired to burn and they just want to sleep," he said, "snuff one in your fist and that's the first sound you'll hear before all the supernova howling. Then it's just real quiet, like. Gravity turns inside out, numbers scatter off the clock."

"You got clocks?"

"I was being figurative."

"What's your business, then?"

"Looking for someone."

"Makes you think I can help?"

"Little bird told me," Icarus said.

"Never did understand that expression."

"Not an expression. Shrunken-down dinosaur wasn't very forthcoming, either."

"How's that?"

"Half-sentences, questions in reverse. Shell game posing as wisdom and insight."

"Smoke and mirrors," said the violin man and Icarus felt his heart beat faster. "Copy that. But you're going on faith, nonetheless."

Icarus said, "Ain't much for faith, but I got to see this through."

"Just who you looking for?"

"Like I said, the beast wasn't very forthcoming. All I know is the man ain't on our frequency. Not unusual, from what I seen, but he was the first of his kind to reckon me back. Unlike the rest, he's on the move. Facewise, though, I may as well be looking for thin air."

"Roger," said the violin man. He stooped to rifle through the discards in the violin case and came up with a glossy photograph. "I believe this may be your missing man." He handed the picture to Icarus. "Look familiar?"

The photo itself was a white blur as though bleached by a bright light.

"He's missing, indeed," said Icarus. "The likeness is uncanny. He pass your way?"

"May have. Or not. Wouldn't know the difference. They all look the same to me." The violin man broke into wheezy laughter and bent down to catch his breath.

"You've been a tremendous help." Icarus held out the photo. "I'll leave you to your recital."

"Here, now, don't go huffing frost on account of some bird sent you on a wild goose chase." The violin man paused, then said, "Bird. Goose." He laughed again. "I ain't seen your man but someone has. Believe. You keep that. Save you some talking next time. Can see you're not much of a people person."

"Wasn't any kind of person until not long ago."

"Explains a thing or two. Roger. How's the skin treating you?"

"Good for little else than holding my insides together," Icarus said.

"Roger. No doubt. Rough landing?"

"Wasn't on my feet."

"Wasn't on your head, either. You copy?"

"Indeed," said Icarus. "Problem ain't the wrapper. Taken all kinds of heat since I been flesh and bone."

"Roger. Tell it."

"Crash landing and buckshot, for instance. Had plenty of help bouncing back each time. All solid on the outside. No," Icarus tapped his head, "trouble's with the candy center. Got a few bells and whistles what make me qualicated to sniff out the likes of our thin air man. Elsewise, New Brain's good for little more than a pinhole scope on things. Like watching an opera through a knothole."

"Maybe so, but like you said, you found plenty of help. More on the road ahead, I'd say. Just what did your feathered prophet tell you, pointed you toward me?"

Icarus flicked the blank photo with his middle finger. "Elsewise than some voodoo-jumbo about this here faded face, just mentioned I should trail that one particular note. Reckoned I'd find our Mr Fade dialed to that wavelength."

The violin man again drew his bow over the strings and played the single, steady note. "F above middle C," he said. "Figured you'd be savvy to that."

"My line of work, there's not much call for hanging name tags on things."

"Roger. But my line of work, there's plenty." The man once more set his violin down and from the bundle of cardboard beside him, he took a scrap of paper from between the flats and handed it to Icarus. "Right there," he said, and pointed to a glyph on the page, something written in dark crayon. "F above middle C. That's what you're listening for. I played it, true enough, but unless your little fortune beak told you exactly where or how many times you'd hear it, I wouldn't lay bets on me or my latest composition being the first or last. I'd say you want to keep following it."

"Like I said, the New Brain's got some top-of-the-line options bolted onto a factory-issue extinction machine."

"Relax, Mr New Brain. All temporary, remember? Believe."

"It's Icarus."

"Roger."

"Just one name between us?"

"Never had much call for a name myself," the violin man said.

"Must make for a frightful headache reserving a table."

"Why I don't eat." He laughed and said, "Was a joke, Icarus. Course I eat. And my name's Roger. Keep telling you that, but it keeps getting lost in your candy center somewhere."

"Can't decide whether I like you, Roger."

"Decide you do, come on back. We'll talk more. Know a place serves free coffee, all you can drink, long as you can listen to a man with silver Elvis hair flap his arms like your bird, sweat and holler about the Second Coming and the end of the world."

"A tempting offer," Icarus said. "I might return once I've made up my mind about you."

"Anything I can do, maybe sway your opinion, tell it."

"You got a notion regarding the next nearest likely transmission of that note? That would sweeten your coffee and snake handling invitation considerably."

"Deep under, friend. Follow the tracks. Trains ain't running but the switchmen are working to fix the juice, so you got some fickle lightning on the third rail. Mind yourself. Hate to be composing anything in your honor."

"That would be terrible, yes."

"First platform gets a draft from above ground," said Roger. "Stairs and escalators and such. Makes a faint whistle from one of the tunnels. You'll recognize it. Walk in that direction until you hear it again." Roger took a cardboard flap from the stack and clipped it to his music stand. "Got something new I've been working on, you ain't in any kind of rush."

"I've lingered long enough."

"Godspeed, Icarus."

~

Dirt hung in the air. Roadbase crushed to dust, diesel fumes and smoke from factories and tailpipes, the haze set alight from millions of streetlamps and headlights and stuttering neon. Staring into the night sky he saw fewer stars than dark spaces where they were missing. Like pressing his shoulder to the hospital wall again, the tiniest cancerous doubt drifted through him in search of a breach.

Icarus had lost the signal. From Roger's violin to whistling air shafts to a fire alarm back above ground. Then a church bell, a cricket. Now he stood on a hill untouched by the quake and by the lives pooled in the city below. Old houses with high windows that conjured visions of hot water, soft beds and whole meals scraped into garbage cans. He was the only person on foot among the hilltop row of houses behind high iron fences.

A slice of light down the center of a window, the silhouette of a head, then the curtains closed again. First the upstairs, then down. The house nearest him, then its neighbor, then from across the street. Opening and closing, slow and furtive. They made no sound so they were no use to Icarus. A breeze ruffled the pant cuffs above his calloused bare feet and pulled at the blossom of grey feathers on his lapel. Light flooded the sidewalk and threw a sunset-stretched version of his shadow, the shape of a man but freakshow-tall from some dark folklore spun to keep children in line. Icarus turned. He'd seen brighter in his time but with more than the pitiful sight with which he was now equipped. He narrowed his eyes to squeeze out the excess light and clocked two patrol men stepping from their car. The first kept out of reach to one side while the other stood close to Icarus and shone a flashlight the size of a man's arm into his face.

"Stay right where you are."

"Been right where I am for some time," said Icarus.

"We know. That's why we're here."

"Rather on the redundant side of things, Blue Man, telling a man who hasn't moved but to breathe for the better part of an hour that he ought not to move."

"Step off the sidewalk. Put your hands on the hood, keep your feet shoulder width apart."

Icarus spread his arms and fanned his fingers on the warm car hood. His head was still above eye level with the patrolmen.

"You been drinking tonight, sir?"

"Found a fountain in the park not far from here, but wasn't easy. Strange how y'all bottle up the same thing comes out of your sink faucet but you turn drinking fountains into folklore."

"Sir, there anything in your pockets I should know about?"

The flashlight man put his hands on Icarus's chest and back, his fingers in his waistband, then groped his hips, his legs.

"Don't have any notion of what you need to know about, Mr Blue Man. As for my pockets, you will find nothing. So be careful."

"Careful of what, sir?"

"Of nothing," Icarus said. "I've seen it, nothing. A long time ago. I don't regret seeing it, but nor would I wish that sight on either of you or anyone else."

The patrolman searched Icarus while his partner observed from a distance, one hand on his gunbelt.

"What's this?" The patrolman squinted at the blank photograph.

"What do you reckon, Blue Man?"

"I *reckon*, sir, that it's a picture of, what, I don't know." He offered the snapshot to his partner, who squinted at it for a moment.

"Looks like nothing to me," he said.

"I warned you," said Icarus.

"Looks like you got nothing for an ID, too." The first patrolman took the photo back and tucked it into his pocket. "We're going to hang onto this."

"Keep it. I got it memorized."

"Okay, let's go. Hands behind your back, sir."

"On what account?"

"Let's start with loitering."

"Tell me to stay right where I am, then tell a judge I'm loitering. What kind of jigsaw puzzles and coloring books they use to reckon you're fit to carry a loaded pistol? Run and dance while you got both feet, Blue Man. You'll be dispatching one of them with that sidearm of yours in due course."

SIGNAL TO NOISE

He curled against her in the dark and cupped her belly in his palm. The dread which had risen around him like the walls of a barren well had shrunk to a tender rise between Sera's hips. Lyle traced the curves and dips of her body, lingered on the jut of her hip bone and feather-brushed her ribs with his fingertips. His own ribs were a dark blueish-purple and hurt if he breathed too deeply. He had two black eyes and spat blood when he brushed his teeth. Sera murmured something but he only heard her say *sleepy*. She pulled his wandering hand close to her and laced her fingers with his. She shifted against him beneath the covers, scratched one foot with the other, then she was still again.

Lyle's faith in Sera's self-sufficiency matched his constant concern for her. He saw this paradox as the difference between loving her and simply being in love, but the last twenty-four hours had upset the balance. One confluence of circumstances – appointments, detours, delays – had placed Lyle instead of Sera on the freeway alongside a drunk driver while another – velocity, angle, impact – had him in his own bed the next night, instead of the hospital or morgue. People hurt each other daily by the millions, for a few dollars or imagined insults, for petty gains far less than the satisfaction sought by those who assaulted Lyle when he was younger. They focused their pressure-cooker rage onto wives

and children or set loose their lifetime of resentment onto coworkers or unfaithful lovers. Some were afraid or wanted to protect themselves while others, Lyle knew, had no reason at all. Millions were pulled from car wrecks and burning buildings each year. Some lived long happy lives with slow laborious deaths while others died in a blink from a ruptured blood vessel or a flight of stairs. Some lived in the streets, bested by vices alongside those who had worked hard and governed their lives with careful judgment but nevertheless died outside and alone. The most Lyle could offer a child were adequate provisions and an empty family tree. Passing on his inherent will to cut and run from imminent danger in such a dangerous world was akin to bequeathing his child the keys to Limbo.

~

Daylight shone through a crack between pillows. Lyle rolled onto his side and pushed himself upright, his body liquid-heavy with slack, injuries detached as though the pain had mistaken him for someone else. Scissors lay curled in a puddle of sunlight, the bedroom bathed in warm yellow and the faint noises from the day long underway. A leaf blower and a mis-triggered car alarm, a honking bus and the steady warning beep of a delivery truck in reverse. Harping crows and tiny speckled sparrows chirping as they twisted in the dust. The nightstand clock said 1:00. The note beside it read,

L–

1:30 ob/gyn appt. Rest easy, will be back later. Love you.

–S

Lyle walked to the kitchen with small tight steps, navigating between pains that were taking fresh root. It was 1:22 when he sat down with a cup of reheated coffee. Screws tightened within his bones, and his hands shook. Lyle picked up the phone and dialed. The answer came after the first ring.

"Reid."

"Officer Reid, this is Lyle Edison."

"How can I help you, Mr Edison."

"I'm calling, I, because–" The words shook loose splinters in his voice that triggered a coughing fit.

"Is there something I can do for you, Mr Edison?"

Lyle swallowed the rest of his coffee. "I was in an accident."

"Were you intoxicated?"

"No. No, sir."

Lyle heard a drawer slamming shut, papers being pushed aside. He pictured Reid firing off the shorthand time and date in the upper-right corner on a fresh sheet for his file.

"Was anyone hurt?"

"No, sir. I mean, I was. Knocked around a little."

"Tell me what *knocked around a little* means?"

Lyle relayed the extent of his injuries but added, "Pretty much walked away from the whole thing. Got out of the hospital last night."

"Doesn't sound like you walked away to me."

Lyle closed his eyes and took a slow breath. Reid knew how to hook into his anxious chatter and could transcribe every word faster than Lyle could stammer them out. First a cutting remark, then a gunslinger's long showdown pause and Lyle's nerves were off and running. "Just breathe, baby," Sera once told him. "Wait two seconds before you answer anything. He's not your drill sergeant."

"I'm fine, really," Lyle said.

"Tell me who else was hurt."

"Nobody."

"So, you're telling me that you were in a wreck, but with nobody else, but you were not intoxicated."

"No, I'm, that's correct, yes. It was a hit and run. Police took a report but right now there's nothing they can do. My truck is totaled."

"You're on probation for a narcotics distribution charge, Mr

Edison. You were in an accident while completely clean and sober but you were not at fault, and you can't tell me who is, and you totaled your vehicle and spent the night in a coma, but everything's a-okay. That's your story."

"I wasn't in a coma. Officer Reid, I can show you the CHP report."

"And you will."

"Okay."

"Okay?"

"Yes, sir."

Another tranquilizing, blind breath and Lyle tallied the call thus far: The rote interrogation during which he held his own, with only two documents to be copied to Reid.

"Why wasn't I informed of this sooner?"

Lyle tabulated the days in his head, sensed Reid's impatience through the line. "I, it was, it was only yesterday."

"So, this all happened yesterday? You said it was the day before."

"It was, I mean, I was discharged yesterday. I told you, I'd been knocked out."

"What time were you discharged, Mr Edison?"

"After dark. It's on the hospital record, I'm sure."

"And from the time you woke up, were discharged, went home for a good night's sleep until now, you couldn't pick up the phone and call."

"I've been pretty fuzzy."

"Fuzzy."

"They, they had me on painkillers."

Lyle stared into his empty coffee cup. A blown drug test and a violation. Ninety days, minimum, if his probation weren't revoked outright. Credit score trashed further, insurance jacked higher, the petition to expunge his record out of reach for another year. Sera on her own, pregnant, unable to cover the rent for too long.

Breathe, count slowly. This was why he called. Damage control.

"Yeah," Lyle said. "Yes, sir."

"Well, I'm going to need you to report for a blood screening. This afternoon."

"Today?"

"What *this afternoon* usually means, yes."

"Officer Reid, I – I'm stuck in bed. I just got out last night, I told you."

"What you told me was you walked away from it."

"I didn't say I could do backflips." Lyle winced, waited for Reid's tirade and when it didn't come he lunged after the silence. "I'm sorry. I'll report this afternoon. Sir."

"Wasn't a request. Bring me that accident report, a copy of your chart and any scripts you've filled. That means the bottle. We clear?"

"Yes, sir. But as long as I provide my hospital documentation, whatever turns up on this screening won't count as a violation?"

"Good afternoon, Mr Edison."

Sera would be gone for another hour, maybe longer. Lyle had seen more than his share of doctors and they were as punctual as cable repair men. There, she'd take another pregnancy test, blood maybe, he wasn't sure, but something more than taking a plastic strip into the bathroom. Maybe it would all turn out to be a false flag, though he hated himself for thinking so. Sera was pregnant with his child. She'd bought vitamins and was seeing her doctor. She had made up her mind.

A strange resolve overtook him, that battlefield clarity wherein one's character wrests control from one's nature. He stood up and inched his way to the bathroom. He wet his hands, ran his fingers through his hair and brushed his teeth in slow motion, a flash of pain when he lifted his elbow too high but he pushed through it. It was nothing. He'd been hurt worse. But the oddest movements – a slight turn or odd angle of reach – triggered a sharp stab somewhere new each time. He lay on the bed, squirming into his jeans like a bug flipped on its back. He couldn't bend his knee, couldn't bend at the waist.

He writhed about slowly, blindly feeling for pant cuffs and belt loops amidst random shots of pain as though being poked with a stick by an animal trainer.

Nurses used to ask him how much pain he was in. On a scale of one to ten, they'd say. But his ten changed with every hospital visit. Pain inflicted on purpose hurt more than the pain of an accident. He pulled himself up and buckled his belt, and when he laced up his boots he winced through the stabbing in his ribs and the sharp flare in his knee.

Almost an hour had passed. He felt his pulse in his nose, its splint and bandages a ghost hovering in his line of sight. His glasses were broken in the wreck, though they wouldn't have fit over the splint. He hated wearing contacts, wasn't sure they were a good idea anyway with the whites of his eyes gone red. He was happy to squint for a few days. There was a cane propped on his side of the bed. A polished shaft like the midsection of a pool cue with a brass crook fixed to the stout end. He couldn't recall taking it from the hospital or Sera bringing it to him. Nor could he recall Sera getting him out of the car, up the stairs and into bed. He marveled at her. Sera had left the prescription on his nightstand. Lyle picked it up and with some hairline degree of motion shot a bolt of pain through his leg. He waited for it to pass and tucked the unopened bottle into his pocket, then he phoned a taxi.

~

"Lyle Edison?" The attendant's lab coat was tinged like an old smoker's teeth.

"Right here." Lyle limped to the admissions desk.

"How can we help you today, Mr Edison?"

"I'm here for a screening."

"Don't see your name on the schedule, and you're not flagged for a random. You sure it's today?"

"I was in an accident. Day before yesterday."

"And?" The attendant held his palms up.

Lyle pointed to his matching black eyes and lifted his cane. "Hospital had me on a morphine drip, or something like it, prescribed more when I checked out."

"Mr Edison, we can't clear you for an exemption without proper documentation."

Lyle unfolded the pink hospital carbon onto the desk, set down the bottle of painkillers.

"Very good, but we also can't clear you without first informing your case officer."

"My PO's the one who sent me here."

"And who is your parole officer?"

"Probation officer. Name's Reid."

"Officer Reid." The attendant drew the name out like an old familiar joke. "Okay, Martin here will take you in back."

Martin spoke in fragments. *This way. To your left.* He nudged Lyle's elbow or shoulder and guided him toward the restroom Lyle had used dozens of times before. They stopped at the door and Martin slipped a pair of blue surgical gloves over his hands, snapped the cuffs for a gust of powder.

"Jesus on the cross pose, boss." Martin held his arms out to demonstrate.

"Be gentle, this time." Lyle favored his good leg and hooked the cane over his wrist.

"You need me to be gentle?" Martin's acne and feathery mustache undercut his attempt at a cold stare. "You ticklish, boss?"

"We've done this plenty before, Martin. You don't need to impress me. I got two broken ribs, so just take it easy."

"And I don't need you to tell me how to do my job." Martin poked a latex finger at Lyle's chest. "I can either pat you down my way or I can watch while you do your business. Up to you."

"Lead the way," Lyle said.

The bathroom was big enough for one person. Sink, garbage

pail, biohazard bucket and a placard above the toilet with a diagram of how to urinate into a specimen cup. Martin blocked the door, arms folded. Lyle hooked his cane over the handicap rail and unzipped.

"Mind tossing that my way?" Lyle nodded to the cup on the sink. Martin passed it to Lyle, folded his arms again. The men were close enough to graze elbow and forearm.

"Not a lot of room, is there?" Lyle grinned, and Martin stared dead in front of him, the color rising in his face.

"Doesn't make you uncomfortable, does it?" Lyle said. "Just another day at the office for you, I imagine." He held back the flow and stared at Martin, their faces a foot apart. "Just give me a sec. Almost. Ah, shit. Thought I had it."

"Dude, come on." Martin looked at the ceiling and then back down.

"Here goes."

"Just piss so I can get out of here, Edison. Jesus."

"Okay, that's not helping. Shouting, stress. Those things do not help."

Martin's color darkened.

Lyle silently counted to sixty and smiled.

~

The narcotics in his blood had waned by the time he arrived at the Probation Department. He walked stiffly, kept the weight off his injured knee. The muscle tension made his ribs throb like a boot heel pressing into his chest and breathing hurt. Worse than the pain was the shattered illusion that he'd so stoically endured it a few hours earlier. The water cooler in the lobby was half full but there were no paper cups.

Lyle stated his business and signed the visitors' log. The sergeant handed him an adhesive badge and returned to his newspaper. Lyle made his way through the office. He caught a few stares and imagined many more. He eased into the plastic

chair beside Reid's desk and wiped his palms on his pants. The shift in his posture felt like a hot wire being pulled taut through his chest.

"Hit and run, you say." Reid didn't look up from his paperwork.

"That's correct, sir."

Lyle handed over his hospital documents and the police report. His case file lay open on Reid's desk and his upside-down mugshot stared back at him. The same booking photo he'd seen on the news when he was younger, this time in color. Something twisted in his stomach and he looked away.

"They marked where my IV dosage is," Lyle said. "On the second page, there."

Reid lowered the pink carbon form and glared at Lyle, the skin beneath his eyes swollen and slack. His phone rang.

"Reid," he said. "Yeah, last name, *Edison*, first name, *Lyle*. L-y-l-e. That's correct." Reid unwrapped a stick of gum while he waited. "You're certain? Yes, to my attention please. Same to you." He hung up and turned back to Lyle. "Lucky day, Mr Edison. You get a free pass, this time. Hope you enjoyed the buzz."

Lyle counted out three seconds before he replied, "What about next time?"

"Next time? How many vehicles you got?"

Lyle counted to three again, like gauging the distance of lighting. "They gave me pills for the pain. Will I have to do this every time?"

"What did they give you?"

Lyle handed over the bottle.

"How many have you taken?"

"Maybe one or two yesterday when I came home, but I wouldn't remember. Nothing today."

"Look at me." Reid thumbed Lyle's chin and nudged his face toward the overhead lights. "Don't squint, just keep your eyes open." He looked into Lyle's pupils. "That girlfriend of yours maybe party with a few, not tell you about it?"

"She's pregnant."

Reid gave Lyle a slit-eyed stare.

"No," said Lyle. "No, sir."

Reid let go of Lyle's chin, popped open the bottle and dumped it across his desk blotter. White caplets scored across their middles on both sides. He counted them out two at a time with a business card, sliding them back into the bottle as he went without dropping a single pill.

"Must be tougher than you look," Reid said. "Next time I see you, I'll count them again. And every time after that. Says here, *as needed*, so I'll keep tabs on how much you need. Give that to your pharmacist." He handed Lyle the business card he'd used to count the pills.

"Just got these," Lyle said. "I'm not due for a refill yet. Couple of weeks, probably."

"You're not waiting for your refill. I want your pharmacy to call me as soon as you give them my card, which you will do immediately. When you get this refilled, I'll know about it and then you and I will have a talk, see how much you really need a reload."

"What about my tests?"

"You know the terms of your probation."

"I know. I mean, is taking these going to hurt my future tests?"

"It's not going to help." The phone rang again. Reid answered, listened for a moment and then covered the mouthpiece. "You need something else, Mr Edison?" When Lyle said nothing, Reid pointed to the exit and went back to his call.

Lyle found a liquor store down the block. He bought a carton of chocolate milk, then tore it open at the register as soon as he'd paid for it and swallowed two painkillers.

~

They called him *John Doe* though he was neither criminal nor dead. They escorted Icarus between them, his hands cuffed

at his back like folded wings, and their radios distorted the Untuned and their surrounding fields. Icarus had heard accounts of alien abduction from fellow patients. They had spoken of superterrestrials with enormous black eyes and the silvery slick skin of sea mammals, risking life and shiny grey limb to reconnoiter from the far end of a wormhole and play doctor on some hayseed monkey or do magic tricks with his cattle. Cave paintings were less fanciful than these stories.

Icarus had paid his dues in excess, personally filling and capping such wormholes and mentoring others likewise over the eons and he was far too efficient for any to linger on his watch, let alone be mapped by another mudball of little grey dolphin-monkeys. But he now had a notion regarding the origin of these accounts, since his keepers had examined, documented and catalogued him like a refugee from a plague zone. After noting his correct name, they photographed him front and profile, took his fingerprints, measured and weighed him, stripped him and shone a light into every orifice and then dusted him with an acrid, antiseptic powder, then locked him in a holding tank of kindred vagrants and squatters, a gutted hall sectioned off with chain-link dividers.

A succession of thick planks fixed parallel to one another ran the length of the cell, their lacquer chafed through to bare wood or etched with initials, tally marks, nicknames, and proclamations of one neighborhood's superiority over another. A display of petty hostilities and the desperate ingenuity of the incarcerated. Icarus studied the swastikas and epithets and wondered at the man industrious enough to pass through booking and multiple intake searches with his tools about him, but too dim to avoid the process altogether.

If the Untuned at the hospital were the victims of some heinous and fatal offense, then the Untuned in his cell were their offenders, denizens of a dark subcarrier signal best left unheard. The prisoners assumed an unspoken Darwinian pecking order throughout the tank, a tense gathering of species at hair-trigger

truce around a watering hole. Some lay unconscious as though beached at the floor's edge by a receding flood, or slumped like unstrung puppets against the holding-tank walls. They snored and mumbled through blood crusted about their noses and lips and they stank of whiskey. The rest aligned according to their own mysterious criteria and surveyed one another with sidelong stares, measuring each other's potential as opponent, ally or victim, the power held in balance by the size or reputation of one individual against the number of a particular group.

Icarus took his perch at the empty end of a bench. He kept his back to the others who slept through the night, while he remained vigilant for a trace of the signal. And at first light, they were all herded back through the gates without a word.

"Icarus." Finn stood with his collar up against the cold, his breath fogging and fading in the morning air.

"Captain. Should have minded your own business in a swankier 'hood. Blue Men would have brought you inside with the rest of us. Much warmer, you don't object to the stink."

"Icarus, let's get some coffee. Warm ourselves up."

"Only one of us minds the cold."

"Okay, just for the coffee."

"I'm plenty awake, Captain."

"Icarus, I don't have to ask, you know."

"Learned that more than once," said Icarus. "Seems nobody's got to ask, they don't like what they see out their windows. Folks living in them gingerbread houses take a keen interest in seeing nobody soils their sidewalk by strolling across it. They all but airlifted me out of there."

"I know. They called me once they matched your name."

"Reckoned as much. That, or you pass your spare time clocking the ass-entrance of a jail for its own sake."

"Icarus, it's cold–"

"They never put nothing on me, either. Just locked me up."

"You're a vagrant, Icarus. And you're an escaped mental patient."

"Make it sound like I tunneled under a barbed wire fence with a spork, Captain. Or like I'm hiding in the woods with a goalie mask and a chainsaw."

"You know that's not true, Icarus."

"As do them Blue Men what brought me in last night. Elsewise they wouldn't have thrown me back with the rest of the catch. Would have gift wrapped me in a straitjacket and handed me up, instead of you waiting out here with blue fingers pining for that cup of coffee."

"We were making progress, Icarus. You were."

"Indeed. Also recollect telling you I would walk out when the time came. I choose my words carefully, Captain, because I keep them."

"Will you come back with me? Try it again?"

"Thought you didn't have to ask."

"I don't want to do it that way, Icarus."

The last of the indigent filtered past and the gate wheeled shut behind them. Finn huffed into his cupped hands, rubbed them together and stuffed them back into his coat pockets. He looked at Icarus's bare feet. They were black with dirt, the nails chipped and yellow, thick as chisels. His suit looked tailor fitted, not some cast-off donation. Trousers, vest and jacket, with a boutonnière made of something like pigeon feathers fixed to his lapel. He wore no shirt or tie, only his bare throat above a wedge of exposed chest, his top vest button level with Finn's nose. Icarus didn't shake from the cold. He showed neither discomfort nor urgency. His face bore every sign of a man well rested and none of a man who'd spent the night with his eyes open, stock still and listening for a particular sound.

"Icarus, please. You have no money. You have no place to go and no identification. You can't prove to anyone who you are. You want to keep wandering around and starving?"

"Ain't up to me."

"Still waiting for a message from God?"

"The Mother Howl. And no, already got that. Now I set to

work following through. I keep my word, Captain. Believe."

"Mind sharing what you heard?"

"You were supposed to know what I know, then the Mother Howl would have been loud and clear about it. I forespeculate it's safe enough to divulgify my charge of making an introduction between two parties what have a communication problem. Seems they got mismatched tuning for their respective monkey leather, and the Mother Howl retrofied this here New Brain of mine to intercept signals on both sides of the telechasm. To what end, ain't for me to know. I reckon it concerns additional parties among the Untuned, but I'll fess up that it's hard to distinguicate between the two in parts of town such as this."

"Tell me about these parties. Who are they?"

"Party A and Party B, Captain. You ain't flying solo in your professional creed to keep radio silent about certain matters. I'll set your mind at rest, tell you ain't nothing I got to make happen involves hurting anybody, myself or elsewise. You want to speculize on the master scheme beyond that, I reckon you might ought to consider putting an ear to your soul and listening for your own calling, Captain."

"You're going to get picked up again, Icarus, sooner than later. And again after that. And you're right. They don't need a reason other than some citizen doesn't like the way you look. And Icarus, you don't inspire warm fuzzy feelings in people."

"Make you a deal, Captain. You get another call when they got me stuffed and cuffed on account of I tripped the trust fund radar a second time, I'll join you for hot tea or whatever else you reckon I need."

"Why not right now?"

"Told you I keep my word, Captain. Comes with the job. Now you've trespassed on my time long enough. I've some wandering and starving to attend to."

~

The row of tents and cardboard mats beneath the transit terminal overpass was gone. The sidewalk hosed clean. The soup kitchen lines but twelve or fifteen deep, the hungry stooped low to ward off the cold.

"Got to prove you need to eat," the woman said.

Her bones shrunk within her skin, the scarf layered around her tiny skull a pandemonium of color.

"Identification and two bucks," she said. "Less you got both, they haul your ass in. Cut you up for experiments. Put chips in your head so they can spy on the rest of us. Los infiltrados. Best hope is to wait here. They been by once. Won't check again but when after they sweep the hotels."

Icarus took his place in line. They were far downhill from the warm storybook houses, and like that neighborhood with its high windows and iron fences there was no cause to believe where he stood was any different before the quake than it was now.

The line stretched longer and the day grew colder. At last the door opened and they filed in and lined up again. A row of wooden tables with steam trays where volunteers with plastic hair nets ladled out stewed potatoes with bits of meat and steamed vegetables. Icarus took a seat and ate. Then he dabbed his empty plate with a hot roll and finished with heavily sweetened tea. They had showers but Icarus would have to wait his turn. With nowhere else to go, he sat in a metal folding chair among the others and waited, listening for the signal. When they called his number he went into the showers and stood beneath the warm jet that lasted for two minutes, then shut off. He toweled off and dressed in his suit, and they gave him a toothbrush and a wool blanket. There were no shoes large enough to fit him and he politely refused the knit cap they offered.

"It's not going to get any warmer," they said.

Icarus tapped his temple. "New Brain. My circuits fire faster in the cold. The blanket is all I require."

He went out into the bitter afternoon. His feet ached against the pavement, the cold like a weight crushing his toes. He walked on and soon felt nothing. An old man wandered up the street, ebbing slowly between the sidewalk's edges. His eyes to the ground, alert for stray change, bus transfers and cigarettes. A woman holding an aluminum walker sat on a bus bench, a plastic grocery bag at her feet. Everywhere men and women squatted on sidewalks beneath the slab of grey sky threatening to break loose and crush them.

The signal had died on a hilltop street of storybook houses full of maidservants and plump children, and Icarus couldn't be invisible long enough to pick up the transmission again. Even the low ground wasn't safe. Blue Men were sweeping the city with armored wagons and clearing the unwanted from sight, perhaps on behalf of a newly elected official flexing his iron fist for the news cameras and campaign donors in their storybook houses. Maybe a conference that drew eyes from across the country onto the city, or a visiting dignitary ensconced in a motorcade that would never pass through the streets they were whitewashing.

The daylight gave up. Icarus slipped into a narrow slice of space between buildings, a lone doorway with a bulb mounted overhead to ward off clandestine transactions. Icarus twisted it once to the left and the alley went dark. He crouched down and wrapped himself in his blanket.

Got to stay invisible. Let the storm pass.

A drainpipe tapped out the seconds behind him. If he remained in his monkey leather for as long as the dripping water kept time, he would be dead before it puddled enough to quench a bird's thirst. He had seen whole planets of nothing but ocean suspended in the void by the millions, but the site had withered to a vague memory like the picture from an outdated book. And there was little to discern the Tuned from the Untuned in the part of town where Icarus found himself.

By day he stayed low and on guard for the roaming Blue

Men as he moved from place to place, alert for the signal. He found a discarded transfer and rode the bus across town and back. After the Blue Men had swept the soup kitchen lines he went to eat. A pair of young women staffed a table stocked with toiletries. Icarus thanked them again for the toothbrush and blanket and inquired about a razor. They stared at Icarus, at his shiny scalp and hard clean jaw.

"I don't wake up this beautiful," he said. "Takes work."

The women laughed and one of them handed over a plastic razor. "You'll have to use soap," she said.

"Bet you say that to all the gentlemen."

He foraged the streets the rest of the day and collected six discarded ballpoint pens. Night came and Icarus returned to his doorway in the alley. He left the overhead light on and worked quickly, cracked the blade sliver from its plastic handle, removed his jacket and cut into his forearm, clean, shallow incisions. The cluster of pens together had no more resistance than a toothpick and Icarus snapped them in half for a drool of blue-black ink that he smeared into his cuts, then rinsed his arm from the dripping rain gutter and blotted the wound with a paper towel from the soup kitchen. He dressed again, unscrewed the bulb and wrapped himself in the blanket and slept.

~

Mr Fade wasn't like the Untuned, with their signals switching unchecked. Mr Fade showed himself in the dense flocks and murmurations overhead, in the air between their beating wings or the dancing flames of a barrel fire. In a curtain of mist, or the wavering dapples of sunlight through the trees.

Icarus could clock the man straight-on for half a breath at most, long enough to make eye contact and see Mr Fade's outstretched hand. Whatever he was offering broke apart with the rest of him as the birds changed direction or the wind

shifted the flames, the mist, the leaves under the sunlight. And then Mr Fade was gone again. Nothing.

And Nothing scared Icarus.

One thing to lay eyes on Mr Fade, another to make the reach.

Not eyes, but *eyeballs*. Blood and jelly tuned to a hairline band of the Signal, but still.

When Smoke and Mirrors had delivered Mother Howl's instructions, the little sister bird had stayed parked on his chest, nails against his skin, awaiting his acknowledgment.

"Some things you just don't stare at," Icarus said, "much less go flapping your own grown-ass monkey leather appendage through, never mind it's on loan."

Smoke eyed him curiously, cocking her head this way and that, while Mirrors scratched his own back with a bit of broom straw.

"Y'all clock what I'm sayin', ear-wise? I hit this dirtball guts-up, got myself cuffed and stuffed, then squatted and coughed, had my patience chummed out to lab coats and brass badges, waiting on word from the Mother Howl–"

"You scared, monkey leather mannequin man?" Smoke kept on with her mimicry of Icarus. His voice, his words.

"Indeed, I am. As any sane child of the Mother Howl is right to be."

"What's the worst that could happen?"

"Nothing," Icarus said. Smoke replied with a tilt of her head, and Mirrors ambled further up his leg. "Worse than the worst thing you might conjure up. Old Brain, New Brain, all the same brain when Nothing's on the line. The way you Beaks tell it, Mr Fade lost a staredown he didn't know he was having, leaned in for a closer look and tumbled face first into Nothing. Now look at him."

"You can't." Mirrors spoke at last. Still, Icarus heard his own voice.

"You tell me this man did right by every other human being every day of his life, and he's got Nothing to show for it. His

shadow ran out for smokes, as they say, and the looking glass won't look back, so he's got to brush his teeth and try not to stab himself in the face."

"You're preaching to the flock," said Mirrors.

"Nothing but static and dial tone from the Mother Howl since I got this here monkey leather skin suit," said Icarus, "and now you tell me I got to not just open the red door myself, but stick my hand through because Mr Fade's got a postcard for somebody? Just 'cause I see him don't mean I'm up for taking his hand, wagering on which one of us pulls the other one across–"

Mirrors whistled, a single steady note that Icarus had heard in the death-rattle of stars.

"That ain't right," said Icarus. "Y'all just making me homesick."

"You'll hear it again." Smoke stepped further up his chest. "Stay with it."

Nothing scared Icarus. But Smoke and Mirrors had spoken.

~

The toe of a boot pressed against his shoulder.

"Sir."

Two dark shapes in a flood of backlight. One spoke into a radio, the other tapped Icarus again with his foot.

"Sir. Need you to stand up. Come on, let's go."

Icarus stood, his chest level with the man's eyes. The Blue Men stepped back, hands at their belts. Nightsticks, tear gas and stun guns.

"You been drinking tonight, sir?"

"Y'all got to shuffle your queries up. Already heard this song."

"Sir. Have you had anything to drink?"

"No."

"Any medications? You taking anything?"

Icarus held his tongue.

"Sir, I need you to answer me. Are you on any kind of medication right now?"

They were going to take him and no response would change that. Civility and restraint would be wasted on these men.

"You think I'd be camping with the rats, some doctor had me under his watch?"

"What's your name, sir?"

"Icarus."

The men laughed. "Where are your wings, Icarus?"

"Flash fire and ashes every which way while I was en route verticalwise. Thought y'all learned that by now. Guess they don't allow books at the chocolate factory where y'all work."

"How about you come with us?"

"No. Thank you."

"Wasn't a request, sir. Turn around."

"Sure sounded like one." Icarus turned and put his hands behind his back. "Y'all going to sing one of them cute little songs on the way over?"

Same hall, different cage. They charged him with nothing. They searched his pockets and informed Icarus he would be held for forty-eight hours, after which he would be bused to well outside the city limits unless he had a relative or someone they could contact. Icarus gave them Dr Walter Finn's name.

He would submit to Finn's care, to the pills that jammed the Mother Howl's transmissions and once those signals were silenced he would regard his mission at hand and the life that preceded it as a lunatic conspiracy of his former self. A slave to the Old Brain. Then Dr Finn would make him an outpatient. There were places he could live, programs to find him work. He would be a civilian and the Blue Men would leave him alone.

Icarus would find his way back, no matter what the System did to him. He knew where to go, even if his Old Brain didn't believe his New Brain. The reminder was permanent, inked

into the flesh of his arm: *20 LONG*. He took his perch in a corner of the holding tank and slept.

~

"I'd offer you a lift home, if I could," Ray said.

"Total your car, too?" Lyle tore open four sugars at once and dumped them into his cup.

"Totaled a few, last one about seven years ago. '65 Nova SS with a newly rebuilt straight-six. Crushed it like a foil gum wrapper."

"Jesus. Oh, right, you mean your license."

"Gone for good," Ray said. "You really are innocent, aren't you?"

"Yeah," Lyle said. "Sure." The diner light quivered on the surface of his tea.

Ray took a single packet of sugar, pinched the edge in one hand and with the other snapped it twice with his middle finger, then tore it open.

"Look here," he said, and lifted the bandanna around his head where a pink ribbon of scar tissue spiked down from his hairline between his left eye and his temple. "Goes all the way back," he said. "That last wreck was close to being the last anything for me."

"Anyone else?"

"Hurt, you mean? Nope. Never hurt anybody but myself. Physically, anyway. God kept cutting me slack and I kept stringing myself up with it." Ray knotted the bandanna back into place.

The waitress arrived and set their plates down. She asked if they needed anything else and they said no, thank you, and she left them alone.

"What'd you think of the speaker tonight?" Ray heaped salsa onto a mound of eggs scrambled with ham and sausage.

Carla had shared her story of losing a custody fight for her

eleven-year-old son, of her multiple blackouts and the electric paddles on her heart that marked her last. She recited a canon of horror and injury without blaming anyone or pitying herself. There was no adequate response to Ray's question, in Lyle's mind.

"Known Carla for some twelve years now," Ray said.

"You two ever together?"

"Nah. Least not yet. Knew a lot of the same people, back when. Bought from the same places. I'd get paroled, she'd get arrested. One of us was always relapsing when the other was pulling it together, going back to meetings. Bad idea to get involved when you first get clean, anyhow. Last few years, though, we've been pretty tight."

The men ate and then Ray spoke after a silence. "Glad to see you made it tonight. You could have had a free pass, you wanted."

"I was going to. Happened to be close by, is all. PO had me jumping through hoops, first day home."

"You're speaking up now," Ray said. "That's good."

Lyle stared at his food. "Thanks," he said. "I guess. Stuff I'm saying doesn't really have anything to do with the group. Recovery, I mean. The accident. Bullshit with my PO."

"Your child."

"Yeah…not sure any of it matters, as far as what the rest of the group is there for."

"All of it matters, Lyle."

"Yeah, I get it."

"But?"

"My arrest, the whole sentence was bullshit." Lyle pushed his plate aside. "And I doubt anyone in the group believes me. Feels like everyone's waiting for me to come clean."

"They believe you, Lyle. So do I. That's what we do here."

"Cool. I just don't want, like I get to thinking, maybe, so everyone does believe me. Okay. Then what am I doing there? I'm just a tourist. Eavesdropping, you know?"

"Lyle, you've heard me and the others share plenty. All of

us endured shit that should have put us in the ground, maybe taken somebody close with us while we were at it. Or at least put us away for a while. You think anybody in that group is looking down their nose at you? Think about it. What we do for each other, why we listen, is we remind each other that there's a bigger world than this one." Ray put a finger to his temple. "We're in this together," he said. "Reason we're all there in the first place is because we ignored the bigger world, by choice, the world outside our own private Hollywood."

"This here," Lyle said, "you and I talking. What, you my sponsor now?"

"If you'll have me. Figured now you're sharing, you're ready for a sponsor."

"But you believe me, said so yourself. That I don't have a problem. And judge didn't say anything about doing the steps. I just got to get my attendance card signed, that's it."

"Relax, ain't going to force you. I can't. Lyle, I believe you when you say you don't have a substance problem. But nobody, not a soul, walks this earth for any length of time without being tested. And not just once or twice. And there ain't a man alive can say he doesn't ever need somebody else and be right about it. Come on, brother, think I don't know ghetto-grade movie star teeth when I see them?"

Ray smiled wide. Two rows of perfectly straight white teeth akin to the replicas screwed into Lyle's jaw. "This ain't your first dance with the Devil, is it?" he said.

Lyle shook his head.

"You got no choice but to attend group. Might ought to make the most of it, brother."

"You get all this wisdom after you grow the Moses beard? Or does it come to you bit by bit?"

Ray laughed, flashing his perfect porcelain teeth again. "Here I thought I was just stepping up and doing my part, sponsoring your ass. Turns out God wants to hold me over the fire a little longer." Ray signaled for more coffee.

Lyle sipped his tea and his hands trembled. He set his cup down and clenched his fists, then stretched his fingers wide. "I was leaving this party," he said. "Hardly knew the guy who invited me, but Sera had been working late, so anyway, I was heading out and this dude, friend of a friend, he asks which way I'm going. I end up giving him a ride."

"Drinking?"

"Maybe half a beer, was all. Plenty sober by the time I wanted to leave."

"So, you're giving this friend a lift."

"Yeah, but I didn't know him. Friend of a friend, like I said. Introduced himself as *Fish Stick*."

"Kind of stupid-ass nickname is that?"

"That should have been my first clue. Anyway, he wants to stop at a liquor store, so I wait in my truck. He's taking his sweet time, so I kill the engine. But right then, he comes walking out, fat smile on his face. Then the clerk comes running out, some old Korean guy, tries to grab him, but Fish Stick bolts and drops the forty he'd stashed in his jacket, explodes on the pavement."

"Jackass."

"The clerk starts waving and yelling, pointing at me through the windshield."

"The Korean guy."

"Yeah, so I step out."

"You did what?"

"I wasn't a getaway driver on a bank job, I just wanted to calm the guy down. But he wasn't having it. Tried to say I'd pay for the beer, but he keeps yelling in Korean. I got my wallet out and tried to hand him some cash, but he wouldn't quit shouting."

"Should have split."

"Was about to, but turned around right as the cops pulled up. They didn't see Fish Stick drop the forty and split, but they saw the clerk yelling."

"I can see right now, you didn't keep your mouth shut."

"Nope, I told them the truth. Same as I'm telling you. I don't know what the clerk's version was, but his English suddenly got really good."

"Never talk to a cop without a lawyer," Ray said. "Ever."

"Trust me, I've learned that. Anyway they ran my license and my plates, and I was clean. One of them asks me, what's in the bag? I say, what bag? He points to a backpack in my passenger seat, asks if he can take a look and I say, 'No problem, it's not mine.'"

"Let me guess," Ray said.

"Yup. Bastard had left me holding." Lyle clenched his fists again. "I was looking at a distribution charge, a couple of years, probably. Tried asking people from the night before, tried to find out who he was but they all fed me the same bullshit. Said they only knew him as Fish Stick, said he was maybe Brad or Brian or something, but nobody knew his last name."

"Looks like you beat it," said Ray. "The jail time, I mean."

"I had a clean record and a bulldog of a lawyer. Cost me all the money I had."

"Trust me on this one, brother. Your money was well spent."

"And Sera, man, can't believe she's still here. Thought for sure she'd ditch my ass."

"Sera loves you."

"And I love her. Asked her once, why she'd stuck around and you know what she said? She told me she'd dump me over that kind of self-pity before most any kind of run-in with the law."

"Lordy, she's a keeper."

"Believe me, I know. So, here I am. Two years of probation, including court-ordered rehab."

"Here you are."

JONES

Icarus needed to prove who he was in order to prove who he was. And to the System, he didn't exist. The social services worker had told him exactly that. She had said, "It's just that on paper, you don't exist."

"I'm right here in front of you."

"I can see that."

"Just told me I was invisible."

"Mr, um, Icarus, I'm saying that there is no proof that you are who you say you are."

"And who else would I be?"

"Sir, you can't work without a Social Security number, and for that you need a birth certificate. Do you know where you were born?"

"Neither where," said Icarus, "or when."

He needed identification for the job placement program. He needed proof of his name and an address for identification. He needed a job and an address to stay off the street, needed to stay off the street to stay out of jail, and to stay out of jail to stay on his medication. He needed his medication to keep his job, stay off the street and find out who he really was, but needed proof of who he was to continue his medication outside the hospital. For each paper he was missing, he needed two in its place. Hospital records, police reports and written authorization from the shelter to use their address. Sworn

statements, signed and notarized, from Dr Finn, a pair of social workers and the shelter supervisor vouching for his name.

"Says here on our log, you're an *NNG*," said the shelter supervisor. "Means, *No Name Given*."

"I keep telling y'all my name's *Icarus* and it keeps bouncing right back."

"For your last name," said the supervisor. "Got to be world famous before you can go by just one name. You want me to swear in writing that you are who you say who you are, then I need your last name, too."

"Don't have one."

"Make one up. Pick something."

Icarus said, "What's yours?"

Weeks passed before he traded a sheaf of documents as thick as a Sunday newspaper for a single, state-issued ID card with his name and face, and he still wasn't finished.

~

"That's how it is," said the clerk. He spoke without looking up from his monitor. "Bring us a birth certificate and we can turn this around in an hour. Otherwise, nothing I can do about it."

"I'm hard pressed to believe you've never met someone else in circumstances akin to mine," said Icarus.

"Happens every day, sir. Thing is, it's easier to lock you people up than make a bunch of exceptions to the laws the rest of us honest taxpayers obey without complaining."

"But you're not going to lock me up."

"Me personally, no. The cops will, you give them a reason. Most of you bums don't bother coming in here expecting us to bend the rules. You scream at traffic lights and shit in public or you just drop dead. Nobody gives a damn about your Social Security number when any of that happens."

"I won't do any such things."

"'Course you won't. But since dropping dead isn't up to

you, don't do anything stupid or dangerous, or at least don't get caught, until two weeks from Thursday. We should have more news for you then." The clerk looked past Icarus and said, "Next."

~

The placement program accepted his Social Security application as provisional for employment, then referred him to an entry-level opening with a city clean-up crew. They photographed him and issued him a laminated badge with his name, face and employee number.

"They'll have your name on file," his supervisor said. "So just show them your badge. Might have to special-order coveralls in your size, but we'll cover your uniform, plus your work boots up to seventy-five bucks. Anything fancy and you got to pay the difference. Make sure they're waterproof and they cover your ankles. You're smart, you'll get steel toes." He pushed up his glasses and looked at the sheet from personnel. "*Icarus Jones*, I got that right?"

"Yes, sir. That's correct."

"*Icarus*. Like the guy, what, stole fire? No, guy whose wings melted."

"Indeed."

"Well then, Mr Jones, be sure and tell them, so they can sew your name up front of your coveralls." He tapped his chest where a white oval patch read *Jerry* embroidered in blue script.

"They'll abide by that, sir?"

"They what?"

"I tell them my name's Icarus, they'll sew it on proper?"

"Why wouldn't they?"

"Trying to be a citizen comes tougher than I guessed. No wonder most people who go down stay down."

"I'm not following you, Mr Jones."

"Just saying I get more than my share of raised eyebrows on

account of my name. Thinking I perhaps should have landed on something more conventional back whenever."

"You came here from a placement service, Mr Jones. Icarus. I'm guessing some kind of Section Eight. Don't care to know the details. But some wingnut screaming the Gospel with his balls hanging out just wants to call himself Bob or Joe, that's just downright anti-whatchamacallit."

"Anticlimactic."

"Exactly. Besides, shit, got us a Zeus, a Thadeus, a Jesus, and that's with a '*j*,' not an '*h*.' Plus a Socrates who is one lazy son of a bitch. You got nothing to worry about."

Icarus bought a billfold from a street vendor to carry those things that proved he existed, that he wasn't an invisible 5150 John Doe in the care of the System which the System outsourced to private agencies, each with its own rubber stamp and carbon triplicate failsafe measures against fraud and abuse, measures by which they accounted to their donors, grant committees and taxpayer watchdogs. Paper slips and cards with his fingerprints or photograph, with stamps, seals, watermarks and numbers, his signature and sometimes that of an agent of the System. They'd replaced his hospital bracelet with an outpatient card. Section Eight rooming vouchers entitled him to a key, a bit of metal that he took great comfort in holding in his fist or stroking with his thumb.

~

The speckled white pills were to be taken once each morning on an empty stomach, the yellow tablet twice daily. If he had any trouble sleeping, Finn could prescribe something to help but Icarus had no trouble sleeping. He once more spent a day with his hearing switching on and off and slipping from its alignment, but it righted itself at last without the coded messages or talking animals and the Untuned were cast back from where they came.

His new home had little in common with the lush and cloistered hospital grounds. His window offered a strip of dull sky above the decrepit city block, a cadaver's gumline shrinking from its jagged teeth. He wrote Dr Finn's number on a scrap of paper and taped it on the wall by an empty phone jack. The stray side table made the apartment feel empty. It wasn't "beside" anything, and it held nothing up. No lamp or anything else. He thought he could put a fishbowl there, have a small creature to care for. But the thought of a fish – just one – moving without a sound and the single phone number stuck to the wall with no phone made the place feel cavernously lonely and coffin-small at the same time.

The half-memory again. The empty space in the shape of a memory, just edges and contours that fit what used to be there, so there was an echo of the memory but not the memory itself.

Old Brain, New Brain.

The echo was clear enough to know the full memory would be of an empty space left by permanent loss.

Stories came daily, from the streets themselves or the newspapers Icarus found on bus benches and in laundromats. The woman who shouted into a taxi at a stoplight, called the driver by someone else's name and accused him of spying, then punched him in the neck with a galvanized framing nail. The young man who scalped himself with a box cutter, who told police he was letting the voices out. Icarus cut stories from the papers and tacked them to his walls. Few had photographs and most were a single column, never longer than two or three inches. The amount of paper depended on the number injured or killed, their income and skin color, the notoriety of the assailant or how creative their method.

He said a prayer of thanks each morning with his speckled white pill and asked the Lord for the strength to take the next one the following morning. With the first yellow tablet of the day he offered up his labors for those souls who had harmed another or themselves for want of such care as he received. With

the second he petitioned the Lord to watch over the victims of
the afflicted. And every night prayed for the discernment of the
angry ashen world around him from the medicines that warded
the Devil's fingers from his brain. Icarus no longer dreamt
of supernovas and interstellar gas clouds or signals traveling
light years from long-extinguished transmitters. Without the
urgency of his phantom mission his only obligations were to
a time clock and a series of appointments with agents of the
System, hour after hour spent waiting in plastic chairs beneath
lights that bled the color from everything beneath them.

What he once remembered as the past he now remembered
as a prolonged and vivid dream. Witnessing the arc of a sun
flare thousands of miles high or a star collapsing on itself.
Being rendered human before falling from the sky like a
flaming asteroid. The space in his memory took shape like a
strange mold, the empty form of something no longer there. A
fish bowl. A bottle of wine. A pair of molded dumbbells. In his
mind, he saw a place he recognized but could not remember,
and the echo of loss washed over him.

~

Icarus Jones was an exemplary worker. He arrived early every
day and nursed a cup of black tea until the time came to punch
the clock. His size and strength made him ideal for heavy labor
which he always took without protest. He was agreeable but
not prone to camaraderie and he especially enjoyed working
in the city parks. Some were expansive and full of dogs with
their owners, or children with their young mothers. Others
were a quarter acre of packed dirt with a rusted swing set, but
they were all outdoors with sunlight and birds. Icarus admired
the variety of trees. He met fearless insistent squirrels who
blocked his path and demanded to be fed and he learned to
identify birds by their calls. In the evenings he volunteered at a
kitchen where he ladled out beans or soup or handed out bread

slices. He scrubbed the pots and mopped floors and afterward ate with the other volunteers, then spent an hour in silent contemplation in a nearby church until they locked the doors. At the end of each day Icarus read the scriptures and cut stories from the papers, then said a prayer of thanks before sleep.

~

The female voice on the phone spoke as though announcing train departure times. Her cadence and tone would have been the same whether Lyle were proposing to her or bleeding to death in a bathtub full of ice. The System had flagged him for a random screening and he was to report to the clinic no later than 4:00 p.m. Failure to do so would constitute a violation of his probation agreement. He would not be excused from the screening without proof of financial or other personal difficulty. The law strictly forbade any punitive actions his employer may take and he was encouraged to report these as soon as possible should they arise. Did he have any questions?

~

Lyle signed in and took the lone empty seat in the waiting room. The man to his left looked familiar, somewhere near his own age but with harder years. Baseball-leather street tan and black gaps over pink gums where his upper-front teeth should have been. Lyle had seen him screaming into a bus stop pay phone the day before and now he looked edgy and eager. Lyle sat leaning away from him. Plenty of others were likewise in the waiting room by the mandate of a judge. They were accustomed to people looking away. Staggering through crowds, bumming change or shouting at empty air, they became invisible after a time but had a captive audience in the clinic lobby. The wrong kind of eye contact garnered someone's life story, a political diatribe, conspiracy theory or a prolonged and

tenacious attempt to save your soul from certain damnation, and the wrong kind of eye contact was any kind at all.

The man to his right missed the seven-foot mark by inches. A face cut from rock. The fluorescent tubes overhead reflected off his bare scalp, a band of highlight along the length of his skull. A hard hat that couldn't have been any more resilient than the man's own head sat upturned in his lap. The name embroidered on his grey coveralls peeked from beneath his orange safety vest. Ivan? Isaac?

The tall man turned his face to Lyle. "Six feet, nine inches," he said.

"I – excuse me?" Lyle felt himself go red. He'd lost himself staring at the grey giant.

"I am six foot, nine inches tall."

"Right. Thanks."

"You wanted to know."

"I – yeah. Sorry. I didn't mean to stare."

"I require no apology."

"You must get that all the time."

"Good thing it doesn't bother me." He extended a hand and said, "Icarus."

Lyle returned the grip. The tall man's fingers wrapped around Lyle's hands like tree roots.

"Sisyphus," Lyle said.

"That's your name?"

"No," Lyle said. "It's what I'm here for. 'Doctor, it burns when I push this rock uphill.'"

A stretch of silence. Voices outside the waiting room, a spontaneous bubble from the water cooler. Then Icarus laughed a booming belly laugh that brought all eyes onto the two of them.

"Funny," Icarus said. "I like that."

"Actually, my name's Lyle."

"Not nearly as funny."

"I'll work on it."

Icarus fixed his attention across the room. A potted ficus and a poster for HIV testing awareness. He had the gaze of a man watching wind blow across a lake surface. "Not much color, is there?" he said.

"In the plant?" Lyle traced his line of vision. "It's probably plastic."

"In everything. Makes you wonder what we don't see." Icarus smiled but his eyes glistened at the edges.

Lyle checked his watch against the wall clock, scanned the other chairs. Nobody had been called since he'd arrived.

"Do I make you uncomfortable?"

"No," said Lyle. "I mean, I'm just waiting to get called."

"I make you uncomfortable."

"Not you. This place makes me uncomfortable."

"Indeed," Icarus said. "Chap in a rented cop uniform standing outside the door while you do your business. Make anybody uncomfortable."

"I made him watch a couple of times," Lyle said. "I saw a whole new kind of uncomfortable. Banged up from a wreck a while back. Didn't want our boy back there doing his usual pat-down."

"Martin does like the pat-down, doesn't he?" said Icarus.

Lyle did his best to contain his laughter.

A nurse entered the waiting room and called out, "Mr Jones, you may come back now."

Icarus stood and put his fingers to his brow as though tipping a hat to Lyle. "Godspeed, Mr Lyle."

~

"Your documents are fine," said the clerk. "That's not the issue. The problem is they require more time to validate and reconcile."

"Hard to work without a number," said Icarus. "And assurances to my employer wear thin, after a time. I understood you would have one assigned to me by today."

"No, I told you to come back today. That's all. You had a phone, I could have saved you the trip. As it stands, everything is in order. You will receive your Social Security card in the mail within thirty days. Until then, you don't have a number. Next."

City employees were paid once a month. Icarus worked for five weeks before he was paid only his first week's wages. The payroll office cashed his check and assured him the next one would be for the full month but they would require a Social Security number to process any further payments. Icarus would not receive benefits until after ninety days of probationary employment and his first week's wages were not enough to reload his medicines. He counted the remaining speckled white pills and yellow tablets. He marked the day they would run out, the day his number would arrive and the day he would next be paid. Icarus would be adrift without his medicines for seventy-two hours.

He worked, served food at the mission, spent his quiet evenings at the church, read newspapers and the Bible and he prayed. He kept his appointments with the screening clinic and his case worker. He explained the gap between pay periods and his benefits, the problems with providing subordinate documents to the SSA. He received referrals for temporary aid which required visits to administrative offices who in turn requested documentation as to the nature of his referral. He waited in plastic chairs beneath pale lights where he would pray silently or ponder the crude tattoo on his arm.

The pills ran out. Icarus prayed for strength and the Lord heard him. That first day passed as had all the others though he slept fitfully that night. The next day dragged on clock hands made of lead. His tools were heavy and the ground pulled at his feet. In the church that night he pondered the absence of his entire life. He did not know where he was born or who gave birth to him or how long ago. He did not know if somebody was missing him or glad to be done with him.

"Was I a good man?"

Above the altar, Jesus craned his neck and turned his eyes skyward, his body twisted on the cross and frozen at the height of his pain.

"What acts of mine did you die for? What have I done, for which I cannot ask forgiveness?"

The third day came, the sky grey as smoke. Grey concrete the color of tin but with none of the sheen. Grey, the color of strange birds pecking at his memory. The color of a cold pit after a fire has been rained out and the color of the rain clouds themselves, that infinite grey air of rain with no way of marking the distance. The grey of scavengers, of pigeons and rats. City shelter bedclothes and begged coins and tin cups for begging and for banging across grey bars in grey cells. The grey of boiled meat and gristle served in rescue mission soup kitchens. Coats and shirts and skin after living on the streets. The grey of winter and the encroaching cold it brings and the death that follows in a grey metal drawer in a grey basement. The color of embalmed human tissue, unclaimed and bloodless. The color of the ashes after the body is burned and the plastic bags wherein the ashes are sealed and then discarded into a grey garbage can, hauled away by a monstrous truck, grey with grime and dumped into the other refuse by a man in grey overalls on a grey morning.

There was no paycheck on the fourth day.

"We can process your check once we have your Social," they said.

"I'll have it soon," Icarus said. "Tomorrow, I'm sure of it."

"That's good news. We'll cut you a manual check, Mr Jones, on the spot. Just as soon as we have that number."

He went to the soup kitchen and waited on the sidewalk with the others for an hour and a half. Then he stood with his tray in front of the steaming pot of chili and the man with the ladle spoke to him.

"Jones. Where you been? Missed your shift three days in a row."

Icarus shed his grey uniform that night and gazed at the glowing clock hands until past three. Sirens and car alarms from the street and music blaring from the other building tenants. His insides shifted as though something within him were squirming in search of air and light. He dressed and went for a walk. The church was closed. The key in his pocket didn't fit any of the doors so he wandered on. Men and women slept on slats of cardboard or crouched against buildings block after block. The burrowing quickened in his chest and he hugged himself to quell it. The key was still in his fist but he had no memory of a lock or a door nor any certainty that it was his own so he dropped it into the street and kept walking. More sounds from the streets that grew louder with each step until he could hear the moon pulling at the earth. Icarus ducked into an alley and pressed his hands over his ears, felt his eyes roll backward and his body collapse like a sack of leaves. Then the sensation of his heart hatching and something stretching through the wall of his chest and trailing a viscous web that he flailed and rent with strange new hands until he stood upright with his feet buried in the husk of his old skin.

New Brain's back. I'm my old new self again.

SUBCARRIER

He saw himself dissolving. He peeled down his lower lid, touched a fingertip to his eye and slipped the lens into place. It drifted sometimes, unable to stay fixed atop the hairline scar on his cornea, but the face in the mirror was now distinct though a shade unfamiliar without his glasses. The haze from their thick frames was gone from the edge of his vision and the room was now vivid but disorienting, as though he'd stumbled through a glass door he hadn't known was open.

Lyle had first learned to tie a half Windsor from his father when he dressed for his middle school graduation. Two-finger grip, wide end around the narrow end, then over and down through the loop. He wore his second tie to a job interview long after he'd left home. Twice around, over and down, his hands had trembled and he thought he was going to be sick. He taught himself the full Windsor though he rarely wore a suit. The more complicated knot demanded rote practice that diminished the original memory.

Sera stepped from the bedroom, the roses tattooed on her shoulder a burst of color against her simple white dress.

"Looks like you're ready," she said.

Lyle stood in his underwear and a dress shirt, his tie fixed at last. "Almost. I still need to put shoes on."

Sera put her hands to his face. "You look so different."

"That good or bad?"

"Different."

"Don't think I can manage with the contacts for too long. I'll probably take them out before we meet everyone."

"As long as you put some pants on."

"Plenty of guys wander outside the courthouse with no pants."

"I'm not marrying one of those guys." Sera kissed him and said, "I love you."

"And I love you."

"I know. Now put some pants on."

~

A pair of crows had staked out the strip of curbside grass. Black oildrop eyes and feathers the color of raw coal. The air smelled like rain. One massive cloud crawled into another and the last gap of naked sky shrank to nothing. The crows didn't move.

"You with us, brother?" Ray leaned against Carla's freshly detailed, candy apple red Galaxie. He was dressed for the occasion in a black leather vest over a starched white pearl-snap shirt. He held a can of root beer in one hand and a bouquet of white roses in the other.

"Yeah," said Lyle. "I'm here."

"What's on your mind?"

The street was quiet. No cars passed, no slamming doors or television noise from the apartment buildings. Lyle imagined the earth spinning beneath the static clouds and a wave hummed through his stomach like the weightless plummet on an elevator.

"Lyle. Talk to me, brother. Don't seem at the top of your game."

"I'm nervous, is all. Groom always gets cold feet."

"Not you."

"I'm getting married. *Until death do us part.* I'm just, it's normal. I'll be fine when it's done."

"You don't get cold feet, Lyle." Ray took one last swallow, then dropped the can and crushed it beneath his boot. "Keep saying how you feel like you don't belong in the group and I keep telling you different. You got an iron spine in you, I know. You don't cave to anything bigger than you, though that's not always a good thing, in my book. But you don't flinch and you don't second-guess yourself and you don't get nervous. What's going on?"

Lyle checked his watch. Sera was still inside with Carla. City Hall issued marriage licenses at one office and performed ceremonies in another. Both appointments required reservations in advance and had to be within thirty minutes of each other. The deposits were non-refundable and there was no rescheduling. Lyle checked his watch again.

"It's cool," he said. "It's just, this. I wish it could be *more*. I mean, thanks. I'm grateful you two made it, we both are. Thank you. But I wish I could do more than this."

"Didn't take you for the Cinderella wedding type."

"For Sera. I want to do more for her."

"Sera loves you."

"I know."

"I know you know, but I'm telling you anyway. Forget the fairy tales. You're giving her your life and she's giving you hers. There is no more. You hear me?"

"Yes. I hear you."

"Good. Now suck it up and get hitched."

~

Their footsteps echoed from the courthouse marble. Lyle held Sera close, her veil and dress a shock of white amidst the police and security guard uniforms, the lawyers and city clerks. Lyle led the way, knew every square foot of the building. They came to a gathering of couples in simplified wedding regalia. Lyle stood in line with Sera while Ray and Carla waited on a pew

outside the registry. The clerk was twice Ray's age and half Lyle's height and she had the face of a sleeping bullfrog. Lyle proffered their papers for her verification and slid his payment through the till. The clerk counted the money, examined the documents, counted Lyle's money a second time, then began filling out the remainder of the marriage license application. *For Official Use Only*. She wrote the date with a slow and meticulous hand.

"Seems you've got the most romantic job in the city," Lyle said.

The clerk froze, her pen hovering above the next blank on the form. She looked up slowly as though regaining consciousness and stared through the banker's glass with the expression of a mounted trophy head.

"I mean, this office." Lyle looked around. The number of white gowns and black suits had doubled. "Nothing but people on the happiest day of their lives."

Sera squeezed his hand. A camera flashed somewhere behind them. Lyle stared back through the glass, tried to discern the woman's message from her silence and read nothing but his own uncertainty. The woman sank back to work. She filled in the remaining blanks, then told Lyle and Sera the marriage certificate would be mailed in ten to fifteen business days.

It was always business days. Three to five, five to seven, seven to ten or ten to fifteen. Sometimes within thirty, sometimes sixty to ninety. Then he would receive the paper that declared he was married, had paid his taxes, was eligible for work, could operate a motor vehicle, leave the country, had graduated school, been inoculated or was born Lyle Edison. A paper that required a certified copy to be vetted along with a list of others confirming who he was before he waited three to five to ninety days for the next piece of his life. The world was run by dead faces behind bulletproof glass.

The clerk slammed the rubber stamp onto the application like she was swatting a bug.

"Next," she said.

They took an elevator up three floors to another waiting room filled with couples wearing black and white. Their names were called and they went through a pair of heavy oak doors to another room, empty but for a wooden lectern in its center. Windows ran from the floor to the cathedral ceiling, the trees outside deep green and the balcony glossy with the day's first rain. The court's officiate took the lectern, Lyle and Sera held hands before him and in less than six minutes they were husband and wife.

The rain was in full force. Ray accompanied Carla retrieving her car while Lyle and Sera waited on the courthouse steps. They kissed. Lyle heard his name but Ray was nowhere to be seen. They kissed again. Someone bellowed *Lyle* again but the rest of his name was lost in the din of traffic and heavy rainfall. A homeless man sat in the shelter of the library entrance, crouched as though prepared to launch himself into the air.

"I know who you are." The homeless man's voice boomed across the street.

"Who is that?" said Sera.

"No idea."

Carla honked from the curb.

The man stood. Shirtless beneath his three-piece suit, barefoot and bald but indifferent to the cold. The scale was wrong, the light twisting the man to measures too large for the distance. Lyle blinked hard. Carla honked again.

"Lyle." Sera pulled at him.

He took off his coat to shelter his wife and they ran down the courthouse steps through the downpour. Ray stepped from the passenger seat and held the door for them. Lyle scooped Sera into his arms and stepped into the current rushing past the tires and Sera laughed and squirmed from his arms into the back seat. Lyle jumped in after her, his legs soaked to the shins and Ray slammed the door. The bald homeless man hollered through the rain and strode freakshow tall toward the Galaxie.

"You know that guy, Lyle?" said Carla.

"No. Drive."

"Who's the Tin Man's grandson?" said Ray.

"I don't know."

"Didn't catch the last name, but it didn't sound like yours. He's off his meds, is all."

"Jesus Christ, just drive." Lyle felt his face go hot.

Carla flipped a fast U-turn and drove away.

"I'm sorry, Carla."

"It's okay, babe. Just say what's up."

"Nothing. Just this is the last day I want some crazy bastard in my face."

"Hey." Sera squeezed his hand. "It's okay."

Lyle pulled her close and kissed her. "Let's get that bouquet good and wet before you throw it over your shoulder."

Their friends were waiting on the tented patio of a Puerto Rican restaurant. Friends of Sera's, others from the program with whom Lyle, Ray and Carla were close. Lyle's feet were numb and Sera's dress clung to her but still Lyle had never seen her smile so brightly. The tears absent during the perfunctory ceremony came during the dogpile of hugs beneath heat lamps. Lyle and Sera kissed in a flurry of flashbulbs. They drank sweet limeade and ate grilled chicken with black beans and fried plantains and danced with each other and with Ray and Carla to nonstop Latin wedding music. The rain kept falling but the wedding party under the bright green tent stayed warm and loud long after dark.

The rain stopped much later. Sera danced with a string of guests while Lyle stood at the edge of the party and stared over the patio wall. An antenna dish mounted to a sloping corrugated tin roof above a bank of empty kegs. FORD'S BEER-POOL-SATELLITE TV written in red neon. Maybe he could do a shot, chase it with something sweet.

Ray stepped beside him. "Still wishing it were more?"

"No," said Lyle. "I'm good. This is so much better than I hoped. It's perfect."

"Something else is on your mind."

"You ever get tired of dispensing sagely wisdom?"

"Not as long as I got someone dumber than me to listen to it."

Lyle grinned. Ray rattled the ice in a plastic cup of root beer while the reception carried on behind them.

"You're your own man, Lyle. You can always tell me to mind my own business."

"No. I'm glad you're here. I'm rattled, is all."

"Figured as much. You're staring at Ford's over there like an orphan outside a candy shop."

"Something I've heard more than once at the meetings, how people say that their drug of choice, whatever it was they used, it worked for them. And that lasted for a long time."

"Something you don't hear too much from folks outside the program," Ray said. "Reason you get hooked is sometimes because what hooked you did the job, made life better. Until one day, it doesn't. What about it?"

"I keep wondering if I could have that first part. Make it all go away with a stiff drink, even temporarily. Like flipping a switch. Just this once."

"Think maybe you could," Ray said. "Might work, too. But you know what I'll say next, right?"

"Yeah."

"So why don't you get it off your chest instead of starting down that road same day as your wedding. What is it that needs to go away?"

"That homeless dude outside the courthouse," Lyle said. "I know him."

"I figured that. How so?"

"Met him at the clinic once, before a screening. We made small talk for two or three minutes."

"And that's it?"

"I guess. He didn't say much. Definitely odd, but he seemed harmless. Very, I don't know, cordial. He was working for the

city, I think. It has to be the same guy. Bald, almost seven feet. Said his name was *Icarus*. Seemed weird but it was stitched on his uniform."

"Job placement program," said Ray. "If he was there for a screening like you, he's probably in a halfway house or in some kind of long-term treatment that didn't take. So no doubt he was on something when he came after you earlier. Or more likely off whatever it is he should be taking. Doesn't explain why that's got you ignoring your bride staring at the back entrance of Ford's."

"He was shouting my name."

"That's what spooked you? Shit, he could have pulled it from the sign-in sheet."

Lyle took a long steady breath. "Ray, he said my full name."

"I heard him. Didn't sound like *Edison* to me."

"It wasn't." Lyle's hands trembled and he shoved them into his pockets, then he inched towards the nearest heat lamp.

Ray looked around, saw how far they were from everyone. "That ain't your real name?"

"It's the name I chose, so it is my *real* name. But it's not the one I was born with."

"Sera know this?"

"Yes. And she knows why. Been almost twenty years since I've heard my birth name."

"Which is?"

"I'd rather not. Now, anyway. I'll explain later."

"Up to you. But tell me straight up, Lyle, you in any kind of danger? Or Sera?"

"No. Neither of us. But I don't know how he got my old name, or why he didn't say something when we met."

"Me neither. But you'll get this off your chest with me when you can? Tell me the whole story?"

"Yeah. I will."

"Right on. Now, go dance with your wife."

Family

NADINE

He blinked and he was a grown man, a husband and very soon a father. He wore a wedding ring, and sometimes when a shopkeeper offered assistance he'd say, "No thank you, I'm just waiting for my wife." People called him *sir*. He was nearly twice the age at which he'd met the red-haired man at the lunch counter near the courthouse, where sealed documents were routinely exchanged in the open.

Lyle Edison tempered his new name over years, filled out hundreds of forms with his name and birth date, sometimes his driver's license number or the names of his nonexistent birth parents. Job applications, tax returns, apartment rentals, bank accounts and a score of small legal headaches before the big headache that was Officer Nestor Reid. He waited for someone to expose him but they never did and after a few years he stopped thinking about it.

Now he was roughly the age of his teachers the year he'd dropped out of school, and slightly younger than his girlfriend's father at the time. The same age as the people who'd turned him down for work, and the cops who'd knocked on his family's door that night. He was the age of most every authority figure he'd crossed as a young man, those whom he'd regarded as adults and who had unequivocally presented themselves as such. He now understood they'd been lying.

The mail arrived. Bulk trash addressed to Occupant OR

135

CURRENT RESIDENT. A credit card statement, a monthly truck payment invoice and letters from three different insurance carriers for their auto coverage and separate health plans. Sera's prenatal care and the aftermath of Lyle's accident each had mounting correspondence of line-item denials, requests for additional documentation and the rare reimbursement. Beneath a mound of bulk mail and more bills, Lyle found a copy of *Rolling Stone* addressed to SERA EDISON.

The marriage certificate had arrived two weeks after their wedding. Sera then made appointments, stood in lines, proffered the same set of documents again and again, and she waited. It took two hours for her bank to change her account information, and she was well into her third trimester before being fully on record as Sera Edison to anyone with such a record of her. Lyle had bought his name with a stack of blank money orders over breakfast, paid for a lie that said he was not Lyle Junior, the son of a murderer, but a different Lyle altogether. Every time someone believed he was Lyle Edison it brought him a small measure of relief. Sera believed him enough to make the name her own but this brought Lyle no relief at all. Every time he saw her name on a piece of mail something of his old dread returned.

A picture of Nadine had been fixed to the refrigerator with a magnet, a grainy swath of black and white like the sweep of a wiper blade over a windshield covered in ashes, rendered from an echo sounding through Sera's drum-tight belly. Head, feet, fingers and heartbeat floating in the dark. The baby had gone from being *it* to being *her* and now she shared his name, too.

"Lyle?" Sera peered from the bathroom door. Wet coils of hair, the naked curve of a shoulder.

"Yeah?"

"Nadine's coming."

"I know, sweetie."

"Lyle." Sera's voice was firm, her eyes urgent. "Nadine's coming. I need to go. Now."

The clarity took hold of Lyle again, an alien calm in the midst of crisis. "I'll bring the truck around while you get dressed."

"No. Lyle, wait. Please."

So Lyle waited, detached and observing, while Sera dressed.

"Lyle, the bag. I can't find it."

"It's by the front door."

Sera stopped and sat on the corner of the bed, her mouth open but silent. Then she said, "Lyle, it's happening. Lyle, Jesus, not now." She seized up again.

"It's a contraction, sweetie. Let it pass, then we'll get you down the stairs."

Sera's face went slack and she took a long breath.

"Let's go, sweetie." Lyle took her hand. "I'm right here."

Sera gripped the railing with one hand and Lyle with her other, squeezing the blood from his fingers. Lyle kept pace with her, watching her feet take each step, in case he had to correct her. They reached the landing and Sera stopped before the second flight.

"Did you lock the front door?"

"Knob and deadbolt. Did you have the baby?"

"No, Lyle." Her breath quickened. "Don't make jokes, not now."

"Can you make it? Should we wait here?"

Sera slowed her breathing and shook her head. They continued down. Three steps from the bottom Sera stopped and crouched in pain again.

"Sit down, sweetie. Come on."

He helped her down and they sat together in the courtyard. A thin squeal slipped from Sera's throat and then she relaxed and took long, heaving breaths. A small dog barked from the neighbors' apartment.

"When you're ready, we'll walk to the front gate. Right there. As soon as we're through, you can sit down again. Just wait on the front steps."

"No."

"Twenty feet, sweetie. Then I'll pull the truck around."

"Don't leave."

"Sixty seconds tops. It's faster that way, okay?"

Sera closed her eyes and breathed deeply. "Take me to the truck. Please."

"Sera, we've got the worst parking spot in the building. It's better if you wait on the front steps while I pull around."

She nodded. "Okay, hurry."

Lyle helped Sera to her feet, gauging his time by her breathing, the strength of her grip. He opened the gate and helped her on the front steps, ran back to the courtyard and grabbed her bag and set it beside her. He kissed her forehead and said, "Sixty seconds."

He shut the gate behind him and ran. When he pulled to the front of the building Sera was already standing at the curb. He jumped out and threw her duffle into the truck bed.

"Did you get everything?" she said.

"Everything."

"Are you sure? I made a list."

"I'm good at packing in a hurry."

"Stop it, Lyle."

The truck idled with a low rumble, its hazard lights flashing in the dark, mist drifted through the headlamp beams. Lyle opened the passenger door and gave the runner a solid tap with his boot. An aluminum plank welded to the undercarriage and lined with black friction paper that sparkled beneath the streetlights. Lyle helped her up, buckled her in.

He drove quickly but cautiously. At a red light, a taxi crossed the intersection but no other cars were out. Lyle checked their door locks and kept one eye on the rearview mirror, watching her bag in the truck bed. An easy grab for a thief at that hour, in that part of town. But nothing inside worth chasing someone down for.

"Just go," Sera said.

"It's straight to jail if I get stopped, no slack at all. You'll end up giving birth right here."

"Okay. Just hurry." Sera's breath quickened again.

Movement in the rearview mirror. Lyle revved his engine, inched forward. Sera turned to him. Her focus drifted past Lyle and her face went slack and then she screamed, but without the twist of pain brought on by contractions. Lyle turned to his window and there stood the man from the clinic who'd bellowed Lyle's birth name in the downpour of their wedding day. Icarus. Enormous, barefoot and shirtless in a dark suit, like a shadow stretched in the late afternoon sun. He bent down and stared into the front seat. Sera hollered again but with pain this time and the light turned green and Lyle had to wrest his hand from Sera's grip to put the truck into gear. He peeled through the intersection, Sera in the grip of another contraction and her crying drowning out the giant bellowing behind them. But Lyle knew exactly what he had said.

Sera had two more contractions before Lyle reached the hospital and the warning tremors of a third shook her when he stopped in the emergency entrance red zone. He set the parking brake and hit the flashers, then jumped out of the truck and ran. Sera breathed, counted from one to ten on the inhale and exhale. She opened her eyes on the second breath. Lyle was gone, hadn't run to her side to open her door. Before her panic could marshal itself, the glass doors of the entrance slid apart and Lyle ran through pushing an empty wheelchair ahead of himself.

Lyle pushed Sera up the concrete slope. The sliding glass entrance a blazing square of yellow. The doors parted without a sound. A watchman strode through the lobby, his powder blue shirt creased from shoulder to cuff, a radio at his hip. Somebody just stole a wheelchair and now the night guard could do what the doctors could not. He stepped directly in their path, intent on Lyle.

"Save it. She's about to pop." Lyle pushed forward, the

heavy footrest plates aimed at the night guard's shins. The guard froze, eyes pinned open as though Sera appeared out of nowhere and then dodged the oncoming chair. Lyle stopped at the admissions desk and picked up the nearest pen in advance of the clipboard and forms from the attending nurse.

"I'm Lyle Edison. My wife Sera's in labor."

~

The contraction cedes to a wave of heat. Her body melts. She feels no pain but only its echo. I can't do this. Yes, you can, sweetie. The warning tremors shudder through her and she steels herself and squeezes the blood from his fingers. Easy honey, breathe. I can't, no. Yes, yes you can. No, no. Yes, come on, it's okay. But she says *no* to the pain and not the breathing but before she can say this, the next contraction seizes her. Everything below her chest tearing loose. A thin ribbon of air squeals through her throat and the strain pushes against her eyes. Then another hot wave of relief, a nanoburst orgasm, a swelling ache in her lungs. Breathe, baby. She releases a rush of air and drifts on another current of heat. Colors pop in the dark. The muscle flutter warning of the pain, which comes sooner each time like the seconds fleeing in panic between the flashing sky and the crash of thunder until her dread of the imminent pain becomes her dread of the imminence itself and there is no room for relief. That's it, sweetie, you're doing fine, keep breathing. His words come from somewhere behind him as though he's overhearing his own voice, the voice of a stranger with no bearing on this woman or her pain or the child she's birthing or the people in blue keeping the mother and her child alive. The stranger says, That's good, honey, that's it, keep breathing, you're almost there. The stranger tells her she's doing just fine, that everything's okay and it will all be over very soon. But she's still in pain, her face twisted and wet. The others attend to the procedure or the machines and

the stranger says nothing because he knows his words won't change how, when or if the child is born. So this is what it's like to be a ghost, to be slowly dying alone and unseen on a sidewalk amidst the millions of living. This is what it's like to not matter and if it would make her stop hurting and keep her and the child from ever hurting again, then he would gladly be a ghost forever. Lyle. I'm right here, Sera. No. I'm right here. No, you're not. Sera, I'm here. Don't drift off. She starts to say *now* but her cry blows the last word out. Lyle back in his skin and not an invisible stranger any more says, Keep pushing, sweetie. God. Yes, just a little more. Something's wrong. Breathe, baby. Lyle, tell me what's wrong. But he doesn't say anything, doesn't ask the doctor so doesn't validate her fear and he buries his own. She screams again and the doctor tells her to keep pushing, harder, harder, his calm voice of experience in contrast to Lyle's stammering anxiousness and God she hates his self-pity that's so brief and rare but always so disastrously timed. That far adrift numbness in his eyes that leaves her stranded in the present and she hates him for being the same mistake with a different face and hates herself for making that same mistake again and she feels something rupture. A snap of cartilage and membrane, something hot spilling from her and when she opens her eyes he's gone like all the others because there was only one with a different name and face each time and she screamed, Lyle. Sera, I'm right here. She squeezes the tears out and he comes back. Blue scrubs like all the rest blurred beneath the bright light and white walls and her hand crushing his and she says, tell me what's wrong, and then a tiny voice from below her begins to cry.

~

The child was too small for its own skin. Blind eye slits in a puckered burl of flesh, slippery and dappled red.

Someone said, "Have you decided on a name?"

"Nadine," said Sera.

Lyle softly repeated, "Nadine."

Nadine clutched Lyle's pinky with fingers like grains of rice, her nails the size of pinholes. Her ears were no bigger than fingerprints and nearly as intricate and when her flush faded, Lyle saw Sera's lips in the cut of his daughter's mouth. His spread palm covered her chest and he felt its slow rise and fall, the warmth of her blood through the thin blanket. The sleeping newborn's breath was the only sound in the world.

~

Back home from the motel with his mother, Lyle had taken it upon himself to board the shattered window. It was likewise upon him to remove human shit from their front porch or garbage from their front lawn, replace the broken mailbox and paint over the graffiti slashed across their garage door. And when he was hungry, he went to the kitchen, opened the refrigerator and like most teenage boys he moved nothing, but stared at the contents as though they were an optical illusion. His father used to say, *You warming the fridge or cooling the house?* But his father was gone so nobody said anything, and every day he stared into the refrigerator a little longer. Milk ran out and vegetables went bad. If his mother ate, he never saw her. He bought groceries with his own money, paid the phone and utilities with her checkbook, wondering if signing her name to keep the electricity on was a crime. He didn't look at her balance but left notes with check numbers and amounts and found them unread when he opened her checkbook again. He was quiet going into her room, though never certain she was fully asleep. She kept a pillow over her face and always seemed strangely rigid beneath the covers. He never saw her drink and there were no pills in her medicine cabinet, but she rarely left her bed.

Sometimes she picked him up from the hospital after he'd

been attacked, most of the time he walked out on his own. The day he dropped out of high school, he stood at the foot of her bed again, his mother burrowed beneath the covers. The withdrawal form required her signature, but he couldn't bring himself to roust her. The last time Lyle had physically touched his mother was in the office of the motel when her purse fell open. The occasional flush or sound of running water from the master bathroom were the only signs he wasn't alone in the house.

In his note to her, he said he would write once he had settled. He left it on the kitchen table, propped between the salt and pepper shakers, knowing it could be weeks before she moved that far from her bedroom. And then Lyle left for the bus station. Holding his daughter in his arms, it occurred to him that he'd never settled until now.

Lyle and Sera's first weeks back home were a sleepless blur, their day and night rhythms broken and scattered through chance windows for bathroom time or a fragmented nap. The ringing in Lyle's ears grew with each hour he kept his eyes open and colored haloes twisted behind whatever he observed for more than a moment. He shaved once a week and cooked or made tea while Sera tended to Nadine, or he tended to her himself while Sera showered or slept. He held Nadine and paced the apartment, gently drumming the small of her back with his fingertips, sometimes while the sun rose. Nadine's face to his shoulder, her head warm against his cheek, her ear pressed to his jaw and bits of his shirt crumpled in her tiny fists. He stared out the window, clouds pluming under a sky the color of Christmas lights, the warmth of his newborn daughter soaking through him and during those first minutes of morning Lyle believed in God, believed that for a moment both fleeting and frozen that he was looking at God and that God was looking back at him.

Lyle installed safety catches throughout the kitchen and bathroom cabinets and covered the wall sockets with plastic

guards. He surveyed the apartment for anything within reach of the small and curious: kerchief tassels dangling from bookshelf ends, the ersatz altar cloths beneath souvenir snow globes and framed pictures. Stereo and VCR controls, power strips, electrical cords and speaker cables snaking through banks of cat hair and lint behind the books and records. The measure of their home according to what their child could choke on revealed a frail sanctuary seeded with threat. Loose coins, buttons or hair pins sunk into the carpet. Sera and Nadine slept while Lyle trolled the closets and corners with a penlight between his teeth.

The police had done the same thing the night they'd arrested his father, before Lyle and his mother were at the hotel and their house picked apart by tech crews and dogs. Lyle's mother spoke with a detective who wore a ratty brown jacket and purple tie. Lyle remembered sitting on the couch with his feet dangling above the carpet, scores of flashlight spots dancing on the ceilings and walls. But that wasn't right. He was seventeen at the time, grown to his full height and tall enough for his feet to reach the floor but in his memory he's the size of a child. The lights had been on throughout the house, too bright to see flashlight spots and there were too many uniforms in the memory, swarming up and down the stairs, in and out of every room.

Lyle picked up a hardened pellet of cat food wedged next to the baseboard and tossed it. Sera and Nadine were curled together on the bed, their breathing hushed and their eyes closed. He had some time before his meeting. He took off his boots and lay down next to his wife and daughter and fell asleep.

WIDE AWAKE

Nadine's eyebrows stretched and squirmed, her face twisting with the effort to wring the blur from her vision. She fixed on slow movements and stark edges and she didn't blink. Lyle imagined killer whales drifting through fog. He marveled at her concentration, the magnetic pull of her eyes that never stopped taking in the world. She churned the air with her hands and feet and when Lyle touched her palm her fingers clamped around his and she promptly drew his fingertip to her mouth.

Ray cradled her in his cupped hands marked by fierce years of work, misfortune and punishment both meted out and fended off. A blackened thumbnail. *S-P-I-T F-I-R-E* written in block letters across odd-sized knuckles. Calloused welts, fingers broken and poorly set, small scars hashed about his chafed and chapped strop-leather skin.

"She's still deciding if she likes you," Lyle said.

Ray leaned forward and Nadine lost her hands in his beard as though she were playing with a cloud of smoke. She froze and then broke into a wet grin, her eyes glittering and electric.

"Guess she likes you just fine."

"Well congratulations, brother," said Ray. "She's perfectly healthy."

Ray's own eyes seemed to Lyle they were catching more than their usual share of light. They had the pronounced gloss

common among the hysteric, delirious and insomniac, or to
the sadness welling after the call of a certain memory. *You carry
this through, you might be among the lucky few has a kid that'll still
speak to him. God bless you, brother.* Someone, somewhere, saw
the world through Ray's pale eyes but beyond their blood they
had only silence, miles and years between them. Lyle had his
own measure of cause to cut loose from a parent and if Ray
were anywhere close to it he wouldn't be on the outside and
certainly not holding Lyle's daughter. Lyle pictured his father
jumpsuited in supermax lockdown, head hanging and eyes
wet with regret. The father he imagined – who for all he knew
was long dead – was from his childhood, and wore a face for
which no time had passed and so Lyle's recollection of the man
was akin to himself being three feet tall the night the police
came to their house. Allowing for his father's remorse was to
disavow the justification by which he abandoned his family
and his name, rendering suspect everything in his life that
came after.

Nadine took Ray's beard in both fists and pulled. She let
loose a piercing squeal and kicked in a fit to contain her smile.
She planted one foot into Ray's jaw, another to his collar bone
and Ray laughed, flashing his plastic movie star teeth.

Lyle's father had killed human beings for sport. Ray had
never killed anyone. On occasion since Nadine had been born,
Lyle had been cradling her and humming softly when the
yearbook portrait of the missing waitress from long ago flashed
to mind, the recollection more faithful to the television's
jagged grain and ambient glow than the details of the young
woman's face. Half-blinded in the afterburn of that flash Lyle
spied the lingering shadows of strangers in the room with
him. The victims' mothers and fathers whether dead or alive
were nevertheless reduced to ghosts by their excruciating and
irrevocable loss, and all the sadness and pain Lyle had ever
known became then like a small rock tossed into a bottomless
black well. If holding his daughter and watching the sunrise

was to stand in the company of God, then this passing wisp of darkness was its very opposite.

As little as he knew of Ray's history, he knew nothing of Ray's child and nothing of that child's reason to disown him. For Lyle to abide by his own decision was to acknowledge cause for that child's, and so dispel any certainty Nadine would not someday have the same.

Ray and Nadine were quiet, the ringing in Lyle's ears mysteriously absent and the world looked for an instant like pictures cast onto a paper-thin screen.

"Don't often get little ones at the meetings," Ray said.

"I didn't want to miss Carla speak," said Lyle, "and figured I might give Sera a couple hours to herself."

"Bet she's had a nap and a long shower, now she's missing her little girl."

"Yeah. I should get out of here soon."

Nadine clamped her fingers around Ray's little finger, her feet absently bunting against his arm.

"Tell already," Ray said, "she's got some black hair that damn sure ain't yours."

"Sera's."

"She's better off, more she gets from her mother."

"Truer than you'll ever know," said Lyle.

"Think she wants her daddy, again." Ray half-stood and handed Nadine across the table. "Got her?"

"Yeah, thanks."

"Easy now."

"I got her, Ray."

Ray held Nadine with seasoned ease. He instinctively supported her head with one hand and moved anything within reach of her happy flailing but gave undue care whenever passing her between himself and Sera or Lyle. He settled back into the booth and dug a heaping spoonful of whipped cream from his plate.

"Wouldn't have taken you for an ice cream-type guy," Lyle said.

"Everybody likes ice cream."

"Badass like yourself, with the nuts and the syrup and the cute little red cherry. I mean, what's with the chocolate shavings?"

"They were out of rainbow sprinkles." Ray used his wrist to wipe his mouth and said, "You're still not doing the steps."

"I'm not. I'm okay, I know, they don't have to be about an addiction."

"Not where I was going," said Ray. "I'll back up. How about the speaker tonight?"

"Was okay. I mean, yeah, really powerful and moving and whatever. But, I guess, was just more of the same thing. That's awful, I know. I don't mean. . ."

"Speak your mind, brother."

"Okay, I get it," Lyle said. "Believe me, I do. Starts out small, always does. Maybe legit, maybe not. Then it becomes every night. Or lunch breaks or weekends. One day you need your refill a little early. Or you start missing work."

"Next thing, you're blowing jockeys in a horse's shit stall," Ray said.

"Or the other way around. That's not me, Ray. Shit, you've known me for almost a year. I've never had a little more of anything on top of anything. I've been treading water since I can remember. Like I told you way back when, sometimes I feel like a tourist."

"You're down to once a month at meetings, far as the Board and your PO's concerned. You did your 90/90 and your six months of weeklies."

"I did."

"Now you're doing monthlies. Except you're already done for this month, but you came tonight anyhow."

"You asked me to."

"I did. But you're plenty busy, and while Sera's got good reason to slap you back to reality whenever you go walkabout in your head, I can see you don't like being away from her any longer than you have to."

Lyle kept quiet and listened. Ray was right, so far.

"So you're only coming to meetings under court order, and you're not doing the steps because you're not an addict. Fair enough. But your attendance goes way beyond the conditions of your probation. Little brother, you're hearing something you need to be hearing, but seems you don't know what to make of it, or what it is."

"Hard to say."

"You understand, some of us crash and burn right out of the gate. Bottom's waiting as soon as we open our eyes."

"I get it."

"No, you don't. For some of us, it's sometimes just plain fun. No inner pain, no daddy issues or denial. Shit, all the bad press makes you forget that, and most people who've never wrecked their lives refuse to believe it. Told you before, my jones gave me some of the best years of my life. Everybody's got their own road to hitting bottom. For some, it's a little bit at a time."

"Like I was saying, it starts out small."

"*Always does*, you said. But that ain't Carla's story, damn sure ain't mine. You keep coming back to it, though. *Starts out small. Always does.* Something in that speaks to you."

"You may have a point."

"Learned to keep my mouth shut, unless I'm damn certain I'm correct. Even then, I get it wrong, sometimes."

"You're not out of line, Ray. It's cool."

"I appreciate that, brother. Little one here disagrees with you, I think."

Nadine screwed her face into a wrinkled red ball and then she relaxed, opened her eyes and lolled her face into his, gummed the tip of his nose. Lyle kissed her and Nadine curled her fingers around his lower lip. Time to clip her nails again. She let go and Lyle kissed her cheek, kissed her ear and nuzzled her neck.

"It's late for her. We should hit the road."

Lyle experienced fatherhood like someone acclimatizing to extreme temperatures or high altitudes. The film-stutter glow

of sleep deprivation, the mysterious crying at odd hours and the emergent medical concerns. One day's crisis became the next day's norm.

Twice en route home Nadine squeezed her eyes shut and squealed like a slipping fan belt, her face flushed and furrowed. Lyle pulled into a gas station and parked by the air and water pumps. Nadine's diaper had leaked, a putty-colored seepage squeezing through the seams at her thighs. Lyle tore the tape loose, gagged and rolled down the windows. Without Sera, there was no speculation about a disastrously full diaper, no intestinal parasites or other worst-case anomalies. But nor were there oversights when packing to leave the house. Lyle cursed silently and dug through the diaper bag. Empty plastic containers, rash cream, extra bibs and pacifiers. A single clean diaper and an empty box of wipes. He gave Nadine a cursory wipe down with a clean burger napkin from the dashboard, balled up the dirty diaper into a plastic bag and swaddled Nadine as quickly as he could manage. He stepped from his truck, lobbed the knotted bag into a garbage barrel and carried Nadine across the lot.

A sheet of notebook paper duct taped to the men's room said OUT OF ORDER.

"Hello? Incoming," he hollered while holding Nadine's blanket in his teeth. Nadine pulled back at it from the crook of his arm.

Lyle shouldered the door open. Water from corner to corner, the toilet unflushed and stagnant, the paper unspooled into a sopping mound. The garbage can lay toppled beside a heap of wet paper towels, bloody tissues, candy wrappers and condom foils beneath a sink that someone had tried to dislodge from the wall. It dipped floorward and someone had stuffed a newspaper into the hollow where the tiles had broken away. The taps were pushdown knobs that ran for a few seconds, then shut off by themselves, a deterrent to the careless and malicious. Lyle hit the left tap and when it stopped running he hit it again, longshot hoping to coax a run of warm water. Nadine squirmed within her blanket, started to cry, stopped,

started again, then kept crying. Lyle cradled her in one arm and worked the tap with his free hand, the diaper bag slung over his shoulder. He caught his reflection in the mirror, FUCK YOU scratched into the glass.

"I'm sorry, sweetie. This is going to be cold."

Nadine quieted down once she was clean and dry. Lyle wrapped her in a fresh blanket from the bag, the other blanket lay in the water at his feet.

Someone knocked.

"It's occupied," Lyle shouted.

"Sir. This is the police. We need you to step outside."

"Christ." Lyle hoisted the bag onto his shoulder and called through the door. "I'm on it, coming right out."

Two squad cars were parked in the lot, a single red roof light on the one closest but no fanfare otherwise.

"Good evening, sir." The officer dragged out the *good* and popped the *sir*. He had the demeanor of someone tearing tickets at a carnival ride. Linebacker big with a salt-and-pepper mustache. His tag said ROESNER, and his chevrons marked him as a sergeant. Lyle committed the name and badge number to memory.

"Sergeant," Lyle said. "Please tell me you brought diapers."

"Afraid not, sir. How about a side arm? Can he handle that, yet?"

"She," Lyle said. "Not yet, she can't. But she'll learn, before she starts dating. Right, sweetie?" He kissed Nadine and the sergeant laughed. Roesner carried himself with the ease of a veteran, a man who'd sized up enough real threats to recognize a haggard and flustered new father when he saw one. Lyle set the diaper bag onto the pavement.

Roesner's partner stepped forward, thumbs hitched into his gearbelt. "Mind if I take a look in here, sir?" He spoke as if reading from a card.

"Have at it," said Lyle.

The name tag said PREHN. Lyle noted it along with the badge number. Prehn was shorter than Lyle and at least eight years

younger. His game face was unlined and untested, and he displayed the deference and robotic propriety common to rookies. Lyle reckoned Prehn did the practical work while Roesner observed, evaluated and in general played the hands-off good cop but still called the shots.

"Anything in here I should know about?"

"A soiled onesie," Lyle said. "Think a bottle of breast milk popped open in there, too. Mind yourself."

"Wouldn't be the first time," said the sergeant.

Maybe he was testing Prehn, shooting barbs at the rookie to toughen him up for the field. Or maybe Roesner just liked reminding him who was weaker. Lyle would have sympathized were it not for his immediate and visceral dislike of the rookie.

The sergeant tickled Nadine's cheek. "And what's this cutie's name?"

"Nadine. Almost three months." Lyle rocked her in his arms. "You must get called to this place a lot," he said.

"First time," said the sergeant. "Why you say that?"

"Just I can't imagine a guy works a 24-hour gas station, and me having a bathroom emergency with my daughter's the strangest thing he's seen, so far."

"Makes you think we got a call from someone who works here?" The sergeant's avuncular tone was gone.

"My mistake," said Lyle.

Prehn asked Lyle for his license and Lyle complied. The rookie held the license at eye-level and arm's length, pinched between his thumb and forefinger while he spoke into his shoulder mic. Sergeant Roesner conferred with a female officer from the other car. Dark hair pulled tightly back, swimmer's shoulders. Lyle had a glimpse at her name tag. Moráles, maybe, he wasn't sure. The rookie joined them, still holding the license like a lab specimen. Lyle's plates and his ID were flagged, so now they could search his car, pat him down, turn out his pockets and maybe check Nadine's blanket, even call his PO. Lyle repeated names and badge numbers to himself.

"So, Lyle Edison, is it?" Sergeant Roesner spoke, the others awaited his cue. "You keeping your nose clean these days, Mr Edison?"

"Nadine here keeps me in line, twenty-four seven."

"Bet she does. Don't have any problem here, of course. But I suppose you know your record came up."

"I know."

The rookie cut in. "Might want to drop the attitude, Mr Edison."

"Officer Prehn, I answered the question. I'm being fully cooperative."

"That your pickup parked there? Maybe we should search it, give your probation officer a call. Think we should do that, Mr Edison?"

"I've got my three-month old infant girl here, Officer Prehn. She's got a bad case of the runs which may mean something serious. You don't need cause or permission to search my vehicle, Officer Prehn, I'm sure they taught you that. But you've kept me standing here with my sick infant daughter since 7:07 and it's now 7:21. And you're threatening to delay me further, jeopardizing my daughter's health, Officer Prehn."

"Nobody's threatened you, Mr Edison. You don't need to use that tone."

"Something gets serious with my three-month old baby, who do you suppose is going to investigate your conduct and your decisions during this call, Officer Prehn?"

Lyle knew from brutal firsthand experience the dead-ends that came from displays of righteous anger, challenges to authority, demands for justification and declaimers of civil rights. Threats and formal complaints were brick walls papered with triplicate forms. He asked his last rhetorical question so as to conjure the darkest possible unknowns from the young rookie's mind: the exhaustive report, drafted and redrafted throughout the night. The oral account to his shift supervisor, repeated for his watch commander and division chief. The

informal IAD interview and the formal Q&A with a nameless, faceless review board. The one-way mirror. The massive, pill-shaped microphone jacked into an antiquated audio deck, tape reels spooling in slow circles beside the ME's report. A pacifier with an evidence tag. Twenty-four months fielding citizens' complaints by phone on the four-to-midnight shift.

"Let's check with your PO then," said Prehn.

"Asshole."

"You care to repeat that, Mr Edison?"

"I said my PO's an asshole."

Roesner stepped in. "What's your PO's name?"

The rookie squinted at his notepad.

"Reid," Lyle said. "Nestor Reid."

"Shit." The sergeant checked his watch. "I know Reid. Man hasn't had a blowjob since he was an altar boy. Give Mr Edison his license back. We're finished here."

~

Sera sat on the couch, Nadine clamped to her breast. "She's hungry. You feed her today?"

"Bottle of milk spilled," Lyle said, then he told her about the emergency stop at the gas station restroom. "Everything's in the wash. Lost one of the blankets, though. Just wanted to get her home."

"All that matters," said Sera.

"Place was filthy. I dropped her blanket, but the water was inch deep in some places. Wasn't going to pick it up and wring it out, then wash my hands while holding her–"

"Lyle, I know. Wasn't blaming you."

"Yeah. Sorry."

"What's wrong, hon?"

"Gas station attendant, somebody, saw me take Nadine into the restroom. Thought I'd abducted her, like I was going to dye her hair or something."

"For real? Like he called the cops?"

"I took care of it. Straightened everything out. But one of them, this rookie, he got off his leash."

"What'd he do?"

"Threatened to search the truck, call Reid, like that. Just thumping his chest."

"But they didn't."

"No. I got in his face. He backed off."

"You *got in his face?* Jesus, Lyle."

"Sera, come on. I didn't even raise my voice."

"You *got in his face* but *didn't raise your voice*. Lyle–"

"He'd need a reason for detaining me, was all I said, Sera. And it was on him if Nadine got worse."

"You brought our *daughter* into this?"

"She wasn't a goddamned human shield."

"Did you honestly think this guy would flex his muscles at the expense of an infant?"

"Of *course* not."

"Then tell me why–"

"Because just this once, I knew he couldn't back it up."

"You made it a pissing match."

"You're making more of it–"

"Lyle. We have a three-month old daughter. You're on probation. Child Services could show up at any time. You want to step up to one of them and see what happens? Did that cop say or do anything you haven't shrugged off since all of this started?"

"Did *you* back down with Reid when it was *my* ass on the block? No. No, you did not."

"Reid couldn't throw me in jail–"

"Come on, you can't–"

"And didn't have a daughter to think about, Lyle. We didn't. Wasn't even the first trimester, and neither one of us–"

"So it's cool if you play momma lion, long as you're safe."

"This is about our daughter. If you pull this kind of shit with

somebody else, get yourself arrested, you think Child Services will just hand her back to me if I say *please*? This sentence of yours, Lyle, all these hoops you're jumping through? Imagine my version of that, trying to get our daughter back if you're locked up."

Both Lyle and Sera had kept their voices down, almost hissing their words as their frustrations with each other mounted. Still, Nadine had fallen asleep in Sera's arms. Wherever she ended up if they took her, nobody would hold her the way Sera did, the way either of them did.

"Just a few more months, Lyle. Then you're done with Reid, with all of it. Can you please keep it together a little longer?"

"Yes." And like that, Lyle was exhausted. "Okay, yes."

~

He passed one of their neighbors on the stairs to the laundry room. Lyle's age but with baby fat, khaki shorts and flipflops. The man and his wife had a four-year old daughter and were expecting again. Lyle didn't know their names. Sera had spoken to the woman a few times, said her husband had made an offer on a house. Lyle had a checking account, a savings account and three credit cards, all of which he mismanaged almost beyond repair. Whatever scrutiny he endured spurred him to invite more. He'd told Sera about the police that evening, but never told her about talking back to the cops at a sobriety checkpoint or honking at a squad car lingering at a green light. It started small, putting his new name on dental forms, and now he had all but shouted during a police stop.

A car alarm, drunken shouts from the street. The clock read 2:19. Nadine awoke and Lyle brought her to their bed. Sera fed her and then went back to sleep. Lyle returned his daughter to her crib, then stared blankly through the kitchen windows for several minutes without moving. He laced up his boots, put on his coat and closed the door quietly behind him.

A BAD PART OF TOWN

Someone called out to him but not by name. Two men in oversized football jackets locked palms and bumped shoulders. Prostitutes called him *Jody* and offered things that sounded vaguely acrobatic and hazardous. He was walking alone after dark in a part of town where people like Lyle were either customers or targets. Being in the wrong neighborhood meant cops could stop him on a whim, could check his ID and ask their questions. He was clean, so they'd have to cut him loose but still, word would get back to Reid.

Icarus had to be near the courthouse, among the alleys, soup kitchens, dive bars and storefront missions where he had crossed Lyle's path twice after their first meeting and would do so again unless Lyle found him first. It couldn't be hard. People remembered a man that size.

Except maybe Lyle.

If Icarus was a stranger to Lyle but knew his birth name, then he was lost to the blanks in Lyle's memory following his father's arrest. And a stranger who knew not just Lyle's name but his face after so many years, then that stranger had lost a loved one to the monster that was Lyle Sr.

"All by yourself, honey?"

She was short with tight curves, her hair slicked into a glossy black knot with two stray curls lacquered against her cheeks like brushstrokes. Her glasses were an odd contrast with the

157

rest of her attire, the cocktail dress that barely stretched to the tops of her thighs and the white stilettos that had her walking on her toes.

"I'm looking for someone," Lyle said.

"I think you're looking for me."

"Thanks, not tonight. Something else. Maybe you can help me."

"Maybe," she said. She kissed her fingertips and brushed them against his cheek, then smiled and walked away.

Lyle's adolescence had crash coursed his instincts for physical threat, and he'd spent his first years away from home living on what he and the other hotel residents believed were society's fringes. The recovery program taught him how much the bohemians of his youth had aspired to the street-scarred credibility of life on the margins but without its risk or toll. Ask him the going rate for anything the street had to offer and Lyle would shrug. He didn't know a hit from a gram or an eightball, or why the streetwalkers all called him *Jody* and what they meant by *around-the-world*. But he knew twenty bucks would get him the answers to a simple question or two as long as the wrong person didn't catch him handing money to the wrong person. He had a pair of twenties in his wallet, one flat and one folded into quarters, another in each of his front pockets, the last in the breast pocket of his jacket along with a book of matches.

He circled the block again, walked two or three blocks in every direction, zig-zagged through the grid of bad neighborhood he'd staked out. Women stood on corners and at bus stops, sauntered down sidewalks alone or in pairs. At the extremes they were petite and gregarious or tall and broad-shouldered with voices like sportscasters. They stood straight-legged and bent at the waist, negotiating curbside through cracked passenger windows. Lyle recognized cars he'd seen earlier, on other blocks, stopping to invite women in or let them out. Those who did neither cornered harder than the rest. They

chased better possibilities down blind alleys and empty bus stops for blown chances and their tires squealed louder the longer they drove with their passenger seats empty.

He'd last seen Icarus in this neighborhood when the strange giant had shouted at his truck window, and after midnight this section of town was the surest possible view of the end of the world. Rescue missions were dark and those needing rescue claimed their place in the queue overnight. Seven hours huddled on the sidewalk for an early shot at the coffee urn and a hot scoop of grits, maybe have a wound re-dressed or score a voucher for the showers. They camped in dense rows the length of whole blocks, drank from brown bags twisted around bottles, swapped stories and arguments and lived out the rest of their lives under the averted eyes of the rest of the city. A man in a wheelchair panhandled for change by dangling a can strung from the end of a mop handle. Someone else had spread out a blanket and anchored the corners with chunks of concrete parking bumpers and there he offered for sale a toaster, a stack of romance novels, an unlabeled VHS tape, an egg beater, a child's stuffed elephant, a pair of cutoff jeans, a pair of candlesticks, a laserdisc copy of *Casablanca* and a single wingtip shoe.

A spotlight hit him from the street. Lyle shielded his eyes with his palm and squinted through the glare. A young patrolman in the squad car regarded him with an untempered scowl that conveyed neither the authority nor seasoned scrutiny intended. Lyle dropped his hand and walked on. He knew better than to feign obliviousness. The determined pantomime of innocently minding one's own business was cause enough to be stopped and questioned. The light shut off, the patrolman drove to the end of the block, then flashed its roof lights and sped through the intersection. The taillights shrank to a pair of red pinpoints and then were gone. He took the close call as a signal to go home. His daughter was waiting. Time to stop chasing ghosts.

"Find what you're looking for, baby?"

She held an unlit cigarette and stood hip-cocked in a brick storefront archway. The overhead bulb broken or burned out, the recess of shadow like the mouth of a tunnel. Her glasses caught the streetlight when she sashayed out of the dark.

"This time, I *am* looking for you," he said.

"Shopped around and figured on crawling back?"

"Something like that," Lyle said. He liked her sass.

"What's your name, sweetie?"

"Folks around here call me Jody."

"Okay, Jody, I'll play that. What you looking for?"

"A bald guy, about seven feet tall." He was about to say, *Goes by Icarus*, but the girl's smile shut off.

"Goddamned five-oh," she said.

"I'm not a cop." Lyle took the matches from his pocket and palmed the folded bill. "Twenty bucks just for talking," he said, and struck a match. The girl cupped her hands around his to steady the flame, lit her cigarette and slipped the money from his fingers.

"Talk fast, Jody." She blew smoke to the streetlight. "I'm waiting for a ride."

"Like I said, big guy. Really tall, shaved head. Barefoot but wears a suit."

"Not around here."

"You sure?"

"The hell you mean, am I sure? Don't think I'd notice a man like you say? Take a look around. Your boy's probably gacked-out in one of them cardboard tents."

"I don't picture him lying down," Lyle said.

"Then looks like you're shit out of luck, Mr Profiler."

She walked away, blew a cloud of smoke and tucked the bill into her purse, a pouch no bigger than a belt buckle and slung by a shoelace strap over her shoulder, then shot him her middle finger without a backward glance.

Not yet midnight but he'd been on foot for almost two hours. He'd conned himself into thinking he had the underworld

savvy to grease a few palms to find out what he wanted but his first attempt got him played with a bonus verbal backhand by a streetwalker ten years his junior but fifty years more streetwise.

He walked another block. More women with tiny purses and unlit cigarettes loitered on the corners. He stepped over broken glass and suspect puddles and crossed the street where the sidewalk was too dark for common sense. Trash scattered curb to curb, ruptured garbage bags and pigeon feathers and spent condoms. A girl at the bus stop wore a bikini top and a skirt of shimmering silver scales. She smiled and Lyle smiled back, then looked away. A sudden and nameless urgency tugged at him and he stopped. He checked his pockets. Wallet, keys, and the remaining four twenties. The flash of recognition loud and bright but lagging on the specifics. Lyle backtracked with his eyes to the ground. Shattered flasks, flattened beer cans, a gutted purse and a lone red stiletto pump. Two pigeon feathers but no evidence of road kill. He held one to the light. The color of flint tipped with a swatch of red as if brushed through a blood puddle. Pigeons didn't have red markings. Maybe some did. He wasn't certain. He pictured a pigeon and saw blood bands across its wingtips and tailfeathers but he knew his memory's mischief well enough to disregard the image. He also knew the vicious flux of luck that turned for the better just before its mark gave up and walked away.

The glimmering silver girl was already gone, working. The corners and bus stops were all empty as well. Last call loomed and soon the bars would set loose their drunk and luckless among the already prowling and desperate, their angry unspent urges pulsing from subwoofers and rattling windows as they passed. Bottles bursting on the pavement, engines revving at red lights and throngs of foiled Lotharios, slurring and half-blind, staggering up the streets and primed for the slightest cross look or shoulder bump. The few memories that didn't play tricks on Lyle were those of similar sounds when he was

seventeen and alone at night. Sometimes he outran them and sometimes he didn't. Time to go home.

The figure had taken shelter in the entryway of an abandoned building. Plywood sheets covered the first-floor windows while those on the higher floors were broken or bore the grainy pocks of small caliber rounds. Accordion gates secured with a length of chain and a rusted padlock, a ridge of trash gathered along the base like seaweed beached at low tide. The figure crouched on the concrete steps, his blanket the color of cigarette ash and spotted with burrs from urban weeds. His bare toes peeked from beneath and his upturned palm extended from a center opening where the edges were twisted together in the fist clenched behind them. His face rested against his knees as though he were begging in his sleep. Lyle removed the coins from his pocket and placed them in the homeless man's palm. Sixty-five cents. The man curled his fingers around the money and looked up. He'd covered his mouth with a strip of silver tape like a kidnap victim. With the coins still curled in his fist the man peeled away the tape with his thumb and forefinger enough to say, "Thank you." Lyle nodded and turned away.

"You looking for Icarus?"

Lyle turned back. The homeless man sat watching him, the tape hanging off one cheek.

"How'd you know?"

"Told me you might be coming around."

"He tell you my name, too?"

"Nope."

"How you know it's me, then?"

"Feather sticking out of your pocket and the look on your face when I said his name."

"Right, then. Where to?"

"Sixty-five cents won't get a man far, nowadays."

Lyle pulled a twenty from his front pocket and handed it over. The man ran his thumbs across the surface, held it to the light and squinted at it, then tucked it away. "You got a light?"

Lyle offered his matches but the man shook his head.

"No, man, like a flashlight. I think maybe, the Beatles, where they're from, they call it a torch or something."

"Sorry, no."

"No need to be sorry."

The man stood and shifted his shoulders beneath the blanket. "Just walk in the dark like everyone else," he said. "Folks should be used to it by now." He swiped his hand across his mouth, fixed the swath of silver tape back over his lips, then hooked a finger at Lyle to follow.

He stopped at a stretch of blank brick beneath a dead streetlamp. From the folds of his blanket he produced a crude gaff, an old gardener's hoe broken at the neck so all that remained were the sawed-off wood handle and a crook of empty metal that he hooked into the sidewalk, lifted open a plate door set flush with the ground and dropped into the opening without a word. Lyle looked after him but the man was gone down the steep steps barely visible in the dark. He imagined stair treads as thin as roof shingles and split down the center, wood rot and nails rusted to red grit.

Lyle followed. He held onto the lip of sidewalk until it was out of reach and then continued his slow descent. He tested each step with partial weight before committing to the next. When he grew tired of counting, there was nothing but darkness but still no floor.

"Hello?" No response so he said it again louder. Still nothing. Then two loud hand claps from below and he resumed his descent until at last his boots hit packed earth.

"Hello?" he said again. "You there?"

The rough blanket brushed him in the dark and then Lyle heard the dull pounding of the man's bare feet as he climbed back up the steps. The opening looked almost three floors above, a square of yellow light framing the silent man's rapid ascent and the blanket flapping about him. Groaning hinges, the clang of the metal plate set into the sidewalk. Blackness utter and complete.

Footsteps. The silent man descending again, now in total darkness. Lyle crouched and fanned his arms, waiting. His knuckles brushed the railing and he oriented himself according to the stairs, then backed from them slowly.

"Hey," Lyle said. "Tell me what's happening. Where are you?"

The man once again clapped twice. There was no echo. Lyle took the matches from his pocket. He heard switches being flipped, the distinct crack of hard plastic toggles inside a breaker box, then a deadbolt scraping across metal and brick. A needle of light shot up from the floor and fanned wide. Lyle turned away and shut his eyes until the flashbulb trails simmered down. When he opened them again he saw the wooden staircase he'd come down with its warped planks and nailheads of rust but nothing else. His shadow lay stretched in front of him but the bright light diffused before it met any sort of wall or column. He turned around. The silent man stood beside an open slab of a door, his blanket and grizzled hair the shape of something from Lyle's imagination, something he had hidden from as a boy. The door opened to a tunnel but from where Lyle stood he could not see the far end. A shop light hung from where the passage curved ahead and odd bricks on the ground here and there matched cavities in the ceiling.

"How far we going?"

The man peeled the tape from his mouth. "I'm going up top," he said. "You just follow the tunnel and don't panic. No way through but one."

"How do I get out?"

"Icarus will show you. Now be on your way so I can seal this up."

Lyle knew bad luck like no one he'd ever met until he met people in jail and at meetings. Each new misfortune compelled him to review the running list in his head until the cloud of despair became so thick he saw nothing else and his resolve drained away. He'd broken through his inertia time and again,

though more to Sera's credit than his own since they'd been living together.

Someone knew his birth name. He called himself Icarus and was most certainly insane. Crossing paths with Icarus was bad luck and nothing else. And there would be more luck to come, both good and bad, Icarus or not. But he'd dressed in the middle of the night, kissed his wife and told her he couldn't sleep and was taking a walk. Then he'd wandered alone for hours through one of the worst neighborhoods in the city and now he was three stories underground standing at the doorway to a tunnel that went God knows where. Bad luck had not laced up his boots or concealed the true reason for his walk.

"You going to make up your mind?"

Lyle stepped through the door. A wire of spider silk cut slantwise across his face and felt for a moment like taut fishing line before it snapped and settled onto his chin and chest. He brushed it from his face, then raked his fingers through his hair and wiped his glasses on his shirt tail. The vault-like door closed behind him and the deadbolt scraped back into place but he stayed facing forward. A distant roar like a crashing wave, then stillness. Another breaking wave farther off. The trains were above him. Lyle stood in a passage not built for subways or sewage, with the rumbling trains chipping at the masonry overhead. Damp earth and broad puddles. Most were shallow, some reached his ankles. The walls were wet to the touch. These clandestine engineers had burrowed dangerously close to the water table.

A shovel handle leaned against the wall at the bright curve of the tunnel, the blade rusted to dust decades ago. Lyle rapped it once to startle away anything small and venomous, then tore it from its veil of webs. The brickwork ended at the curve and beyond it the tunnel was bare rock that ran more or less straight and exceeded the reach of the light. He reckoned a good hundred yards of darkness between the fixture above

him and the distant star point of the next. The shovel handle could probe the puddles and pitfalls, knock the webs from his path and thump the dirt to send scurrying anything unclean or rabid in the dark.

He was as wrong about the distance as he had been with the stairs. The light behind him grew weaker and the darkness stretched on and the light in the distance was no closer. He probed for walls or a ceiling but the shovel handle swung through air. Somewhere high above, the short curvy girl with the thick glasses and the glimmering silver girl were still working. Sera was fast asleep on her side of the bed and Nadine was curled in her crib. Lyle kept his eyes on the light, testing the ground ahead of him with the shovel as he walked.

The grotto had never been completed or had fallen into ruin or both. Unfinished wood beams and mounds of broken rock. A trowel stabbed into the dirt, a pick laying in a puddle of brown water. The tunnel split, one direction completely dark and the other collapsed at the entry. A flight of steps cut into the opposite wall stopped at a door so ordinary it came as a great relief to Lyle.

Icarus crouched atop an outcropping of rock, his toes curled over the edge level with Lyle's forehead. Knees to his shoulders, hands draped between his ankles. Perched.

"Mr–"

Lyle cut him short and said, "Edison, please. Or just Lyle."

"Very well, Mr Edison. You know who you are."

Icarus appeared even larger in the flesh than in Lyle's recollection. He had first impressed Lyle as physically imposing but humbled by circumstances. Twice thereafter he'd seen him dressed as he was in the grey suit, shirtless and barefoot. Instead of the sagely, docile custodian he'd been homeless, and ignorant of the rain and cold, and wholly insane but for the damning name he hurled at Lyle. Prolonged street living had visibly tested the fine suit but it remained largely intact. Dirt caked his feet. The overgrown toenails thick and deep yellow,

a chip of brown glass set into the calloused ball of one foot and worn flush with the skin. Icarus otherwise bore no signs of exposure, fatigue, disease or malnutrition. His head and face were clean and freshly shaven if they had ever needed shaving at all. His eyes were too deeply set to gauge their color and whether he was a hard thirty-five or a robust fifty-five, Lyle saw nothing to determine his age.

"Who, I mean, how, how do you know my name?"

"You told it to me," said Icarus. "Just now. We both heard it."

"Mr Icarus–"

"Icarus. Just."

"Icarus, please. I've had a long – I came a very long way to get here."

"You have no idea, Mr Lyle Edison."

"And I really do not like it down here."

"Like I just said."

"My name, Icarus. Sir. The one you've been shouting at me on the street. How do you, who told you my–" Lyle had never been given cause to decide on a phrase neutral enough for his comfort. *My real name. Other name. Old name. My birth name, family name, given name.* The stalemate of choices left him nearly dumbstricken. He at last said, "Who told you the name I was born with?"

"Mr Fade told me."

"I have no clue who you mean."

"He's your granddaddy. And your granddaddy was the Tin Man's boy, your great-granddaddy. Means you got metal in your blood, son. You hear thunder, you best stay indoors. I reckon you must have drawn your new name from one hellish deep and very dark hat, Mr Edison. Your monikersake once took to dishing Ben Franklin's thunderkite treatment to some ignorant pachyderm guilty of nothing but being big and ugly. All on account of a business feud, seeing who could faster cook the incarcerated. Be a damn waste to see you on the smoking end of that legacy."

"You've lost me. Again, Icarus, like I said, I came a very long way."

"And I said it once earlier, Mr Edison, you don't know the meaning."

Lyle brushed the dirt and cement dust from his jacket, scraped his boot soles on a stray brick. He picked at the pale crust on his sleeve where Nadine had spat up that day. There was a shade of Ray in Icarus, a daunting presence but ultimately non-threatening. But Lyle knew Ray and while he sensed no physical danger from Icarus, Icarus was cryptic and frustrating, crazy enough to name himself after a Greek myth but sane enough to know who Lyle really was.

"What do you want, Icarus? You want money?"

"Wouldn't be down here if I did."

"You've shown up twice since the clinic. On my wedding day and the day my girl was born. That's some shitty timing, not to mention you blowing open the thing I've spent my life keeping buried. You wanted something on those two days, but now I have to go spelunking for you in, what, I don't know, wherever this is we are."

"Smugglers' tunnels," said Icarus. "Dug to run bootleg whiskey back in the day. Sewers would have been sanctuary, all the same. Blue Men up top got too many eyes on the payroll for me to be hollering after you during civilian hours. As for cutting your wedding cake with a wrecking ball and giving Mrs Edison a heart attack for her baby shower, please extend my apologies to your wife and child. But my faith in the Mother Howl started drying up the second I got myself shrink-wrapped in this here monkey leather for the sake of hunting your ass down. A loss of faith makes cruel demands on a man's temper, I reckon, and faith ain't never been part of my equation. But I cashed in the last of mine, on the hope that whatever rank juju you got staining your birth name would bring you knocking. Don't know if you reckon just how happy I am to see you, Mr Edison."

"I appreciate that."

"Not sure you do, son. I don't go throwing confetti at the sight of most folks. Not that I'd take a shine to you elsewise, I didn't know better."

"I'm flattered."

"Mr Edison, I wouldn't be here if you weren't on the ass-end of a bum deal. You got yourself one glow-in-the-dark heart, damned straight, and clearly of your own making. My people take an interest in one of you monkeys, it's for a good reason. Believe."

Icarus stood up and at his full height atop the rock ledge he looked like a monument, then he dropped to the ground with fluid and nearly silent ease. They stood before each other, face to chest, and Icarus looked larger than ever. There had been nothing in his hands while they spoke and Lyle hadn't seen him reach for his pockets, but now Icarus held out a small package wrapped in newsprint and bound with twine.

"It don't bite," he said.

It felt like a slim stack of paper to Lyle. "What is it?"

"My ticket home," said Icarus.

"So why give it to me?"

"The giving is my ticket, not what's inside. I want out of here more than you, hard as that may be for you to apprehend."

"What is it?"

"Since the package ain't for me, it ain't for me to know what's inside. Seems we went to a goodly amount of trouble, Mr Edison, saw to it you got tricked out with a pair of working eyeballs and two perfectly good thumbs. Reckon you might ought to get some mileage out of them while you're still young and breathing."

Lyle flexed the bundle in his hands, just enough to know that it was indeed a stack of papers. He tucked the bundle into his inside coat pocket and then suddenly more than anything on earth wanted to be back in his own bed, asleep beside his wife.

"Are we finished, you and I? We're done for good?"

"Consider this relationship flatlined, Mr Edison."

"I don't have to worry about you shouting my birth name on the streets? And you haven't told anyone else? And I don't have to wonder if I'll see you again?"

"You do not. I have not. And you will not."

"And you don't want money? It's the last time I'll ask."

"Mr Edison, you needn't concern yourself with my welfare. But I'd be remiss in my messenger detail if I didn't forespeculate on your future state of affairs. The name your momma and daddy gave you, just the sound of it, makes the hair on the back of your soul stand on end." Icarus punched the word *sound* like a tent preacher shouting *Jesus*. "None of my business," he continued. "But whatever name you been giving that face looking back at you when you floss and preen all these years means you owe that poor mismonikered soul a visit through the perplexiglass. Give yourselves a chance to settle things, man to mirror."

"Without a doubt the most colorfully useless advice I've ever heard. I'll keep it in mind."

"Wise if you do. I wouldn't be here, you didn't have one last uphill run with that rock of yours, Sisyphus. Now, let me show you out of here."

"Thanks, but I can backtrack."

"The Mother Howl's machine favors forward, son."

"Okay, then I'm guessing it's that door right there, at the top of those steps."

"Seems you got grey matter to burn, son. Through that door, indeed. Those ain't the last of your steps, so take them one at a time."

"What am I looking for?"

"Up, Mr Edison."

"You're very profound, sir."

"Ain't nothing profound about up, son. Just want to see you on your way so I can be on mine. Wherever you find yourself,

won't be but one way up. That way will be tougher in some places than others. And some final advice you'd best regard as gospel."

"My ears are wide open."

"Last thing before you hit the street, you'll be in the one place where your next move won't be so loud and clear. You'll see a red door."

"A fire exit."

"No, a door. It will be red. I figured I was clear when I said it the first time but I guess not. It'll look like that one there behind you, top of the stairs."

"I get it."

"Not taking my chances with you, son. This door, it'll be like a square but oblong. More like a rectangle."

"Like a door."

"Not exactly, but near enough for the likes of you to walk through it, less I school you proper. So you'll see this rectangle, it will be red. Think of something red. You thinking? That's what color this door will be."

"And that's where I want to go."

"That is exactly where you do not want to go. Walk the opposite direction, as far from that red door as you can get. You'll find yourself on familiar turf in due course. You copy that?"

"Roger."

"Thought it was Lyle."

"Pardon?"

"A joke. Never you mind."

"If it's all the same, what's with your red door? Where's it go?"

"Nowhere. The very last place you want to go. Believe. Now home with you, Mr Edison."

Lyle went home. Up the stairs and out the grotto door to a sub-basement more thoroughly constructed but with no less ruin and debris. Stairwells upon stairwells to more chambers

and sub-basements. The construction more complete the higher he climbed, the shortest way up always apparent but not always accessible.

A long tunnel, straight and fully finished like a pedestrian walkway, came to a dead-end chamber with a break in the ceiling as though something had crashed through the rock but left no trace of itself below. From a running start he leapt for the opening and after his third attempt he caught a length of exposed rebar, chinned himself up and climbed through.

At last he arrived at a subway tunnel catwalk and felt the warm wind of an approaching train. First came the growing light, then a deafening horn as it roared past him less than a foot from the walkway, then snaked upward in the distance and curved out of sight. At the far end of the catwalk was the door adorned with nothing but a brass knob and a coat of molten fire engine red as though the paint were still wet. He was too tired to be curious so he walked the opposite way and found a maintenance entrance that opened onto an empty train platform.

When Lyle reached the surface he was covered in a layer of white dust and his clothes sweated completely through. He was far from the bad part of town where he'd begun and the sky was still dark but with the first light on the horizon.

RADIO SILENCE

Lyle unlaced his boots in the courtyard, then climbed the stairs barefoot to their apartment, entering his home like a thief with a stolen key. Except for the door, still misaligned from the quake, which seemed to take his full weight to open. He slipped the bundle of papers into a Skip James record sleeve, the record shelves cobbled from wooden citrus crates and scrap. The couch had been left behind by the previous tenant and he'd salvaged the kitchen table after someone had taped a handwritten note that said FREE onto one of the chairs and then left them on the street. The bed, coffee table and most of the dishes and cookware were Sera's. He was well past thirty with a wife and a child but without a stick of real furniture.

He stuffed his clothes deep into the hamper, then showered and climbed into bed. Sera lay curled at the edge with her back to him. He scooted closer to her and rested his hand on her hip. She felt too rigid to be fully asleep but she didn't respond to his touch. Her husband had been out all night, had returned just before sunrise with as little noise as possible and had showered immediately. His habit of assuming her suspicions, her condemnation of him, had a will of its own.

Nadine stirred. Lyle checked the clock. Right on schedule. Sera tossed the covers away and stood without stretching and took Nadine to the living room. Lyle remained in bed for another half hour before he dressed for work and drove to the job site.

He brought dinner home after his meeting and they ate without speaking. Lyle held Nadine for a while, her ear warm against his cheek, her nose pressed into his shoulder. When Sera took her she brushed hands with Lyle but she didn't look at him.

Lyle sifted through the mail. A mound of catalogues and junk solicitations addressed to two previous tenants. Lyle's monthly bill from the Probation Department had arrived. He'd groused once about having to shoulder part of the county's expense for his sentence but Sera shut him down. He knew she was right and he never brought it up again. A second notice for their phone, a final notice on their electric bill, a credit card invoice, hospital statements for both Lyle and Sera with tests and procedures listed in cryptic abbreviations and corresponding numeric codes, amenities tagged with extortionate dollar amounts. A box of tissues for nine dollars. A six-dollar cup of apple juice. Letters from their insurance carriers with small reimbursements and large denials along with instructions to resubmit claims with additional documentation.

A large envelope from the hospital. Lyle read the postmark date and ran the numbers as he opened it. Ninety days, almost exactly. Certification of Live Birth. Nadine Sera Edison. Lyle whispered the string of names, his daughter's, his wife's and his own linked together. He ran his fingers over the scalloped edges and the embossed seal of the County Registrar, held it to the light and saw the faint watermark that dimmed again when he lowered it to eye level.

Sera sat with Nadine in the bedroom, the television turned down low. Lyle sat beside them and showed Nadine's birth certificate to Sera. She smiled and said something about getting it framed. Lyle set it aside.

"I'm sorry," he said.

The television cut from a slow shot of a lone boxer in the ring to that same boxer years later, homeless and shuffling through the desert. He was muttering something in the voiceover but the sound was too low for Lyle to hear.

Lyle added, "I wasn't with anyone."

"Didn't say you were."

"You didn't have to. I know how it looked."

"So where were you from 11:30 until sunrise?"

The boxer had wandered into a bar and ordered a beer. He was babbling on, making the barkeep and the lone female customer uneasy.

"I went looking for that homeless guy. One that scared the crap out of us on the way to the hospital. Same guy who was screaming in the rain outside the courthouse the day of our wedding."

"I remember. But why?"

"He was shouting my name, Sera."

Sera remained quiet. Lyle wouldn't force her to drag it out of him.

"We met once. At the clinic, we were both getting screened. He's on some kind of assistance, I guess, requires him to get checked. Must have fallen off his meds since then, or been booted from whatever program he was in. But anyway, that's not it." Lyle stopped, then he said, "He was shouting my birth name."

"Are you sure?"

"Without a doubt. And before you ask, no, I don't know how he knows it."

"I hope it was worth it, Lyle."

"Yes. Listen, Sera, I don't know any more now than I did before. I found him, but still I have no idea who he is or how he knows who I am. But I think, I'm sure, he won't be a problem anymore."

"You think? Or are you sure?"

"Can I tell you the whole story another time? Right now, I just wanted you to understand that I wasn't seeing someone else."

"Yeah, another time. Just don't go doing that again."

"I won't," he said. "I love you."

"I love you, too."

When Nadine fell asleep Lyle put her into her crib and then sat with Sera until she nodded off. Lyle turned off the television and the light, closed the door quietly behind him and went to the kitchen. He washed the mound of accumulated dishes without his customary background music, handling three days' worth of silverware, cups, glasses, plates and bowls as though they might detonate. A spoon slipped from his soapy hands and clamored against a saucepan. He shut the tap and held still, listened for Nadine, then resumed work. Dishes used to be nightly for him, almost meditative. He'd never felt the need for a dishwasher until recently, which he couldn't think about without weighing the need for a washer-dryer and ultimately a bigger apartment.

Small differences in rates had seemed trivial compared to a given crisis he could solve with plastic. And years of checking his back had a way of inviting emergencies, and all that mattered in the moment was whether he could shoulder his monthly payments. So he made more money than Sera but carried more debt. He'd missed the window to file Chapter 11 before they'd merged finances. Which would Sera prefer for a husband? Just a convicted felon, or a deadbeat bankrupt convicted felon?

A stuffed plastic bag sat cinched and knotted beside the freshly lined kitchen garbage. Taking it downstairs meant putting on shoes and he didn't want to go outside again, not tonight. Piles of dishes, trash and laundry, the disarray of everything shifting from the force of the new child in their home.

He lit the stove beneath the kettle, then sat at the kitchen table and took in the quiet. He retrieved the papers from the record shelf and brought them back to his chair. The bundle smelled of dust and mildewed paper but not the reek Lyle expected from something stashed in a vagrant's waistband. He cut the twine and peeled apart the newsprint wrapping and

imagined briefly a cocoon of spiders or a whiff of toxic dust but there were only unbound papers folded into thirds that fell loose across the table. Pages from a letter. The pages were dark at the edges, broken through at some of the creases and filled with exquisite handwriting.

Lyle shut off the gas below the kettle, then brewed himself a cup of black tea, strong and sweet. He sat alone at the kitchen table, the one he'd found in the street, and read the letter Icarus had given him.

A MURDER OF MEMORIES

Dear Lyle,

This is both my confession to you and my last urgent effort to gather my fading recollections that scatter like scores of frightened crows for each one I seize.

Mom told me it was spring when Dad proposed beneath the shade of Grandpa's almond trees, the groves were bursting with white blossoms. I imagined the view from the topmost gable of Grandpa's house was like looking down onto the clouds, but I never saw the orchards until after the trees were gone. Dad said he'd never known anyone to work harder than Grandpa. He was up before sunrise every day, whereupon he took a long leisurely stretch first thing out of bed and then he would stand at the window and contemplate the morning for two minutes. Grandma said he was always to the second. Grandpa never touched a drop of liquor in his life, and Grandma said he would sooner cut his tongue out than speak ill of another soul. Dad said Grandpa never once raised his hand to him, and to hear Grandma tell it, Dad was the very sort of reckless and scheming whelp for whom accounts of Hell were written.

Most of these things are scraps from a patchwork of stories I heard when I was a boy. My first real memory is the clamor at our front door in the middle of the night. Mom told me to stay in my room so I never knew who it was, but I found out

later they had brought word the almond groves were on fire. Grandpa was burning down the trees, every last one. Dad left for a while to attend to things. The doctor said there was nothing wrong with Grandpa that he could see, but Grandpa just sat on the porch without speaking a word to anyone, watching Dad and the hired crew fell the blackened trees. He rarely spoke at all after that day. He still woke before dawn but he didn't do his morning stretch or take his two minutes of silent reflection. Grandma said he was like a machine going through the motions of being a man. While he continued to work very hard, the new nature of his work distressed Grandma more than the fires had. One afternoon as she was stepping out, she spied him carrying his tools to the upstairs. She thought nothing of it, given the steady call for small repairs throughout the house. But she returned to discover he'd hammered through a wall on the top floor. When Grandma protested, he built a door through which anyone walking would drop twelve feet to the ground below. Grandma protested again but instead of locking it Grandpa built a staircase that descended from the second floor to the packed dirt behind the house. It seemed to Grandma that voicing her objections only made things worse so she stopped, but Grandpa kept building. At the foot of the staircase outside, he framed another door to another room, and then another, with no forethought or plan. Every nail he hammered into that growing tangle of hallways was just as well a nail in the coffin wherein he buried his sense of truth and reason, and Grandma felt each one as though he'd driven it through her heart. As the house grew, there was no other choice for Dad but constant vigil, so a year after the fire we moved in with them.

My earliest memory of Grandma is of her eyes, the frantic eyes of a snared animal, and the knots of wrinkled cloth where she crumpled her apron in her fists. That same time is also my earliest memory of the house they lived in, where Dad was born. Two stories, gabled windows and a massive stone fireplace.

Finely carved balustrades and archways, workmanship of a kind that mixed pride with patience and that I've seldom seen since. But I was just a boy, and my excitement at the house was due to nothing more than its size, as it was so much bigger than where Mom and Dad and I lived. But I soon forgot that as well, when I found the door that opened to the staircase and everything that followed. What boy can resist a maze of secret passages and hidden doors?

Grandpa was a lean stalk of a man who had to duck through most doors he hadn't built himself. I could feel the stippled ridge of his spine through his work clothes when I hugged him. He smelled like Sloan's Liniment and his breath like cloves from his chewing gum. Grandpa's eyes had weakened rapidly, his hands had grown less steady. The further I walked into the labyrinth, the more gaps there were in the wood. The walls and floors were uneven, some doors were poorly fitted and so couldn't close properly. The newer rooms and halls were unpapered and without baseboards or wainscots and had been constructed with careless and trembling haste. Except for one door at the utmost end of a long, dark and very crooked hallway. That door was the brilliant glossy red of a candied apple. There were no brush marks nor any hint of wood. It had been expertly hanged, so flush and perfectly fitted you could barely slip a playing card through the jamb. Grandpa was there. I hadn't heard him walking up behind me, but he was there. He reached past me, locked the door and warned me to stay away. His voice was gentle but he left me no doubt that he was serious.

"This is as far as you go," he said. He had the key on a chain, which he presently slipped over his neck and tucked beneath his shirt. I asked him where the door went and he said, "Nowhere."

"So why can't I open it, Grandpa, if there's nothing there?"

"Nothing is precisely why," he said. "Can't have you wandering through into nothing. That's why I built the door,

to keep everyone safe." He took my hand and walked me back to the main house. He made chocolate milk and we retired to the porch. I sat on his lap and I remember how much I loved him then.

The porch looked onto the rows of blackened stumps and the soil and ash crawling with weeds, tough as haywire. Where the trees had once stood there was now Grandpa's latest endeavor, since his labyrinth was evidently complete. Evenly spaced rows of rail ties split and nailed together into crossbeams had been sunk into the dirt. Some were empty as though they'd been harvested of the crucified dead and were awaiting the next rain, others were dressed in castoff clothing and stuffed with straw and equipped with rusted tools. I heard ticking from the pocket of Grandpa's overalls and asked if he would show me his watch.

"That's not my watch," he said. "That's my mechanical heart." He stroked my hair and looked down without a trace of a smile. "My heart kept breaking so I built a new one after I met your grandmother, because I loved her so much I wanted a heart that would never break."

I asked him if he would live forever.

"It will rust someday," he said. "The scrapyard awaits us all."

I felt safe in the comfort of his lap, so the gravity of what he'd said was lost to me. I could only pester him with more boyish questions, and so I asked him if I'd ever have a house like his.

"You'll have this one," he said. "It belongs to your daddy now, but it will be yours, someday. And when you have a child of your own, you can pass it on, and one day it will go to your grandchild."

"So great-grandpa gave it to you?"

"No, it was mine, first."

"Did you build it?"

Grandpa said, "No," and when I asked him who did, he asked me if I could keep a secret. I told him I could.

"You promise?" he said.

"Promise."

Grandpa pointed to his field of crosses. Straw men holding headless axes, rusted shovels, railroad signal lamps and rifle stocks fitted with broom handles. They wore moldy, moth-eaten clothes and sun-faded hats and their slack faces were made from burlap grain sacks. Acres of them, their coats flapping and straw fists dissolving in the wind.

"Scarecrows," Grandpa said. "The scarecrows built your daddy's house."

I went to sleep that night with the understanding of death taking shape inside of me. At first my fear was that of losing my grandfather whom I loved so much and who seemed closer to death than all of us. When a man no longer marks the passing years according to the events in his life but rather the injury and wear to himself, he knows what it is to be old. Grandpa called our bodies "soul machines." The skin, blood and bones built to house that which connects us with God. My Sunday school lessons of Jesus and life everlasting were no comfort, that night. They were stories from the Bible, the Word of God, and though I believed the stories I was still very young and so was my faith. But I had seen scrapyards with my own eyes, and I had seen tools and equipment ruined by time and neglect, lingering in the dirt fields of foreclosed farms. I didn't need faith to believe in death. It was real enough and soon it would come for me.

I dreamed about that red door. It opened to nothing but darkness so thick I could reach across the threshold and lose sight of my arm, as though buried to the elbow in a wall of black loam that would fill my lungs and eyes should I walk through it. From behind me came the dried cornhusk rustle of scarecrows limping on wicker limbs, their hobnail boots unlaced and the soles worn through to their straw feet. I was too afraid to turn around and too afraid to run and I was still afraid long after I awoke in the dark.

After that, there wasn't a preacher alive who could spin a tale of Hell hot enough to make me go near those ranks of weathered straw men hanging like faceless crucified drifters. And I never went exploring those hallways again.

Death did indeed come for Grandpa soon after. I remember Grandma holding a kerchief to her face and holding Dad's hand. They had a woodpile out back, with an old splitting maul mounted to a pair of hooks above it, and when I thought about what would happen to it now that it was rusted and useless I started crying and couldn't stop. Grandma let go of Dad and held me for what seemed like hours. Dad cut down the scarecrows after the funeral, and with a small crew of workers tore down the outside staircase from the second floor and all the hallways and rooms it led to. They amassed everything into a pile far from the house and as I watched them I looked for the red door but never saw it. Dad set a match to the pile that night and we watched it burn. I asked him about the red door but he didn't say anything.

Years later I met a woman who was nothing less than the living and breathing grace of our God. Never had someone else seen me as the Lord looks upon all of us until she and I met, this woman so blind to my failings and weaknesses. She saw God's likeness in me and therefore I was witness to God's grace through her: an unmerited gift, neither earned nor bargained for but freely and humbly accepted, and I prayed daily for the wisdom and fortitude to see all men as she did, as the breath of God preceding the flesh. I offered my humble thanks, promising before our Lord to love and honor this woman until the day of my death. God, in His infinite kindness, smiled upon me and she promised the same in return.

You were born five weeks early, Lyle. I'd found your mother deathly pale on the kitchen floor and her eyes were closed but trembling. If you've ever come across an injured bird, its chest humming with panic, you can imagine the movement of her eyes. I went to phone the doctor and when I looked back I saw

my shoe prints like dark red ink tracked across the tile from where your mother lay bleeding beneath her dress. I could have told you something about fear, that day. But your mother lived, and when I cradled you in my cupped palms (you were so very small) I was speechless with joy. To feel so much love for another human being is to be embraced by the Divine.

Dad left soon after you were born, Lyle, so you never knew your grandfather. If there was ever a warning that he might do so or a hint of a reason why, he took it with him. All Mom ever said was, "No, no. Your father is just confused." I remember the break in her words before she said *confused*. "He'll return home when it's time," she'd say. This rigid delusion served to both dull and prolong her pain in equal measure. Instead of being outright ruined by Dad's betrayal, a ruin from which she could perhaps have recovered, Mom lived with a slow leak in her heart through which her soul quietly drained away, and she spent the last years of her life as an effigy of her former self.

I was complicit in this, Lyle. You were still just a baby when we moved back in with Mom, after Dad left. The newsagent at the train station recognized me one afternoon. He inquired as to how my father was doing and without a thought I said he was quite well, thank you. 'I imagine so,' he said. He'd spoken with Dad just a few days previous, and I've never forgotten that man's words:

'Don't reckon I've ever seen a man as full of sunshine as that fella. He kept saying "swell" and "dandy" and smiled like he'd been planting daisies and struck oil.'

And Dad vanished, no doubt on one of those trains but by all rights could have been in a cloud of smoke. He was gone for no other reason than he wanted something else more than the life he had with Mom, and not even a daughter-in-law and a new grandson could change that. We were something he wanted less than something else.

I never said a word about it to Mom, and so told myself she

was better living with a false hope instead of the simple ugly truth that she wasn't wanted, that none of us were. But the justification that I knew what was right for her was just my own delusion. If I told Mom what I knew, then it would have been I who broke her heart, not Dad. So, Mom's levy of denial was as much my handiwork as hers.

It would have been better, I believed, had Dad simply turned up dead. Mom would have been scarred, of course, we all would have. Death isn't a choice, but abandoning family is. And though it might have been sudden and premature, it would have been no less inevitable. And I doubt she would have lived any longer than she did. But she would have been Mom herself, the mother I'd always known. Broken but healed after a time and certainly scarred, but Mom nonetheless. But without Dad's casket or any argument contrary to what she wanted to think, Mom was at liberty to spin her own comfortable story in which her friends and loved ones could partake under the cloak of consolation.

I brought her a cup of tea one afternoon and she whispered, "Thank you," and looked at me as though I were a porter or a nurse. Her smile was sincere and gracious but without a hint of recognition. And in truth, I stared back into her eyes for as long as I could, standing there frozen, holding a lump of sugar in a pair of tongs, but I didn't recognize her either, this dead-eyed, crippled scarecrow who soon after drew her last breath while watching a game show.

Which brings me to you, Lyle. With the birth of your child, Lyle Junior, it seemed our bloodline had at last discharged its lunatic carpenters and vanishing husbands and fathers, ending our legacy of mad men breaking the hearts of their loved ones.

As Lyle Junior grew up, you seemed to grow away from your mother and me. We gathered together for holidays, but the calls and letters in between came further apart. In time, you were like a ghost. The only proof you were alive came with your rare midnight visits to the farmhouse, from the dirt

you'd tracked inside and the kitchen towels you'd sullied. I knew you'd been coming back, Lyle, beset by some darker form of the madness I hoped had left with my father.

Your wife telephoned one evening. She called me "Dad," and in that single word I heard a pain that told me my worst fear wasn't enough, and I was right. When I told your mother the news from your wife, she said, "No, no, no." We turned on the news and saw your face and she said it again, 'No, no, no.' And when the police came to talk to us she told them "No," that our son would never do such things. Parents of the victims (I had to stop, just now – I couldn't write "your victims," though I just did) all said likewise, that the police were mistaken, that it must be someone else's child they'd found. In every story in every newspaper, every parent's first words were, "No."

But God forgive me, Lyle, I believed all of it. The papers, the television and the police, I accepted every account without question. And I felt a profound shame for having once believed my father's sudden, senseless death would have been kinder to Mom than his abandonment.

Your mother succumbed to tearful fits day after day, and with each one I held her to me while she cried and said, "No, no, no." She backed away from me one day, and with her eyes and voice both raw with sorrow demanded I say aloud they were mistaken, that you would never do such things. I pulled her close to me again but held my peace. I had not only inherited my grandfather's house but his hammer as well, the very one with which he'd driven nails through my grandmother's heart, as did my father through my mother's heart. It was now mine to do the same to the woman I loved more than my own life.

She refused to leave the house. One Sunday morning I returned to services alone and there I remained alone throughout. Everyone was watching me but no one would look at me. I'll join the ranks of heretics alongside my grandfather and tell you this, Lyle: there is no Hell. That place of fiery damnation is a fish story spun for the sake of cowing

medieval serfs and unruly schoolboys such as my father once was. There is no Lake of Eternal Torment. There is only God or the absence of God, the "darkness on the face of the deep" as written in Genesis. And that Sunday-morning service was the first time I knew the absence of God. An hour of songs, prayers and Gospel but not a single pair of eyes would meet mine. My brothers and sisters in the faith examined the ground in earnest when I looked to them, their faces hidden behind hymnals and veils and after the service I said 'God bless you' to nothing but hat brims. Having sought the comfort and strength of my church, I found myself standing once more among my grandfather's scarecrows.

The fissure between your mother and I grew to a chasm after you went to prison. As the years passed she steadily grew ill until finally I was willing to say anything at all, true or not, to close the distance between us. But our Lord saw fit to call her home.

The day of her funeral, the mirror found my Sunday best wanting, my black suit muted to a deep gray and its contours lost in the dull light of the rainy morning. The cold puddles about the cemetery reflected everything, it seemed, but my own feet. Your wife was there, and while her attendance was perfunctory, her manner cool (perhaps she blamed your mother and me for you, the man she married), I was nonetheless grateful to see her. When I asked after Lyle Junior, she informed me he had left without word or warning. The boy shared your name, your blood and perhaps with time even your likeness. I can well imagine what ignominy dogged him violently throughout his formative years. Given Lyle Junior's redoubtable will, it's unlikely he will ever be seen or heard from again.

My eyes remained at the mercy of my grief long after your mother was gone, everything in plain sight but for me. My hair appeared thinner, my fingernails became like onion skin and my shadow tentative and uncertain. I took eleven stitches

in my forehead when I struck a glass door, like a bird that doesn't see its own reflection, and on a hot cloudless afternoon following services I observed the mingling faithful. Their sharp shadows seemed cast from pitch while my own shone blood pink and blurry, the noonday light half-ignoring my very flesh and bone. Bright threads of color twisted across the ground with my movements, the sun passing through me as though I were a dislodged pane of stained glass from the church window.

My left hand felt like static, which I remember, and I fell, which I do not. At the hospital, they said my heart had failed me. I told them I already knew this, and that I was disappearing as a consequence. My assessment met with deaf ears and rolled eyes from the doctors, scarcely more than boys in their own right who patronized me with words borne on the illusory permanence of youth, words of those who believe they've seen everything though have yet to lose anything.

They discharged me but I returned soon enough after I was struck by a car on my way to visit your mother's grave. The driver knelt beside me while we waited for the ambulance and I recall how young he looked. His gold wedding band glimmered in the sun and he smelled like a barbershop. He claimed I had jumped in front of him but I did no such thing. It was a bright day and I doubt he could discern my faint outline through the grime on his windshield. The doctors asked me if I felt depressed and I said yes, more than I've ever been, and they moved me to this sanatorium. And here I've remained.

Lyle, when my grandfather took that abrupt turn onto that strange inner road visible only to himself, he defied everything my grandmother knew of him and so rendered suspect the life they had shared. In setting those trees alight, he put a match to my grandmother's very existence: her memories and beliefs, her judgments of what was true and good – those years with him which informed the woman we all knew and loved – were erased. So then, was she. And every thread of Dad's life spun in common with Grandpa became a lie the moment Grandpa

revealed himself as someone other than the man Dad knew. Mom tried to ignore the truth of Dad's betrayal and spent her waning years standing above the crater where her life had once been, afraid of looking into the void but incapable of turning away.

So once again, son, this brings me to you. This is why I accepted the accusations against you as truth the instant I heard them. In the wake of two generations' damage and denial, I was done with illusions, delusions, white lies and silent, candy-coated, family theater. I was proud, and believed myself possessed of wisdom and temper in excess of my wife, my parents and my grandparents, that I was stronger than those truths they could never face. I put my shoulder to that blood-red door to nowhere, broke it down and charged headlong into the dark. In so doing I betrayed your mother, and I betrayed you. And the void has long since swallowed me whole.

The fade is complete, Lyle. Staring into a bathroom mirror, I see nothing but the wall behind me. I have lost all sensation in my fingers. There is no small drift of heat when I exhale into my cupped palms, my breath and blood as cold as the air around me. Time has taken its leave of me and I don't know whether I've been here for weeks or years. Our numbers dwindled as new patients were turned away, and the orderlies grew infrequent and irregular in their rounds, from diligent to derelict with each new discharge or death. The beds have long been stripped and the lights are all dead. Red water drips from the taps and webs like thick fog span the high corners of the washrooms. My hunger followed suit and faded with my flesh, so they ceased ushering me to mealtimes. Or they neglected me during meals and so my hunger gave up. I don't know which. I do know that my want of anything is a memory and like the rest of my memories it is more dim and distant with every moment I am unable to close my eyes.

I should, by all reason, be blind, as light passes through

my eyes without stopping. But logic and reason took their leave the day I saw wallpaper patterns through my chest. My eyelids are of no consequence either open or closed and so my elaborate labyrinth of memory, sanity, reason and recognition strains against the unceasing flood of sight coming every waking moment. The rotting walls in my head give way and the floors of the labyrinth buckle, the years caving in on each other. I don't eat but am never hungry. I'm tired but never sleep. Finding warmth takes more effort than enduring the cold. I have no desire. I'm afraid to pray because I'm afraid of not hearing an answer. My own footsteps in this empty place are but the creaks and echoes of age and rot, nothing more. I am the sole remaining tenant in this storehouse of dead ends and empty rooms. I have no more cause to stay than to leave. Neither guard inside nor vigil outside. I am the sound of attrition. I am inert.

Only one truth remains, and in my stubbornness to confront what I believed my wife could not, I was blind to this singular, profound and enduring truth. I failed to abide by it when your mother was alive, and I failed to express it to you when you needed it the most. Know this, then: I love you, Lyle. You are my son and I love you beyond reason or measure, no less than when I held you in my hands the day you were born. I love you without constraint or condition, with or without your love in return, regardless of your choices, with or without your remorse for those choices. I love you unconditionally, Lyle, and I always have.

For me to disavow our kinship was my own lie. I hid this love in an effort to spare your mother and me the scorn of our community. I am sorry for that, Lyle, from the very center of my heart, I am sorry. If I could trade my breath and blood for the innocent you robbed of theirs, I would do so to spare you even a moment's suffering. I continue to pray for you, your wife and for Lyle Junior, wherever they may be. I pray that Lyle Junior continues to summon his indomitable will and

fortitude, that he may see himself as his own man, defined by his own choices and not by the shadow of yours.

These are the last words I will ever write. May the Lord keep you and your family in the shelter of His embrace until such time I can do the same.

All My Love.

FISSURES OF MEN

He read the letter twice, wrapped the pages together again, slipped the sheaf back into his record collection, then took it out and read it a third time. His tea was cold. Lyle drank the last of it then sat tilting his cup this way and that, his mind a riot of questions, speculations and refutals, his remaining clarity sufficient for watching the sugary dregs bank sluggishly about the bottom of his cup. Nadine hadn't stirred but here he was foregoing precious rest for a letter that read like a fortune teller's swindle: generations of inherited wealth and madness, with a curious lack of specifics but for those rare few whose poignancy distracted from the story's baroque imprecision. It bore no signature or address, and lacked only a wax seal for an air of antiquity. Whether a hoax or not, it was certainly delivered to the wrong Lyle. The correspondent – ostensibly his grandfather – hadn't written to him but to his father. He hadn't requested money, personal information or a reply of any sort. If this were someone's play at a long con, there were better marks than Lyle to be found among those living on the street. He sat for a while in the company of the ringing in his ears, then Lyle shut his eyes.

~

Reid was a scarecrow. He never appeared, but in the dream Lyle knew it to be true. Lyle had papers to be signed or stamped or

192

otherwise ratified. He knew nothing other than they pertained to him and that they were urgent, so the dream left him to wander through a bureaucratic maze of dark hallways, with each agency unmanned and locked behind a bright red door.

Rain rattled the windows and a siren wailed in the distance. Steel-colored light suffused the living room where Sera sat with Nadine nestled against her breast, Nadine's tiny, ricegrain fingers pressing into her mother's skin. Sera had tied back her hair, shocks of it matted from sleep and jutting from beneath a dark green bandanna. The skin beneath her eyes slack with exhaustion, the razor-fine creases bracketing her lips sunk more deeply so soon after waking. She stroked Nadine's black wisp of hair, her thumb sweeping slowly over her child's tiny crown. Nadine's eyebrows, a pair of small, downy ridges, twisted together in her earnest feeding. Sera was oblivious to Lyle watching from the bedroom doorway, rapt as she was with Nadine, just as Lyle was with the two of them.

His heart felt like it wouldn't stop growing. He wanted to stand behind Sera and wrap his arms around her, one hand on her open breast and the other on his nursing daughter and feel their heartbeats and their breathing together, to bury his face in the warmth of Sera's neck and hold them until his swelling heart enveloped them completely.

~

Driver's license and current utility bill. First name, last name, middle initial, date of birth, home address and phone number. One such form out of hundreds like it in his past and thousands more to come. The red-haired man had bumped Lyle's birthday forward by exactly one day, one month and one year to lessen the load on his memory. Whenever stricken with the odd urge to recall the actual date of birth he'd celebrated for seventeen

years, he found the numbers had bled and faded with age and his mind would go blank.

The librarian handed Lyle his card, plastic with rounded edges like a credit card and inked with his name and a bar code. Lyle slipped it into his wallet along with the other cards bearing his name, thickening his Lyle Edison shell another fraction of an inch. He took the stairs and circled each floor before climbing to the next. He made note of the reference section, then continued until he stood at a reading room window on the topmost floor with a view of the civic center. The courthouse where he'd been arraigned, City Hall where he and Sera had been married, the library entrance directly below, where Icarus had first shouted out his given name. The hospital where Nadine had been born was visible in the distance, but the bus terminal where Lyle had arrived years before had been demolished and the hotel where he'd first lived had been converted to condominiums with a coffee franchise on the ground floor.

He toured the reference section stacks until he came to the newspaper indices, an aisle of muddy-green, clothbound books, their spines stamped with gold foil dates, eighteen to twenty-four months per volume. Lyle stopped at the index marked with the year he dropped out of high school, the date range on its spine encompassing every hellish event up to the issue date of his Lyle Edison driver's license, with the subsequent volume beginning with the day he bought his one-way bus ticket. He pulled it from the shelf, took a scrap of paper and a golf pencil from atop the card catalogue and settled into the most remote available seat.

The binding opened with the audible crack of those books displayed as ornaments. He found his father's name in bold block capitals, last name first and first name last. The register following filled two full pages, those days which Lyle recalled as a blur of spray-painted invective, broken windows, anonymous telephone threats, fires on their front porch and an encampment of television reporters whose vigil always

lapsed during those incursions. The articles began with his father's arrest and confession, then the investigation, the plea bargain and the further confessions, the locations of unmarked graves, the exhumation and the identification of loved ones. The headlines were written in the blunt, truncated language of B-movie cavemen. Without his glasses, Lyle would have taken the litany of bloody reportage for a phone book or dictionary.

Two entries concerned police interviews with the "wife of accused serial killer", a third announced a brief public statement from Lyle's mother after she'd been cleared as a person of interest. There were no mentions of extended family. If the police had questioned any of his relatives or searched their property, they would have done so early on, so Lyle wrote down the call numbers for the half-dozen earliest articles and submitted a request for microfilm.

The spool hummed and the days fired in bursts across the screen. A train crash. A mattress sale. Real estate listings. A hotel fire. A Third World insurrection. Baseball scores, film reviews, elections and obituaries. He zoomed in to better read the dates and page numbers and then scrolled forward and when his father's mugshot filled the screen Lyle's mind went white. No sound but the ringing in his ears, a jackrabbit gone stone-still to blend with the briar shadows. Like staring into a strange mirror, the reflection was faithful except for the eyes. They weren't eyes, but lenses that lacked the glimmer of any inner life behind them. He switched off the viewer and the screen went dark. After a few seconds the fan spun down and Lyle stopped holding his breath.

~

Nadine lay on her belly and lifted her head long enough to look about for a moment and then rested her cheek against her blanket, pale yellow and dotted with tiny barnyard animals. She did this over and again, taking in the view without a blink.

Lyle worked in the kitchen, slicing vegetables and scraping the cuttings into a wok. When Sera had first commented on his speed with the knife, he shrugged.

"How many times have you cut yourself?"

"Never."

"Not once?"

"If I worked in a restaurant, I'd be missing a few fingers by now. It's different on my own. I can concentrate."

He prepared dinner, focusing on his knife work to temper the lingering effect of his earlier shock. He'd so long defined his life by what he'd disavowed that he seldom thought about what he wanted. He decided long ago that he wanted Sera, and he discovered how profoundly he wanted to be a father on the day Nadine was born. And right then, with the rain tapping at the windows, his daughter on the living room floor and his wife reading on the couch while he made dinner and listened to Robert Johnson, what Lyle Edison wanted most in the world was nothing else at all.

They ate on the couch while Nadine swam in place in the center of her blanket.

"So, that big homeless guy I went looking for," Lyle said. "He gave me a letter. Long one, looks like it was written a hundred years ago."

"And?" Sera nudged him with her knee.

Lyle summarized the letter as best he could, but it sounded more like a far-fetched prank when he heard himself say it out loud.

"No names other than yours in all of it?"

"There's 'Lyle', yeah, but a different one. The rest is things like 'wife', 'mother', 'Dad' and so on. But there's definitely two Lyles."

"Okay, father and son," Sera said. She was looking somewhere off to her left at nothing in particular, the way she did when she was thinking out loud. "Dad's a criminal and has a son with the same name," she said. "But it mentions nothing specific about either one, right?"

"He, I mean, it mentions the father's victims, but doesn't say outright that he killed anyone. But it's pretty clear he's not talking about embezzlement or something."

"But there's no details, no places or dates. Doesn't say anything specific about what your dad did?"

"Nope," said Lyle. "I know, it sounds thin."

"Let me read it. Please."

"Sure."

~

He shaved without his glasses, mostly going by touch. He knew the contours of his face well enough to handle a razor in the dark. The booking photo had shown his father with a thick horseshoe mustache and several day's growth of stubble. He'd grown a full beard once or twice but for most of Lyle's life he'd kept his face clean except for the mustache. Lyle splashed the razor through the sink and then shaved his neck, trailing the upstrokes with the fingers of his free hand.

The mustache had been a constant, that was certain, trimmed to the corners of his father's mouth until some time not long before his arrest, when he'd let it arc down to his chin. Lyle's mother hated it, said it made him look like a truck driver but Lyle never understood why that was an insult.

Lyle finished his cheeks and jawline, splashed his face with fresh water and blotted dry, then put his glasses back on. The letter had said nothing about hair color. His father's hair and mustache were thick and black. He looked like a TV show cop. His mother's hair had been equally dark, while Lyle's was a dirty brown-blond hybrid that had slipped through some genetic crack between his parents. He wore Buddy Holly-style glasses he first thought ugly but affordable. By the time a generation of models and movie stars eager to appear bookish off camera had made the style less affordable but no less ugly, he'd grown fond of the ungainly black frames that

obscured the bones around his eyes, dampening his family resemblance.

Lyle was six years younger than the face in the mugshot, though he looked much older. The face in the mugshot had shown none of the traits of middle age. It had displayed superficial expressions in lieu of emotions, as necessary to impersonate an ordinary man with a conscience. Women had always remarked on how young Lyle's father looked. The earliest lines in Lyle's face appeared in candid photographs or unexpected reflections when he was twenty-eight or twenty-nine. Creases around his eyes when he smiled, hairline cracks above his eyebrows. At seventeen, he'd been anxious about passing for eighteen, but now his age fluxed with the time of day. The angle and wattage of a single light bulb could cast him as twenty-five or thirty-seven. By the time Nadine would be old enough for him to have a solid night's sleep, the bags beneath his eyes would be permanent and the thought of this made him smile.

Sometimes he felt his wife's fingers tracing his scars as he lay half asleep. There was the hook around his eye socket from the steel toe or aluminum bat that had torn the skin and ruptured his cornea. Seams along his joints where pins had been set into his bones and pale pinstripes on his forearms from box cutters meant for his face. His nose had been reset twice and he once took his meals through a straw for thirty-five days before the doctors cut the wires loose. His new jawline made him look that much more like his father. Sera had stopped asking about his scars once she understood his answer was always the same.

Lyle joined Sera in bed, the pages from Icarus face down on the comforter.

"It sounds like it could be legit," she said. "It also sounds like a carnival psychic. Really vague, but manipulative. Insincere."

"I should just forward it to him, my father. Belongs to him, anyway. Be done with it."

"Maybe that's the ploy, to get you to contact him."

"Could be, I suppose. Still, he had to dream this whole thing up, and somehow get it to a crazy homeless dude who was supposed to track me down without any idea where I'm living or that I'd changed my name."

They sat beside each other, not sharing the silence but each in their own.

"What do you want to do?" she said.

Lyle had come to define his life according to an incessant rash of deadlines, appointments and waiting periods, but the day he first cradled Nadine was the day the clocks stopped. At his most beleaguered and sleepless, sitting with Sera and holding Nadine made his every mistake and downturn of luck feel like a bad dream. He had just a few more months under Nestor Reid's heel, when the terms of his probation would be at their least restrictive and Reid would be turning his attention to his newest roster of offenders.

"I'll forward it and forget about it. I won't write anything or use our address. He won't even know it's from me."

Nadine stirred in her crib and Sera took her hands from Lyle's chest and stood without the customary trailing of her fingertips or rearranging the quilt across his shoulders and went to feed her daughter. Lyle opened his eyes again. The molding overhead was still gapped from the wall since the quake. He traced a crack that ran from the corner above him to the light fixture at the center of the ceiling. The more he kept from Sera, the less she truly knew him, just as he never truly knew his father. And like his father, the longer he kept up the lie, the more it was going to hurt her.

Lyle packed the letter into a padded mailer, then dialed information for the Department of Corrections, who provided the prison address and his father's federal ID number. He marked the package accordingly and used the street number for a defunct lumber supplier as the return address. He washed his truck and cleaned the inside, checked his headlights, taillights and brake lights, then drove for two hours to a street

corner mailbox in another city to keep the postmark far from his zip code. He'd left the county without informing Reid, violating his probation, and when he dropped the letter into the mailbox he awaited the rush of relief that never came. He kept to the speed limit on his return trip home, favored the slow lane and watched his mirrors for flashing red lights.

His father's mugshot had stared back from the newsstands, liquor store racks and street corner newspaper machines during those first days after the arrest. Four columns wide and above the fold when the story broke, it shrank and shifted about the front pages alongside photos of the victims or inset within crime scenes. To the young Lyle it felt like they were tracking his whereabouts, as though his presence triggered a bank of monitors to broadcast an aged likeness of himself whenever he left the motel. He stopped shaving but only grew the thin, wispy beard of a teenager. He wore dark glasses, baseball caps and oversized jackets but seemed to himself all the more conspicuous when he saw his reflection.

The last of the unmarked graves had finally been exhumed and the grainy booking photo of Lyle Sr shrank from the front pages altogether. The public's collective shock and outrage waned and the story went dark. Then came a wave of new photographs. Lyle Sr shackled between escorts and standing in court or being ushered to a transport van. The dailies had begun experimenting with color and the volcanic orange of the county jumpsuit made the newsprint look as though it had caught fire. The frozen flame glowing inside a newspaper machine was visible from a block away and Lyle knew to keep indoors when he saw it.

He spent more time in front of the mirror. Like watching for the subtle rise and fall of Nadine's blanket while she slept, he looked for the shifting glimmer in his pupils as evidence of life. He checked the details of his face against his memory of the mugshot. The bones around his eyes, the span of his forehead and cheekbones, the shape of his lips and the slope of his nose.

He stopped shaving and this time his beard grew in thick and full but it frightened Nadine so he shaved his face clean again. His stare down with the bathroom mirror further prolonged his morning and evening rituals. He stopped noticing the traces of age or the compounded sleeplessness of fatherhood whenever he glimpsed his face in a passing window. The more distinctions he attempted between his face and his father's, the longer he held his father's mugshot in mind and the more it shifted like soft clay into a memory of his own reflection.

On his drive back from a meeting, he stopped behind a patrol car at a red light. He looked into his rearview mirror at the scar shadowing his glasses, then back to the cop in front of him. The light turned green and he shifted into first but the cop didn't move. Lyle counted to ten, then tapped his horn, the second time he'd honked at a cop. The car idled for another moment and then drove ahead. Lyle followed, minding the posted speed and then the car changed lanes before it slowed, almost side by side with Lyle. The roof lights flared, red and blue flashes that sent Lyle's pulse racing. Lyle downshifted, hit his turn signal and pulled to the curb but the cruiser shot ahead, its siren howling through the intersection ahead and then it was gone. Lyle idled at the curb with his hazards blinking until his heartbeat slowed to normal.

Blood

FACIAL RECOGNITION

An eight-foot square vault without dust or shadows. Slabs of ballistic glass drilled for ventilation and sound. Benches extruded from the walls as though the room had been cast whole from synthetic resin the color of sunlit snow.

"They got him under escort as we speak," the guard said. "Take all the time you need. When you're finished, or you think you got a problem, hit the call button there on the door. One of us'll be along, directly."

"You're not going to have someone right here?" Lyle said.

"Sorry, hoss. Don't have the manpower. One of us for every hundred and fifty of them. You want to pull out, say the word now. I got to take a leak."

"No. I'm good."

"You're good."

"Yeah."

"Nervous?"

"Yeah. No. A little."

"A little. Not scared shitless?"

Lyle shook his head.

The guard narrowed his eyes. "Take off your glasses."

"I've been searched. They X-rayed my glasses."

"Take off your goddamned glasses or I'll do it for you."

Lyle complied and the guard unholstered his baton, held the tip beneath Lyle's chin and nudged his face upward.

"Look at me," he said. "What'd you say your name was?"

"Edison."

"Edison." He stepped out of the cell, closed the door. "Right."

"Hey," Lyle said.

"Hey?" The guard spoke through a block of holes drilled through the banker's glass.

"Excuse me, sir?"

"What?"

"I'd appreciate it, um–"

"Say it."

"It's just, I don't know you. And I'm thinking you don't have any, hoping anyway, you don't any reason to mention this to anyone. My name."

"Relax, Edison. I'd have done the same thing."

"Thanks. Thank you very much. I appreciate it."

"Forget it. Tell you what else I'd do, though. I was you, I'd sit myself closer to that call button." The guard rapped the partition once with his fist and walked away. The door at the far end of the hallway buzzed open and he was gone.

The blood left Lyle's fingers and his hands went cold. A flatline whistle rang within his ears like a distant distress signal. He heard the far door open again, manacles chiming against the floor and a prisoner's fettered and jangling left–right–left closing the distance. He fixed his eyes on the vacant bench in front of him. The cell door opened and bright orange flared from the corner of his sight.

A guard said, "Eyes front."

The snap of locks, the ringing shackles collapsing into chain puddles.

"Turn once to your left." The guard spoke in the monotone bark of a drill instructor. "Step through the door and sit facing the visitor."

The prisoner's hands remained bound in a pair of cuffs welded to a flat length of metal between them, his face hidden beneath a densely woven mesh hood hinting at the man

underneath, like a face staring back through a cloud of black smoke. The contour of a head, the dim shadow of a brow. The fabric swelled and sank with his breathing. The guard tore loose the clasp at the prisoner's neck and yanked the hood free and Lyle looked into the face of a man who was half-memory, half-stranger. Hair razored close to the skull, the shadow of a beard from the top of his cheeks to the middle of his neck. The prisoner pulled a cigarette from behind his ear, held it in his mouth and waited. The guard obliged him with a light before locking the cell door. The two men regarded each other in silence until they were alone.

"Hello, boy."

Lyle nodded in reply.

The prisoner ran his tongue along his gums, then spat at the floor, wiped his lips on his shoulder. "Rash of spiders, lately," he said. "*Spitters and biters*. Make us wear the hangman's hood whenever we're on escort. But thing is, they don't wash them, so you got to smell some other convict's lunch, ever you want a sit-down with your lawyer." The prisoner took another drag from his cigarette and scratched his nose with his cuffed wrist.

For a time, Lyle had imagined an alternate life where someone else's father had appeared on the evening news. In this alternate life, he had graduated high school and kept his name and when he came home from college during the holidays, his father would smile and ask how he'd been. He'd imagined the question more times than he could count, but he'd never imagined responding. He sat listening to the ringing in his ears and the rustle of the prisoner's jumpsuit.

"You're not," Lyle said. "Um, you don't look surprised to see me."

"Surprised." The prisoner cracked a grin, his teeth the same bleached resin color of the cell. "Seem to forget I reared you, boy. I *know* you. You're here after all this time because you want something from me. So, what is it?"

During the long drive, he'd tried to imagine what he might

say, what he might hear back and all the possible threads and digressions their meeting might take. Now the prisoner was in front of him. Flesh, blood and words. *What do you want?*

"Take your time," said the prisoner.

The strange letter was still in transit. Icarus had delivered it to Lyle with the seal unbroken, but here the guards reviewed incoming mail. A uniformed stranger would learn their legacy of heartache, betrayal, disappearance and death, a stranger like Reid who could pry open someone's private life just to pass the time. Lyle pictured the field of scarecrows and charred stumps, a piece of land passed from one generation to the next, and weighed the chance of it being real. He thought of the disappearing man who would be his grandfather, the son of a man who built his own mechanical heart.

"The farm," Lyle said.

"What farm would that be?"

"Your grandfather – my great-grandfather – built a house. Had some farmland that he willed to your father, who willed it to you."

"That a fact?"

"You tell me."

The prisoner curled his hand inward and tapped the cigarette against his wrist restraint. "And just where'd you come by this information, boy?" A nugget of ash fell to the floor, grey flecks drifting to the legs of his jumpsuit.

"Let's say I got access to a better library than you."

"One you don't need permission to use." The prisoner gave no sign he was sharing the joke with Lyle or aiming it at him. "Don't think I ever set foot in a library my whole life until they locked me up. Bet I've read more books than you."

"I'm not much of a reader," Lyle said, unsure if the prisoner was reaching for a connection and whether Lyle had squandered it.

"But you just up and decided one day to look into some family estate at a public library, that right? You care to tell me,

boy, where this magical place is? You seen a deed or anything with the family name on it?"

"Heard it from granddad."

"Your granddaddy's dead, boy. Never mind you couldn't pick him out of a lineup if he was alive, anyway."

"He wrote to you. I don't know when, there wasn't a date. But I mailed it here. You'll get it soon."

The prisoner laughed once, like a sharp cough. "Sent it here after you read it? Snooping around where you shouldn't, sounds like."

"It came to the wrong 'Lyle', so yeah, I read it."

"Somebody's running a con on you, boy."

"Was your father a con man?"

The prisoner fixed a slit-eyed grin on Lyle and took a long pull from his smoke. "Not only taller, but seems you grew a pair since I last saw you. Tell me, what do you know about my old man?"

"I know he believed the news, soon as you were arrested. Nobody else in the family wanted to. Most people won't believe accusations like that against family, but he did. Am I right so far?"

There was nothing to read in the prisoner's face. "What's my father's name?" he said.

Lyle stared at his feet. The floor could have been poured and set that morning, with Lyle the first to walk across it. He shifted his foot to cover the black slash mark left by his boot heel.

"Boy," said the prisoner, "your ego is astounding. Had everything, growing up. Roof over your head, clothes on your back. Christmas, birthday. You disappear in a cloud of smoke and here after almost two decades you come looking for a handout."

"Not a handout."

"What, then? Think you're entitled to an inheritance?"

"No more or less than you were."

"Still a child after all, looks like. Hoped for better, but I

should have known the family fortune would bring you crawling back."

The prisoner aimed his eyes toward Lyle without looking directly at him, his attention trained on a pane of air between them as if monitoring a bank of switches and dials wired to Lyle's pulse or the set of his jaw. Switches labeled *boy* or *child*, dials marked *ego*, *handout*. Some words were like needles, others like electric shocks.

"It's not for me," Lyle said. "We… I got a kid, now."

The prisoner's face softened, the pockets of shadow in his cheeks and the veins in his temples dissolving at once. Lyle caught a sheen in his eyes like he'd seen when Ray cradled Nadine. A second passed and the prisoner was himself again.

"Who's *we*?" he said. "Get somebody knocked up?"

"It ain't like that."

"Tell me, boy, what's it like?"

"Jesus, you must be bored out of your mind in this place."

"Meaning?"

"Meaning," Lyle said, "instead of growing a pair yourself and just telling me *no*, you're playing games, expecting me to justify myself."

"Seems you ought to. Had yourself one hell of a college fund, I remember. Don't go thanking me for it, boy. Must have pissed it away a while back, else you'd have a decent job and you wouldn't be here. Because you got your principles, and all."

"My college fund. Right, thanks. Schools would touch me after you made the news, not one of them. As for the money, it went to these teeth here, for starters. Porcelain with titanium screws. Had my jaw wired shut for five weeks after I got jumped one night. Almost lost my eye the first time. Had my nose fixed twice–"

"Boo fucking hoo."

"–had to drop out of eleventh grade. Lost my job and couldn't get hired to save my life. So as for your generous college fund,

I spent most of it on ER visits and reconstructive dentistry. Oh, and the name change, so yeah, it's *Edison*, now."

"Went and stuck your head in the sand."

"Didn't leave me much choice."

"Didn't put a gun to your head."

"Not *my* head, you didn't."

The prisoner tapped his ashes against the restraint again, the cigarette burning close to the filter. He brought his hands to his face for a long drag and held it in, then put his hands to his knees. He rolled the butt between his fingers, contemplating the bit of remaining tobacco, then looked to the ceiling and blew another lungful of smoke at the lights and once more aimed his eyes at Lyle.

"Ready to dance, boy? Clock's ticking. Pick your song."

"I didn't come here to get into it with you."

"*It,*" said the prisoner. He repeated the word twice, *it,* almost like spitting. "Yeah, there's some land, sure. Still belonged to Dad, last time I saw you." The prisoner finished the cigarette and flicked the butt aside. "So, let's talk."

Lyle stared at his knuckles, his hands locked together, then loosed his grip and said, "Talk about what?"

"Haven't seen you for some twenty years, Lyle." The prisoner's voice softened, the voice of a man in solitude before a headstone, and the sound of his own name took to Lyle's chest like a morphine drip. "And I reckon," he went on, "I won't ever again, after this."

"Sure," said Lyle.

"*Sure.* Say anything, won't you?"

"You're not very good at this."

The prisoner smiled wide and shook with silent laughter that trailed off in a wheeze. "That is some lip you got on you, boy. Damn sure didn't get it from your mother. But go on, tell me all about yourself."

"Narrow it down a bit, maybe?"

"Okay. This lady of yours, she got a name?"

"Try something else."

"Okay," said the prisoner. "I get it. How about a cat? Ever get another one?"

"Had a few over the years."

"And now?"

"Yeah," said Lyle. "Scissors."

"Kind of name is that for a cat?"

"Was a joke. Got her as a kitten. The other one – big one named Wolfgang – picked on the kitten, chased her around and hissed at her. So we'd say, 'Wolfgang, no running with Scissors in the house.'"

"You always were so damned clever," the prisoner said. "What else?"

"Wolfgang disappeared a while back. Scissors doesn't have long."

"Why's that?"

"Old. She's a sack of bones, hardly eats anymore. Need to put her down, soon."

"I suppose you'll be digging another hole in your back yard." The prisoner squinted, looked for any flicker in Lyle's eyes. "Relax, boy, just messing with you. Bet you don't even have a back yard. Anyway, what's keeping you? Your cat's at death's door and you won't end her misery."

"Maybe I just need your encouragement."

"Boy, you're a daddy, now. You don't have the stomach to gas a little kitty cat, you might ought've coat-hangered your problem when you had the chance. Now you got to buy diapers and start saving for college."

"Wonder what other paternal wisdom I've missed over the years," Lyle said.

"That mouth of yours."

"Come to think of it, I don't recall getting *the talk* from you back then. Guess I missed out on all your advice about women."

"Figured I'd be wasting my time."

"Thought all those father-son projects, that was you teaching me how to handle women. Nail guns and power saws, right?"

"Boy—"

"It just tears me up inside, to think how ungrateful I've been all these years."

The prisoner broke into a wide grin.

"What?" said Lyle.

"Just seeing you now, listening, all that fire you got in you. Just like always. Had it the day you were born." The prisoner was quiet for a minute, then said, "When did you give up?"

"One more time?"

The prisoner laughed. "Christ, boy. Your old lady's knocked up and you're broke. So you're begging me to bail you out. You caved to somebody else and now she owns you."

"You don't know jack shit about me."

"I know the hack escorted you in here gave you the third-degree. I know you got a visitor's pass but he still busted your balls, and I know you took it like some fish straight off DOC transport."

"He's a cop. What was I going— look, Jesus, what's your point?"

"Point is you gave up. A long time ago. He treated you like a convict and you took it like one. Only one kind of man takes a dressing down like that. Kind of man who knows it'll only get worse if he doesn't suck it up good and fast. *Supplicate*." The prisoner punched each syllable as though teaching the word to a child.

"This place," he said, "a man learns that the hard way. See, we already got something else in common, you and me. Now, I know you're no killer. So, what was it? Shoplifting candy bars? Stealing cars? I can maybe see that. No? What, you a bank robber, boy? Jesse the Kid, what's his name, Dillinger? Come on, give your old man a hint. Pissing in public? Cheat on your taxes?"

"Possession," Lyle said, "with intent to distribute."

"Dealing. Shit. How'd I miss that? Boy, I could introduce you to some people, solve your money problems like you wouldn't believe."

"I didn't do anything."

"That's right, never cop to it. Looks like you do know your way around the system."

"You're not listening. I said I didn't do anything."

"Hey, I'm with you on this." The prisoner's voice was firm and even, the same way Ray had said, *Now suck it up and get hitched.*

The morphine glow returned to Lyle's chest and he tried to push it away but couldn't.

"Christ." Lyle sighed, shut his eyes and pressed his fingers to his forehead.

The memory unfurled in an instant. The story didn't involve his wife or daughter so Lyle let it flow. The prisoner listened, wide-eyed and attentive, sometimes nodding. Was this what convicts did? Swap war stories, commiserate and laugh about each other's mistakes? Was this what talking to a father was like? Talking man to man with someone who understood you better than yourself, who'd made the same mistakes and survived and was living proof that the significance of those mistakes shrank with time?

When Lyle finished, the prisoner cringed.

"I know," said Lyle. "I know. Yeah, motherfucker left me holding the bag, literally. A half kilo."

"And you didn't rat him out."

"How do you know?"

"Because you took the fall, boy. You can be pissed about it, but no need to be shy."

Lyle took the fall because he'd met the kid once and didn't know his full name. But right then he was smiling just as he had the night of his arrest. His made-up last name and counterfeit identity had surpassed every level of scrutiny the System brought to bear. Applications for jobs, apartments, bank

accounts, credit cards and a passport. Tax returns, insurance claims and moving violations. Up until then, everything but a felony arrest. At the time, the consequences of his arrest meant nothing next to the final, incontrovertible evidence that he was Lyle Edison, that he was not the son of a killer.

When the prisoner spoke, the lines in his face had softened again. "I'm proud of you, son."

"It wasn't like that," Lyle said. "I'm not you."

"You are my flesh and blood. Nobody on this earth is as much like me as you are."

"I'm nothing like you."

"But here you turn up after all these years, tell me you got a lady, that you've got your own flesh and blood in the world. My grandchild. But you won't give me names."

"My wife and baby? No."

"Wife," the prisoner said.

Lyle forced himself to go cold. He'd slipped, revealed their marriage.

"What are you afraid of, boy?"

He was afraid of that bank of switches and dials, of just how far it could reach, how long those connections could stretch. He was afraid of Nadine getting sick, afraid of not affording good day care or moving closer to better schools. He was afraid of Sera moving back with her parents on the East Coast, the last thing on earth she wanted to do. He was afraid of Sera taking Nadine with her, and equally of Sera not taking her and Lyle raising his daughter alone. He was afraid of living on the street.

"Okay," Lyle said. "Pick one."

"That's easy. You got a boy or a girl?"

"Girl."

"And what's my granddaughter's name?"

Lyle held his breath for a moment and then said, "Nadine."

"*Na-dine.*" The prisoner dragged the name out slowly when he said it, a sleepy grin on his face as though he'd come in

from the cold to a roaring fireplace. "That's a pretty name. Bet she's a little baby rose, looks like her momma. *Na-dine*," he drew the name out again. "Sure I've heard that name from somewhere."

Lyle shrugged.

"What, boy? You throw a goddamned dart at the phone book?"

"Just came to me. We both liked it, is all."

"*Just came to you*. When?"

"Day we found out she was pregnant."

"And the name *Nadine* jumped into your head all on its own."

"Pretty much."

The prisoner burst out a wet, raspy laugh that went silent while it shook him. "Used to know me a Nadine," he said. "Little raven-haired flower. Worked at that pancake place we'd go to. Think she knew you were my boy. Said to me once she saw you coming in on school nights. Turned a little pink when she told me."

Cold voltage hummed through Lyle's stomach. Like the puzzle in front of him wasn't really a puzzle at all and there never had been any answer to begin with, right or wrong, and the men behind the glass with their clipboards were laughing and flipping coins to see who got to pull the one really big black switch they'd been wanting to pull from the beginning.

And her face came to him so clearly, her profile as she reached across the table to refill his coffee, the loose strand of hair poking at her bottom lip. Her high-school yearbook photo on the evening news, on the humming blue television in his parents' darkened bedroom and his mother staring at her face from the bed she'd shared with the man now sitting across from him who'd been the last person to see that missing girl's face while she was alive and the first person to see her face after she was dead and for all of those moments in between that must have been an eternity to her. He saw her white plastic name

tag and this time the red block letters that he'd been unable to picture when he'd seen her face on the evening news: Nadine.

"What you suppose ever happened to her?" said the prisoner.

"You tell me," Lyle said.

"Tell *you*? Know how hard they keep trying to work me, boy? To this day, every couple months, they send some kid fresh out of cop school, shiny new badge, probably wet himself ever he had to pull his gun. They'll send this kid with a cold file to talk to me, see if I know anything. They open these files in front of me and they got stuff done on *typewriters*. See what I'm saying? They got goddamned carbon paper forms in there. Teletypes. I'm doing life times three in here and they still got a museum full of frozen Jane Does from before you were born they want me to cop to. What makes you think I'll tell you a damned thing?"

The prisoner relaxed again, scratched the stubble on his neck. His gaze wandered and came to rest on a high corner behind Lyle. Then he spoke again, softly.

"I's about twenty-two," he said. "Walked off the base at Fort Bliss the week before, hit Mexico to celebrate my discharge. Couple three days after, I'm back on the white side of the border, not a clue how I got there and smelling like goat seven days dead in the sun, sledgehammer in my head. Got some time before my bus home, so I'm in this cafeteria and this son-of-a-bitch will not shut up, just keeps yapping like some little dog. Place was full, more than enough guys there could take me. I wasn't that big. But I step out of line and I bust my tray right over his head. Kicked his chair from under him and nobody did a goddamned thing. Guy's on the ground, milk in his hair, mashed potatoes sopping up his bloody nose, wondering what the Christ just happened and why. And the whole room, about a hundred people staring at me with their mouths open, not moving or saying a word. Walked right up to the cashier, gave her my money and waited. She about started crying, she was shaking so bad. And I just walked out of there,

nobody said a word to me or did a thing to stop me. People see the real thing, boy, they freeze. Deer in the headlights. Sure, they maybe called the cops after I was gone, but every one of them watched me blindside that bastard and walk, and not one of them lifted a finger. Tell you, boy, no matter what happened to that Nadine and those others, every one of them died that afternoon."

"So," said Lyle, "it's society's fault. You're saying that with a straight face."

"Get off that high horse of yours, boy. You, all of you, walk past men and women dying in the street every day and you keep walking."

"Not the same thing."

"Explain to me the difference."

"Between not handing out change and murdering someone?" Lyle said. "Know how many times I've heard the *we're not so different* monologue at three in the morning watching some bullshit B-movie?"

"Matter of degrees," said the prisoner. "Crimes of commission, omission, complicity and accessory, it's all just fancy quibbling for the courts, lawyers splitting hairs. Your inaction makes you an accomplice, boy."

"How about Mom? You going to blame her, too?"

"Oh, your mother knew. Something, at least. Always telling her I had to work late. Weakest excuse in the world but she took it without a peep, every time. Just looked the other way."

"So, Mom thought, maybe, that you might be having an affair, but she didn't say anything. And in your mind, that makes her your accomplice."

"You want to believe she was all that ignorant? Then tell me this, why'd you cut us both loose all those years back, instead of just your old man? Think on that, boy. Deep down, you know. Tell you something else–"

"Slow down," said Lyle. "Yeah, I disappeared and never looked back. Because my father had been raping and murdering–"

"Allegedly. I pleaded out, handed them their entire case, gift-wrapped in plastic tarps."

"And while you were doing that, I was boarding up windows and painting over graffiti on our house."

"*Your* house?"

"Cleaning garbage off our lawn and shit off our front porch. When I wasn't having bones set or teeth replaced or getting turned down from jobs."

"There you go, again."

"So I cut Mom loose, maybe took it too far. But I wasn't thinking beyond keeping myself from getting killed, trying to work again, maybe go back to school someday. Doing all the things I couldn't because of my name."

"You left your mother all alone. Firstborn son's supposed to be the man of the house, once his father's gone. But you turned tail and ran."

"You're in here doing life, but think I owe you some kind of justification for mine."

"Didn't put a gun to your head."

"You already said that."

"Came here all on your own, near as I can tell."

Lyle rubbed his temples. There was no puzzle and there were no correct answers. He was a diversion for the prisoner, an amusement, nothing more than a single tick on a faceless clock.

"Okay, you win," Lyle said. "Guilty as charged. I knew."

"Don't patronize me, boy."

"I abandoned Mom because on some gut level, I knew something was wrong but I did nothing, which makes me as guilty as the next."

"Now you're talking."

"Your turn."

"For what?"

"Let's talk about why you're in here."

"I'm here, all that matters, now."

"No, it's not."

"What then, boy? Just what is it you want to hear from me?"

"The truth. What you did and to whom. You remember any other names? Because I'm curious if maybe there's things you aren't doing time for. Maybe you didn't give up everything and you're just aching for the world to know how smart you are."

"Won't bring anybody back from the dead."

"Just what exactly is that? What truth won't bring anyone back from the dead?"

The prisoner spat a fleck of stray tobacco but kept quiet. With that, the voltage humming through Lyle stopped and the man in front of him looked very, very old. He spoke directly to his incarceration but elliptically to his crimes and never coupled the two. He believed in the hardwired nature of everything, a universe of effect without cause but he would never dignify the truth with his denial. It was easier to cast the world as full of hypocrites.

"You," said Lyle, "are a joke."

"Am I, now? Starting to like you, boy."

"Then tell me what you did to Nadine."

The prisoner laughed. "The fuck you care what happened to her?"

"No," said Lyle. "Not *what happened*, but what you did."

"You're too late, boy. Get over it."

"Say her name again," said Lyle. "At least give me that."

"Her name don't matter anymore," said the prisoner. "You understand? She's dead."

"Okay, how about your own? Can you tell me that?"

"You know my name, boy. Same as yours."

"I know, but who else knows your name?"

"You're wasting my time."

"Want me to leave?"

"Didn't say that."

"When was the last time you had a visitor who wasn't a cop?"

The prisoner said nothing.

"How about letters? I hear people like you get all kinds of fan mail. Marriage proposals, even."

"I get plenty of mail."

Lyle leaned toward the prisoner and said, "Funny, fan mail but no visitors. See, most anybody can rattle off three or four names, guys like you. Manson, Gacy, Berkowitz. *Psycho*, what's his name, Ed Gein. Infamous names everybody knows, years after. But you don't even rate."

"Don't even try to get in my head, boy. Don't have it in you."

"Not *trying* anything, old man. Just had a light come on. You can't cop to what you did, you act like it doesn't matter, so it's really no surprise then that you don't matter, now is it? And you have this, I don't know, *contempt*, for everyone. Like the whole world is beneath you, but you need so goddamned badly for everyone to know it. And still, nobody knows who you are."

"Tell you a little something about contempt, boy. Can't put a price on a human life, they say. Bullshit. I wanted out of the gas chamber, D.A. wanted the juice for closing enough cold cases so he could run for office. Nine graves, all's it took. Hear me? *Nine.* Eight more bodies, after your coffee shop sweetheart. You think I'm a bad person? There's a man in D.C. right now, got there by climbing across nine corpses and saying *no* to everyone howling for my blood twenty years ago. Think I got my own room, free medical and dental for life plus three hot meals a day thanks to a judge and jury? Guess again, boy. My end of the barter, that's all this place is. All them dead people and their grieving families weren't nothing but chips and markers to a politician. Lecture me about contempt, boy, and you wonder why I got so much."

"But you still need an audience for it."

"You quite through, boy?"

"No. Still waiting for you to tell me about Nadine."

"There you go again. What is it with her?"

"I'm the first person, ever, to wonder exactly why you killed her? Or the rest of those people? That what you expect me to believe?"

"'Course not. I expect you, boy, to give me a reason why any of them matter to you. Millions drop dead every day. Why is it those nine people matter more than all the others?"

"And why is it every time I ask you a point-blank question, you dodge, find some way to ricochet the blame onto everyone else?"

"Boy–"

"What? Tell me about juice, old man. You want it all, whatever comes from doing what you did, but you won't own any of it. You're a joke."

"That pair of yours just keeps getting bigger. Tell you, last guy gave me that kind of lip drowned in a bucket of mop water. Strangest thing."

"Must have been really old. Or paralyzed."

"Neither, tough guy. Didn't say it was yesterday. Sealed my rep in here, years back. You get to keep breathing on account nobody heard you."

Lyle checked himself, like he did with every tirade he swallowed around Reid. The thoughts were coming too quickly and with too much heat, building up slack like a fishing line and he'd just get tangled up and then angrier and angrier if he struggled to get free and then the game would be over.

"Tell you about your Nadine," the prisoner said. "Spent two weeks in her apartment before she made the news. Peace and quiet after a long day, you know? Was one of those times I told your momma I was working late, and so she told herself the same thing, like always. Anyway, I finished her shitty wine, Nadine's, flushed her fish down the toilet. Nobody saw me coming and going. None of her neighbors figured she was missing, or didn't care. Girl was invisible. Fancied herself an artist or something. Guess she made shit out of metal to sell

at street fairs, but still needed to wait tables to make the rent. Should have learned a woman's got no business playing with welding gear.

"Anyway, not a single knock at her door for fourteen days. Phone rang twice that whole time. Job called to fire her and her bank said she was overdrawn. That was all. Parents never called. No boyfriend, no girlfriends. Couldn't find an address book anywhere. Piece of paper taped by the phone with some guy's name crossed out, her doctor, couple other girls with question marks by their numbers. I showed up one night, there was an eviction notice nailed to her door. Gave her three days. That was it. But fuck me, she turns up in a plastic tarp and all of a sudden she's the goddamned prom queen.

"Tell you what else, those eight other names? Two were a couple Mexican guys, illegals. They didn't mean shit to the D.A. Goddamned scumbag wouldn't start negotiating until I gave up another Nadine. The man made his whole case on the yearbook pictures of seven white girls. TV and papers never even mentioned them by name, them Mexicans. They were good for the body count, is about it. Wouldn't be surprised if they just left them two wetbacks right where they found them.

"The whole bunch been nine middle-aged spics? I promise you not one goddamned cop, reporter, politician or civilian would have given their dead asses a second thought. None of those good citizens seen my car at the filling station would have given a damn and I'd still be on the outside. So tell me, boy, why you bawling over some donut shop, graveyard-shift skank whose parents never showed up in court, didn't even claim her body? Quit acting like you're so different from everyone else, because you're not. Pretty white girls always going to be the best cards in the game. Ask any newsman or politician. Might ought to remember that, seeing how you got one of your own, now."

"You finished?" said Lyle.

"Your move, boy."

"You going to sign over the property?"

"You going to call me Dad?"

"Sure thing, *Dad*. Great seeing you again. *Dad*."

"Like you mean it."

"I'd be lying."

"Guess we're done here, boy. Maybe see you again, next time you're looking for a handout."

Lyle pressed the call button, casually as ringing a doorbell. It hummed beneath his finger for a few seconds and then he released it.

"That's it?" said the prisoner. "Just giving up?"

"We're done, like you said."

"And you're just going to let your wife and daughter starve."

"I've let people die before, right?"

Lyle looked at his wrist, but his watch was with prison security along with his keys. If he actually had needed to hit the button for an emergency, he doubted it would have saved him.

"*He who fights with monsters should look to it that he himself does not become a monster,*" said the prisoner.

"And?"

"That's from Nietzsche."

"I know."

"Then you know I'm a part of you."

"No, you're not," said Lyle.

"Have been and will always be."

"What is it with convicts and Nietzsche, anyway?"

"I made you, boy. And I been making you every day of your life. You can't run from your own blood."

"And you can't admit you're the monster."

"Think on this, boy: your baby girl's got your daddy's blood. You going to disappear on her, too? My granddaughter?"

"Disappear. You mean like turning up on the news? Leaving my family to serve a triple life sentence?"

An electronic lock buzzed far down the hallway and a pair

of guards approached. One of them said to remain seated. Lyle didn't know if they meant him, his father or both. He looked straight into the prisoner's eyes one last time, eyes he'd not looked into since he was a teenager. Nothing looked back.

The guards opened the cell door, entered and addressed the prisoner. "On your feet. Eyes front."

The prisoner stood. The guards locked his cuffs to the restraint at his waist, shackled his ankles and likewise chained the shackles to his waist.

"Twenty acres," he said. "Two-story house in the middle of nowhere. Probably collapsed, long gone by now. Ain't mine anyway, never was. My father changed his will the day they arrested me, set up a trust to handle the taxes. Some lawyer name of March is all I know, but a smart guy like you could probably track him down, you wanted. Thing is, my old man willed it to his grandson. *My son*. He's got the same name as me, but with *Junior* of course. So, Mr ... *Edison*, you said your name was? Soon as my son steps up, proves who he is, admits he's my flesh and blood, then it's all his, whatever it's worth. I figure that March fella's probably been looking for my boy all this time. You ever inclined to track him down, pass that along about March and everything. Think you can do that?"

"Yeah, I can do that."

"Tell him, tell my boy I want him to have it."

"Sure? Nothing else you want to say?"

One of the guards said, "Wrap it up," and the other pulled the dark mesh over the prisoner's head.

Lyle spoke to the faceless black hood. "Goodbye," he said. "Dad."

THE DOOR

And then he was outside. Like a sleepwalker coming to, barefoot on a neighbor's wet grass in the middle of the night. Lyle stood in the prison visitors' lot, staring at the keys in his hand, his silver ID bracelet catching the amber light of late afternoon and cutting short his fugue. He'd spoken with his father for maybe an hour but hadn't shaken the man's hand or otherwise touched him. He recalled saying *Goodbye, Dad*, but the rest came like snatches of a dream: the escort back to the visitor's lobby, signing for his belongings, walking past more guards, a buzzer that opened an enormous, blood-red metal door and then reaching open air.

His mouth was dry and his stomach growled. He'd paid thirty-five dollars in cash for a motel room to spend the night staring at the ceiling, another six dollars at the motel's lunch counter that morning for coffee, toast and fruit but had eaten nothing. His shirt stuck to him. He loosened the top buttons, then removed his jacket. A breeze chilled him so he put it back on and then walked to his truck.

~

A chain link fence enclosed the swimming pool, drained and full of tumbleweeds. The sign read, No Lifeguard On Duty. Outside the fence was a patch of sand with a swing set and a slide, an empty

plastic jug caught in the dry weeds at the base of a see-saw. Lyle returned to his room, showered and dressed. He threw on his work pants, army surplus smoke jumpers, and a Stooges t-shirt he hadn't worn in years. The weak-wattage lamps smoothed out the lines in his face, and without his glasses, his vision was blurry enough that his twenty-two-year-old self stared back from the mirrored closet door. Lyle Edison when his name and life were still new, before he told anyone who he really was, before a stranger on the street recognized him, before he'd been arrested, before he became a husband and father.

The aromas in the motel coffee shop took him back to his first dinner with Ray. Lyle caught his reflection again in a mirrored display cabinet, staring back from behind pillows of meringue and glossy mounds of blueberries and peaches. He left the memory of Ray's company and for a moment stood trembling in Nadine's coffee shop, job application in hand. There he heard the first clear echoes of his father's somnolent snarl, *Nadine*, and his hunger disappeared.

He sat on the motel bed, the telephone receiver barbell-heavy in his hand and a third memory swimming like a subcarrier beneath the dial tone, as though the years were rushing to fill the vacuum of his missing hour from the prison. Jagged pieces of time, rusted clean through and patched with scraps of his boyhood, memories of seventeen refracted through his eyes at age five. His parents' darkened kitchen where he'd last dialed his high-school girlfriend. The countertops level with his head, the kitchen dark and cavernous and the green telephone mounted on the wall, out of reach, though he held the receiver in his hand.

She can't talk right now. Or ever. Do not call this house again.

Someday his daughter would find herself the object of a boy's affections and knowing his own adolescent disposition, Lyle would assume the best in his daughter and the worst in her young suitors until one of them proved otherwise. But if that young man's father turned up on the news, that father's

house cordoned off with yellow tape and overrun by search dogs, the same house where his daughter had spent afternoons following school, his daughter who had the same hair color as the dead girls below the newspaper headlines, Lyle would say and do exactly the same thing.

The dial tone changed to an urgent pulsing that awakened Lyle back to the wood veneer walls and cloth lampshades that cast the room in a dim orange light. He hung up, lifted the receiver again and dialed. A recording of his own voice told him nobody was home.

"Sera, hey, you there? Can you pick up?"

He paused for Sera to interrupt the recording but the tape kept rolling.

"I'm at the motel, think I'm going to stay. Call me here if you want, but I'll be on the road first thing." He hung up but didn't take his hand off the phone, just stared at the nightstand. His keys and wallet next to the ashtray, a chunk of glass with the motel's name and address at the bottom. *The Oasis Motor Inn.* Sera couldn't call him if she didn't know where he was. He dialed again, distracted with unlacing his boots when he heard his voice, and out of habit he punched the code to skip the outgoing message and listen to the rest.

Mr Edison, this is Officer Reid. Stopped by the job site this afternoon and was informed you'd taken the day off. You're nearing the end of your probation, so I'd just like to square up a few things. Please call me as soon as possible.

Mr Edison, this is Officer Reid again. I won't call a third time. I need to see you at my desk by five o'clock tomorrow or your probation will be revoked.

~

The freeways had long ago quit splitting and merging. Only a single lane remained in each direction, the nighttime clouds overhead as black as the road below. He could have been

hanging in deep space if not for the highway slicing through the double-arc of his brights. Bits of the dark broke loose and scurried across the road. Pelts the color of dirt, invisible until they moved or their eyes flared like coins catching the oncoming light. Lyle veered on instinct, his shoulders tensed for a thump from his tires but he felt only the humming blacktop beneath him. Tumbleweeds cresting higher than his windows pitched about the roadside or snagged against mile markers. A trundling dust funnel staggered up the painted median and collapsed into an eddy of twigs and a plastic coffee lid. He flashed his brights now and then like calling into an old empty house. He'd been alone on the road for miles.

Long before Lyle met Sera, he'd told a woman he loved her and she said the same to him. She would hold his face with the insides of her forearms, her fingertips brushing the top of his head and she would stare at him with her sleepy smile and Lyle would hold her tiny waist for a moment before he pulled her in and kissed her. She had fair skin and bright blue eyes, wore her hair cropped short and carried herself with a restless mischief as though she could jump from one place to the next in a puff of smoke.

She left him for somebody else and he had violent dreams for months after, dreams where he followed her through a tangle of hallways and screamed at her from room to room but she couldn't hear him, as though he were dead and ineptly haunting her while she boxed up his things for Goodwill without a second thought.

In another dream he was drowning her but she didn't fight him. She was naked and he was aroused in spite of his anger. When he looked at her face she was breathing underwater, oblivious to him, her hair floating away from her face in a swaying halo beneath the clear pool in his dream. She took in deep lungfuls of water, looking all the more serene for it and this made him angrier. He awoke after a long night of deep sleep feeling as though he had never shut his eyes. The dream

didn't persuade him that he was anything like his father, but reminded him of the hollow left by someone who was wholly other than what he'd believed. Every minute of every year shared with this person is time that never existed, pieces of his life that became nothing and the cyclone of hurt and rage were his alone. The person he loved, who hurt and enraged him and rendered void all those years, she didn't know his rage or pain because that person was never real.

The prison visitors' lobby had been filled with the families of the incarcerated, families of the men who had murdered or raped or otherwise destroyed countless lives but whose mothers and children refused to believe their loved ones were monsters, a truth Lyle somehow accepted the moment he learned it when he was seventeen, thus exhausting his capacity to ever face such truth again, so his smallest heartache lingered for ages and invaded his sleep with violent dreams.

His father's pale, weathered face from the prison had subsumed the ageless face in his memory. The time Lyle had worked the plastic dropper into the cat's mouth, prying its teeth open and flinching at its resistance, his father's hands were on his shoulders. His father said the cat was fighting him, and that meant it wanted to stay alive. Lyle tensed and his father squeezed, reassuring. His hands were like knots of wood wrapped in dry leather, always dirt under his nails and grime in the cracks of his knuckles. Lyle had never thought to ask how an electrician's hands could get so dirty. Those massive, hardened hands were evidence to Lyle of his father's resilience, his lifetime of small battles and hard work. Lyle's wish to be like his father was a wish to outgrow the small, soft hands of his boyhood. Those hands he had aspired to, those on his arm at the hospital or around his mother's waist in their family photo, had been the same hands over Nadine's mouth, or pulling a twist of her hair to make her quiet.

Nine graves. Out of how many? Nadine was the first one found but that didn't make her the last one buried.

Had the ride itself been worse than the moment their killer stopped? Had Nadine or any of the others even been alive when he pulled off the road? It felt wrong to hope not, but worse to hope otherwise. Bound and gagged beneath a blanket across the back seat, wondering as Lyle was just where all the other cars and trucks could possibly be, while tossing upon the electric rise and crushing fall of hope with each pair of headlights that dimmed as they approached and lit up as they passed. All the while witnessing reality itself sundered and crumpled like a paper screen, their lives laid bare as a fairy tale moving image projected onto nothing, diffusing into the emptiness they had pretended away since birth. Or their last hours spent locked in a darkened trunk beside a shovel, huffing for air within folds of plastic while riding through the middle of nowhere and telling themselves over and over that it wasn't happening, that it wasn't real. The truest horror of all was admitting to themselves they were right, that none of it was real. Not the trunk or the dark or the nowhere, not a single waking and breathing moment of their lives they ever thought had mattered.

A ripple of dust shifted in the road ahead. Lyle tapped his brakes and squinted at something like the sine wave edge of a tide washing across the highway but without the tide itself following. He hit his brakes harder and slid across a patch of loose sand to a stop. The sidewinder roiled across his lane, a three-foot adult thicker than Lyle's wrist at the middle, and then it was gone. Lyle stopped twice for gas and a bathroom, popped two caffeine pills in a service station parking lot and threw the rest away. He came to his off-ramp just before morning rush hour.

~

Scissors lay by the kitchen table, the floor wet beneath his hind legs. Lyle crouched to scratch between the cat's ears and he purred in response but didn't lift his head.

"Lyle?" Sera came from the bedroom.

"I'm putting him down today," he said. "I have to."

"You came back," she said. A statement of fact that implied neither accusation nor relief. Her eyes were red and swollen, the glass-crack crow's feet deeper, creeping to her cheeks and temples. The darkest opposite of how she'd looked when Lyle woke up in the hospital.

"What's wrong?" He trailed his fingers down Scissors's neck, the cat's shoulder like a dull blade beneath his thumb.

"You don't get to ask the questions." She stopped, composed herself. "The first time I asked where you'd been all night was one time too many."

Scissors made a brief protest of pain and Lyle lifted his hand.

"You understand me?" Sera said.

He didn't. Whether an ultimatum, a condition of leaving him or as notice that she was doing so, he didn't know and didn't ask.

"Jesus, Sera–" Lyle stood, his back drawn tight from the long drive. His knees popped and his head swam, and he steadied himself on a dining chair.

She said his name from the far end of a tunnel. "Lyle?"

He sat down and waited for the spinning to stop, his palms flat on the wooden table, the one he'd found in the street, the upper half of a stable door that was probably fake because there weren't any horses for a hundred miles. Lyle had refinished it, then bolted it to a center stand of wrought iron, and Sera had adorned it with a single, squat candle in the center. They shared meals there every day since they'd moved in together.

In his head, he saw clearly the white Formica dining table where he'd sat with his parents, the bright yellow napkins and ceramic salt and pepper shakers glazed with sunbursts where he'd left the note for his gutted ghost of a mother.

"Tell me where you were," she said.

"I saw my father."

"You went to see him. In prison."

"Closer than where you're standing." The missing time came back, flowering in the hollow from when he'd emerged in the visitor's lot. "Nobody else around, not even a guard. Maybe an hour, I can't remember. Wanted me to call him *Dad*, but I wouldn't. When I told about our daughter, and he had this look on his face, like it was a joke he'd planted years ago."

Sera took a seat across the table and rested her hands between them. Not reaching for Lyle, not pulling away. Listening.

"I remember seeing it, his picture, on TV when the news broke. Hers too. I can see her face clearly in my head but I don't remember hearing anything. Like I was doing homework with the sound off, but I know that isn't right. I would have heard her name."

"This isn't helping, Lyle."

"There was a girl, a woman, she worked at this all-night pancake place near my house. Took my order a few times. The night the police came, when the story broke, she was the first one they'd found. Her name was Nadine."

Lyle paused after the cruel punchline but saw no reaction from her. From the floor, Scissors made a noise like a leaking balloon.

"You don't get it?" Lyle said.

"I get it. *Nadine*. Same as our daughter. Are you done?"

"Doesn't that bother you–"

"What bothers me," Sera cut in, "is I came home to find your half of the bathroom sink cleared out. So I looked for your overnight bag, but that was gone–"

"It was spur of the moment. I had to see him. I *had* to."

"So you left a blank sheet of paper in the middle of our bed. Thanks for–" Sera clamped a hand over her mouth, then stood up and left the kitchen. Lyle heard her in the bedroom, sniffing loudly and blowing her nose. She returned with a box of tissues and sat down, wiping her eyes.

She'd been out with Nadine – the park? daycare at the gym? – when Lyle had left in such a hurry. He'd rifled through

his clothes, stuffed his bag, grabbed a sheet of stationary and was scrambling for a pen when the phone rang. Somebody selling newspaper subscriptions. Lyle hung up, remembered his shaving kit, packed it, then ran out the door.

The note had slipped his mind. Not entirely, but what little he had remembered seemed deliberate: a single, empty page in the middle of their bed that said he was either a coward who couldn't be honest, or a monster who left his wife alone to fill that page with her worst fears about him and their marriage.

Raking the candle stump with his finger, fixated on the wax piling beneath his overgrown nail, Lyle let himself detach from the moment. The ringing in his ears drowned out the faint ticking of the clock. His awareness seemed to hover in the air beside himself as though, if he turned, he might see the temple of his glasses, the side of his own head.

"Hey," she said, "you here?"

"Yes." He snapped back into himself, heard the clock ticking again. "I'm here, of course."

"And?"

"And I'm sorry. I know that's not enough, but I mean it."

"I know you do, and no, it's not enough. Nadine's name has nothing to do with this. He was manipulating you, Lyle."

"I know what he was doing."

"You honestly believe he orchestrated all of this to, what, somehow mark his territory in this family? That he *planned* for you – for us – to have a daughter, and then name her after a woman you hardly remember, someone I've never met?"

"*Hardly remember?* Want to know what–"

"No, I want you to quit clinging to this dark secret as an excuse."

"Excuse for what?"

"Disappearing."

"I was gone for *one night*, Sera."

"*Two*. And it's not just the vanishing act. You keep half your life in some underground vault, and don't say it's to protect me."

"But it is, for both of you."

"You're protecting yourself." Sera wiped her eyes again with the heels of her hands but wouldn't look at him.

"Of course I am." Lyle said. "Jesus, I had to leave home and get a new name when I was just a *kid*."

"You were an adult, Lyle. Nobody forced a name change on you."

"No, I wasn't." He rubbed his forehead, wincing as though he felt a migraine coming. "I honked at a cop that night. When I went to mail that letter, I mean. Wanted the postmark to be far away from here. Anyway, guy was just stopped at a green light. I just tapped my horn, is all, to get his attention. Nothing came of it, he just took off. I know, I keep pushing my luck with them. I was thinking about that after he drove away, and I finally got it."

"You're rambling again."

"Every time somebody runs my ID – landlords, employers, banks, the courts – I expect some agents in suits to appear and say, *Can you come with us, please?* But they never do."

"Why would they?"

"And I get the W-2 or the DMV registration, or whatever, that says *Lyle Edison*. And right then, I've escaped. I'm not his son anymore and nothing in the world feels better, *nothing*. So I keep testing it, doing stupid shit, proving to myself I escaped for good."

"Lyle," Sera spoke with a cool, steady voice, "why would *agents* be alerted to your ID?"

"Because," he said, "I wasn't eighteen. The court wouldn't, I mean, I couldn't wait another year. I paid a guy." Lyle clambered through his explanation. The taciturn, red-haired man near the courthouse, the cash transactions, and choosing his last name almost at random.

Across the table, Sera's body slackened as though she'd been unplugged. The more she withdrew, the more Lyle backtracked, piling on details to quell her doubts. But she retreated further,

pulling her hands into her lap, crossing her ankles beneath her chair.

"It's not like I bought a fake ID to buy beer," Lyle said. "This guy was a serious pro. High-end, black market stuff." Right away, he knew that was the wrong choice of words, and backtracked again. "He had a numbering sequence, I guess, birth certificates from some one-horse town. They lost a bunch of records in a fire. See? There's no way to trace anything back. Like a gun without a serial number."

"And that's supposed to reassure me?"

"That's not what I meant. Listen–"

"No, you listen. I took that name. I had to…" she trailed off, then said, "all those forms, that paperwork."

There had been forms upon forms, all with the same blanks to fill yet each somehow longer than the last. There had been waiting rooms and lines where the clocks didn't move, and clerks who demanded her forms and her documents – birth certificate, current ID and marriage license – who always looked dissatisfied but never said so.

"And now," Sera said, "you tell me our marriage is a fraud?"

"Don't lecture me about forms because I *know*. And no, our marriage isn't a fraud. You're overreacting."

"Every time you've filed taxes or renewed your license as *Lyle Edison*, you've committed a felony. You used that name when you were arrested. It's on the insurance claim from your accident, on your credit cards and every single piece of mail. Those are federal offenses, each one, do you understand?"

"If anybody were going to catch on, they would have a long time ago. I'm safe, okay?"

"You're safe? Lyle, you've put all of us in jeopardy. Even without your drug arrest, you're a repeat felon. Every time you use that name, it's a crime, and the more you do it, the closer you get to being caught. What happens to us when you go to prison?"

Sera was right. They had little savings, growing debt and

a newborn daughter. He tried to think through a rough emergency plan, something to put Sera at ease.

"Lyle?"

"Yeah, I know," he said. It meant nothing, just a way to keep her from talking, let him float on a current of thought for a few quiet seconds.

"You know *what*?"

"I was almost killed, remember?" He snapped at her. There would be no floating, no quiet. "Was a matter of time before someone burned our house down, *with me inside.* So forgive me for not thinking of my future wife and child when I was seventeen."

"With you inside," Sera said. "I'm sure your mother would have been fine."

Lyle couldn't think of a response that didn't end everything right then and there, so he kept his mouth shut.

Scissors made another seeping noise of pain, quieter than the last, but longer.

"Can you do something about him, please?" Sera said. "He's in pain." She stood, walked to the bedroom and closed the door.

SCARECROWS

Scissors didn't fight when he saw the mesh carrier. As a kitten he'd drawn blood, thrashing like a hooked fish and defying physics to make a zippered opening three times his size insufficient for Lyle to force him through, protesting the impending checkup or a few ear drops with a hiss like a butane torch. The old cat was quiet this time.

Lyle held him while the vet tapped his withered foreleg with a syringe and slowly pushed the plunger through the barrel. Lyle ran his thumb back and forth between the cat's ears, waiting for Scissors to further subside in his lap. The vet withdrew the syringe and dropped it through the lobster-trap opening atop a red biobucket.

"How long?" Lyle said.

"That's it." The vet peeled off his gloves and tossed them into a knee-high waste pail. "Take a minute with him, if you want, but he'll evacuate very soon." The vet washed his hands and left. Lyle sat for a moment before an accurate understanding of *evacuate* dawned on him, then lifted Scissors from his lap and rested him on the metal examination table.

Scissors used to fine-tune his position whenever Lyle moved him from atop the newspaper or from a kitchen chair. He would stand and stretch, settle onto his opposite side or shift his haunches and tuck his tail beneath his hind legs. But the black sack of bones before Lyle sank to the table like a

238

plastic bag of food scraps. No internal symmetry or cohesion. Tail draped over the edge, the eyes and mouth open to slits. It bore no resemblance to the feral cat Lyle and Sera had found wandering in the wild, hungry and cold but alert.

Lyle waited for some feeling of sadness or loss to ebb through him like the delayed effect of some pill and it occurred to him then why Sera might be angry.

~

The line ran halfway down the block, a clear sign the city had cast its net for a fresh pool of potential jurors. Lyle took his place among them and the others, the civilians appearing for misdemeanor offenses, traffic fines, parole appointments, divorce and child custody hearings, all shuffling toward the security check. Most of them carried an envelope or loose document whose letterhead revealed their business: JURY SUMMONS; PROBATION DEPARTMENT; RED LIGHT ENFORCEMENT DIVISION.

A deputy shouted, "Belts, keys, change and sunglasses in the plastic bins. Purses, bags, backpacks and briefcases flat on the belt."

The young men in front of Lyle wore their jeans in low-slung street fashion and compensated for the exposure with t-shirts and numbered jerseys like small tents. One of them removed a belt that served no apparent purpose, cinched the front of his pants in one fist and waddled like a penguin through the metal detectors.

A deputy iterated the checklist to anyone who triggered the alarm. "Belt, keys, loose change, sunglasses. Okay, go back and step through once more, please."

Some people got the wand, others were waved through. Penguins always got the wand. Lyle emptied his pockets and stepped through the security gates. The alarm beeped.

"It's my boots," he said.

"The machine tells me, not you."

His shoulder patch read CADET. He was ten years younger than Lyle and like most of them working security detail was under the supervision of the actual deputies. He instructed Lyle to walk through the metal detectors again, and once more Lyle tripped the alarm.

"I'm telling you, it's my boots. Happens every time."

"And I said the machine tells me, not you. Now, do you have any metal in your pockets?"

"Doesn't the machine tell you?"

"Lift your pant leg." The cadet's voice was louder each time he addressed Lyle. "Now the other leg," he said, then crouched and gripped each of Lyle's ankles like a fireman's pole, then waved Lyle through.

Lyle laughed softly and collected his belongings from the X-ray bin.

"Something funny, sir?" said the cadet.

"Yes," Lyle said, and walked away.

He strode through the fourth floor like he worked there. Work pants and dress jacket, tie loose already, working on a cup of tea from the lobby snack shop. He knew most everyone's name whom he passed. Officers Berenbaum, J., Saenger, J., and McNellis, R., among others on the phone or hunched over a departmental form. He nodded to those who made eye contact, as though they had a professional acquaintance on a common side of the legal wall. Most nodded back, something Lyle discovered the first time he'd met with Reid on the same day he'd come from a hearing, so he'd worn a tie to the department ever since.

He took a seat at Reid's empty desk, traced the sweep of the second hand for two laps around the wall clock, then dropped his teabag into the trash. He gauged the distance between his chair and Reid's to be the same he'd sat from his father twenty-four hours prior. Reid's chair was highbacked and cushioned with imitation leather and pushed back from the desk to reveal the wedge of foam for Reid's lumbar support, strapped in place with an elastic band. The surfeit of paperwork across the

Probation Department desks was by all evidence organized by routine flash floods. Officer Nestor Reid's desk had once been the conspicuous exception during Lyle's early appointments. No family photos, children's drawings or political cartoon clippings. A virtual scale model of the Bonneville Flats. The telephone, Rolodex and file stands, the near-empty inbox above an overstuffed outbox all at right angles around a barren, white blotter. Reid's only personal effects had been the exercise grips near the pencil holder, but a bottle of antacid tablets had taken their place some time ago. The paper load now favored the inbox and the disorder suggested the desk itself had been moving at high speed and come to a sudden dead stop.

"Mr Edison."

"Officer Reid."

Reid took his chair, made a show of checking his watch and giving Lyle a few seconds of deadeye. He opened a legal pad to a blank sheet and filled in the top three lines before speaking again.

"Mind telling me where you been?" he said.

"Did I miss a screening?"

"Didn't say you missed a screening, I asked where you were all day yesterday. Thought I made it clear how much I hate making the same phone call twice."

Lyle was at a loss to recall when Reid had ever made such a thing clear.

"I took a couple days off from work," Lyle said.

"And what did you do on these couple days off? Without that girlfriend of yours? Got something on the side?"

Without that girlfriend of yours. A salvo of questions, intimidation, innuendo and accusation together meant to put Lyle on the defensive because defensive people talked too much for their own good.

"No, sir," said Lyle.

Reid didn't know whether or not Lyle was with Sera until Lyle confirmed or denied it.

"This time off, it involve drinking or smoking anything I ought to be aware of?"

"No, sir."

Reid opened a drawer, took out a plastic specimen jar and broke the shrink wrap, wrote Lyle's name and case number across the face.

"The human body don't lie," he said. "Don't get up just yet. Still need to know where you were all yesterday and last night."

"Driving."

"Another delivery? You back in business?"

"Was never in business."

"Course not. That's why you're here, all that volunteer work you do at the church. Helping the homeless."

A rumpled grocery bag sat atop the file cabinet behind Reid, the cabinet's middle drawer two inches ajar with a small key still in the lock. The phone rang. Reid answered, grunted *yes* or *no* for a minute-long conversation, then hung up. He swiveled his chair back toward Lyle, then folded his hands across his belly.

"What happens," he said, "I get some jack-off like you, maybe not exactly, but whatever. Most of you are unrepentant fuckups. Blow a piss test or get caught with rock, miss an appointment or something, get bounced from probation to the work farm. I don't give a shit, plenty of losers waiting for that chair where you're sitting. Rest of you keep your nose clean, especially after you've met me. Happens is, after maybe a year, and I got me a whole new freshman class of shitheads to babysit, rest of you think you can slide. Like I'm not watching you the way I started out. But I am, believe you me. And it's right about the home stretch one of you thinks you can slip something by me. Like you here, right now. Looks like maybe you'll be finishing your time in jail."

"And why would I be in jail?"

"Because you gave me a bad sample. Because I tore that

truck of yours apart, down to the chassis, found something I wasn't supposed to. Because nobody's ever been given house arrest on my watch."

Lyle held Reid's stare and didn't respond.

"I know people, Mr Edison. Especially people like you, the position you're in. You're keeping your nose clean, sure. But you knocked up your girlfriend and now you're a daddy. You're trapped and it's all starting to get to you. You just had to blow off some steam. Means I'm likely to find something wrong with whatever you bring me back."

Reid nodded toward the specimen jar.

"Or maybe not," he said. "Maybe you were just driving, like you said. Got a room for the night, away from that girlfriend of yours and the rug rat. You want to play it hard, suit yourself. Your girlfriend won't have that option."

"We're married now," said Lyle. "She doesn't have to talk to anyone."

"What else, is I can run your credit cards. You got a room, something to eat, filled your tank, right? Had to, gone all that time. Anything comes back, any transaction proves you crossed the county line without my say so, you are fucked, son. You understand me?"

"I understand."

"Same for parking tickets or traffic cameras. Better pray you didn't get busted speeding because I'll find out if you did. Even inside the county lines, that fucks you. Inside or outside of the county, you are fucked. Now, anything you want to tell me?"

"No, sir."

Reid's eyes hardened. He waited. It was the very sort of silence Reid conducted for sustained discomfort. Fifteen, twenty seconds of squirming before Lyle felt he had to stammer something, anything, to make it go away. Phones rang in the background, sirens and traffic noises sounded from the street below. Lyle mentally erased the file cabinets and bulletin boards, the checkered linoleum worn through to concrete at

the doorways and water cooler. But he kept his mouth shut, stared back at his probation officer who was so much larger in Lyle's memory than in person. The set of Reid's jaw had dampened with age and his crosshair gaze had regressed to that of a man struggling to stay awake. After sitting face-to-face with a killer, Lyle saw nothing to fear about Reid. The silent stare from an embittered, overworked civil servant was far from that of a man who'd spent a lifetime not feeling anything for anyone. A man who didn't like you, who wanted answers from you and resented you for making him ask versus a man who fathered you but cared no more or less about you than anyone else, which was not at all.

Lyle Edison had spent the night tracking the hours on the motel's clock radio, a spindle of white-on-black numbers dropping forward with each new minute. The departure times at the bus station when he'd left home had done the same but faster, hundreds of rotating shingles rattling like poker chips, dozens of times and places changing in unison as though the trains and buses were time traveling. But the luminous clock numbers in his room at the Hotel Firebird had seemed frozen in amber along with any chance of sleep and Lyle had spent the following night racing the sunrise back to the county line. Now the overlapping voices, the clamor of the garbage truck outside and every other sound was cast against the steady distress signal backdrop in Lyle's ears.

He stifled a yawn but another immediately followed. His vision blurred and he dug the heels of his hands into his watery eyes. Lyle yawned again, then reached for the specimen jar and uncapped it. He stood up, unbuckled his pants and filled the jar, pissing directly in front of Reid's eye level. He re-capped it, set it on the blotter and buckled up.

"Let me know if you find anything," he said. "Now, am I free to go?"

~

The bedroom door was still closed when he returned home a few minutes before noon. Scissors's food and water bowls underscored the charged silence as though Lyle were standing in the vestibule of an armed bank vault. He set his keys down gently, took his boots off and lit a burner beneath the kettle.

They called it the mystery drawer, at the far right-hand end of the counter closest to the table. Coupons for pizza and Chinese delivery a year expired. Matchbooks, key fobs, loose pennies, thumbtacks and paperclips. A roll of tape, a box cutter, a tube of glue and an assortment of dried pens and broken pencils. Lyle had never once found a pen in the mystery drawer that worked, but no matter how many he threw out, the others underwent some sort of mitosis beneath the out-of-date catalogues and circulars for missing children. *Have you seen me? Jeremy Tabler, 4'8", Blond Hair, Blue Eyes; last seen wearing a grey sweatshirt, jeans and red Converse All-Stars. Show this flyer for a 10% discount from All City Steam Carpet Cleaning until June 1st.* A digital watch, a pocket calculator, a locked padlock with no key and one to three of each kind of battery from D to AAA, plus a single nine-volt.

"It's a pan-geolocational archive," Lyle once said. "Alien technology, highly advanced. A single repository for the most common specimens of junk from daily human life."

Sera had rolled her eyes, but still he'd made her smile.

"Seriously. That's why there's one in every house. Have you honestly never lived someplace where a kitchen drawer full of useless crap didn't spontaneously appear without anyone ever knowing when?"

"And why would an advanced race of aliens build millions of identical drawers full of useless crap?"

"No, that's the brilliant part. There's only one drawer existing simultaneously in a million different places. Like an electron. That's why things keep disappearing from it. You go looking for the tape measure or clothespin you know was in there last time, but now it's gone."

"Because someone took it from another drawer."

"Heisenberg's principle in action. Just by opening the drawer and looking in, you interfere with its behavior."

The kettle whimpered. Lyle switched off the gas, mindful of his presence still unacknowledged by either him or his wife since his return. He considered the odds of a night on the couch, alone. There were extra blankets in the front closet, but unless he wanted to take a leak off the balcony, he'd need to open the bedroom door at some point.

He filled a coffee cup and left a bag of black tea to steep while he went back to the drawer and retrieved the one key he needed from among the rings of strays that went to unknown doors and locks. He'd made the joke about the drawer a long time ago, too far back to remember exactly when but he did know it was the last time he'd made Sera laugh.

He'd sat eye to eye with his father, alone and with no barrier between them, their knees within two feet of touching. He'd held his ground beyond defiance with his probation officer as he had with other cops over the years, throwing his *Lyle Edison* identity into the crucible time and again for the rush of seeing it tumble out unscathed, cool to the touch. The hollow of forgotten years with his birth name had finally begun to collapse beneath the accumulated years as Lyle Edison. Facts, dates, events and his imperfect recollections of them mingling through the cracks.

So the thoughts began thinking themselves: Is this what it's like to be old? So demented you remember things you didn't do? Things like leaving a note for your wife when in fact all you left her was the thought that she'd been abandoned with her infant child? That her worst fears about the man she loved had been true from the beginning?

Lyle dumped three scoops of sugar into his tea and then retrieved the fire box from beneath the couch, unlocked it at the kitchen table. Their marriage license, Nadine's birth certificate, along with his and Sera's. The three birth certificates

were distinct products of their times and places but with similar courtly detail. Gothic lettering, lace etched into the borders and civic seals. Sera's passport was stamped with visas from Heathrow, Schiphol, de Gaulle, Milan and the most recent from Singapore, her last trip before she'd met Lyle. His own passport was expired. And blank. He left Sera's documents along with Nadine's birth certificate and the rest he spread across the table. His own birth certificate, his social security card and a small stack of expired driver licenses held together with an elastic band. His arrest report and probation agreement with his lawyer's business card clipped to the front. The lease to their apartment, the title to his truck and its insurance papers.

The sudden stricture in his throat left him holding a mouthful of tea and unable to breathe through his nose. He spat the tea back into his cup and when he inhaled it was like a rush of hot air over a waning fire. His throat tightened further and the pressure from behind his eyes dissolved the grid of documents before him into a warm haze. He held his breath, took off his glasses and wiped his forearm across his eyes. For a moment he saw clearly enough to stand and step into the kitchen but then was blind again, groping for a dishtowel where he could bury his face and stifle his ravenous breathing.

Lyle rinsed his face over the sink. He blew his nose with a paper towel, dried his face and hands on a clean dishrag, then looked about for his glasses, still moving quietly. Nadine was asleep, just as when he'd arrived that morning. Since her birth, hardly a day had passed without her mouth dampening his shoulder and her fingers clamped to his shirt. The top of her head, warm and downy with the first wisps of her mother's hair, brushing against his lips. She would have been in her bed earlier when he dressed for his meeting with Reid but he hadn't stopped to look before he left. He hadn't seen his daughter, asleep or awake, for two days, maybe more.

He found his glasses and returned to the documents spread gridwise on the kitchen table, his reasons for the survey unclear

even to himself. They ratified and certified a handful of facts –
names and dates, mostly – the forgeries indistinguishable from
the authentic. A slip of paper lay half-crushed among them,
something from when he'd emptied his pockets. He smoothed
it flat for a quick look before he tossed it, a receipt for a tank of
gas and a box of caffeine pills, stamped EDISON, L., with the last
four digits of his account number along with the time, date and
location of his pit stop early that morning. He'd been too sleep-
deprived to think twice about swiping his card and tagging his
location. He'd left proof of leaving the state and to Nestor Reid,
that was the same as fleeing probation.

VICIOUS CIRCLE

Holding Lyle in her arms one night years before, Sera told herself that it wasn't too late. They'd been together only a short while and the attachments were fresh, more than skin deep but still without roots. They could be cut with little effort, not leaving her heart choked in a thicket of memories and resentments that took twice as long to die as they did to grow.

Lyle grinned, the slightest shadow in the curve of his mouth, invisible in a sudden wash of television light, then altogether gone once he'd drifted past the shallow end of sleep. Sera studied his face while he slept in her arms and she let the roots grow.

She'd gone to Europe the summer after she'd finished college. On a train from Amsterdam to Paris, a man with a newspaper seated across the aisle had stared at her for the entire ride. He'd boarded with her at Schiphol and during the four-hour trip he never turned the page and Sera never closed her eyes.

Up the concourse at Gare du Nord, young men approached her with offers in broken English to carry her backpack or buy her a drink, sometimes both. Each time she politely declined and each time their chivalry vanished.

In a taxi queue outside Gare du Nord, two blood-eyed college boys reeking of liquor propositioned her in English, shared private jokes with each other in French, then resumed in English their attempts to woo her. Their friendly invitations

turned to friendly imperatives, then to demands that she justify her refusals. One of them took her elbow but she shook him off, then took her bag and left.

The taxi she hailed on a narrow street a few blocks away turned out to be an unlicensed gypsy cab who sped away with her bag in the trunk, and while speaking to an agent at the nearby *commissariat* Sera discovered her passport and traveler's checks were missing from her coat pocket. She still had some cash and her credit cards, but the youth hostel wouldn't honor her booking without a passport. They referred her to a small hotel whose proprietor wasn't as particular. She paid twice the normal rate for a room with heat and a private bath, and in return received a view of the neighboring roofline, a bar of soap atop a stiff towel folded at the foot of a salvaged hospital bed, and the proprietor's total lack of questions or scrutiny.

Sera faxed the police report and stolen check numbers to American Express twice, and was repeatedly questioned by embassy officials about the theft of her passport. When they pronounced the word *stolen*, she could hear the quotation marks.

She waited for three days in a place she didn't belong but that wouldn't allow her to leave, with nothing but the clothes on her back and a phrase book for a language she didn't speak, alone but afraid to leave the room she could barely afford, unable to prove she was who she said she was, and no one to believe her.

From the hotel lobby, she phoned her old roommate, who offered to wire her money. Sera declined. She didn't need money, but her friend insisted.

"It's just..." Sera stopped. The relief of hearing a familiar voice was overwhelming. She said, "I feel like a ghost."

~

Sera sat, knees to her chin and arms wrapped around her shins, with Nadine asleep beside her on the bed she shared with the

man she'd married. The bedroom was somehow different. Not smaller or darker, not different in any way she could name but it brought back the memory of that room in Paris. The closet door was open a crack, and through it she spied the frayed and faded cuff of an old denim jacket.

Is that mine or his?

And with that, the strangeness of the room named itself: *borrowed*. The room was borrowed and her stay was temporary. She was obliged to repay the kindness by respecting the occupant's privacy and leaving as few traces of her daily presence as possible.

The bedroom door opened and her husband came in. She didn't look at him. He walked past her to the bathroom and shut the door gently. She heard the toilet, the sink, then a pause that was a shade too long for a man just drying his hands, before her husband came out again and stood by their bed. Perhaps he was considering the baby, not sitting so as not to disturb her. No telling. But he was mustering his nerve to say something, an apology, maybe, she couldn't be certain, any more than she could be certain of what she wanted to hear. She still couldn't look at him yet wanted him beside her even if she might stiffen at his touch, this man she so profoundly loved who presented to her only those parts of himself he deemed lovable. This man who claimed to love her back with everything he was, including what he hid from her. She had changed the course of her life to be with him, but she was measured against his secrets instead of by her actions. And she was exhausted with all of it.

Her husband said, "I owe you more than just one apology right now. But I can't think where to begin."

Her vision blurred but she didn't move. As long as he didn't reach for her, she could hold herself together. As long as he didn't touch her – she loved his hands – and she didn't have to pull away, she could listen to him and not lose herself. Maybe the baby would wake up and then he would have to talk about this later.

"But I will," he said. "I promise, I will. Just as soon as I can."

She'd been biting her lip and now she stopped. The heat left her eyes and she looked up at him, waited for the rest.

"I fucked up," he said.

She waited while her husband pieced together an explanation that collapsed in his mind before he spoke it.

"Reid knows you broke probation," she said.

"Sera, please. I didn't say anything, not a word. He brought me in to lean on me, let me know he's still around, still on me."

"But you haven't missed any appointments or failed a single drug test."

Nadine stirred, then was still again.

"I used a credit card," he said. "On my way back this morning, while I was outside the state. There's a record of the transaction, down to the minute. My face too, on a security camera at the gas station, probably."

She saw everything on his face. Running the scenarios, extrapolating possible outcomes from every imaginable circumstance, and they all ended with him in jail. They all ended with *him*. Her heart ached for him but that ache faded with each second he said nothing about their daughter.

"How much longer? On your sentence?"

"Six months."

"Only way he could find out about the gas station is if he runs a credit check. Can he do that? Legally?"

"I think so. Doesn't matter. It would take longer than my remaining sentence to fight it. System works like that."

"He brought you in, you said. To show you he's still watching."

"Yeah."

Sera stood. She picked up the empty diaper bag and thrust it at Lyle, almost punching his chest. She opened the closet and as she took her bags from the shelf a precognition seized her, the warning flare of what she could still avoid: the shotgun

newlyweds arguing over the noise of a crying baby while the angry bride stuffed her suitcase. She set her bags on the floor so as not to roust Nadine, then began packing.

"You can't be serious," Lyle said.

"Lower your voice."

"Sera, I might be looking at six months, here. In *jail*."

"I know, Lyle, and I may not act like it right now, but that is the last thing on earth I want for you. But I'm thinking about our infant daughter."

"Worst case, Sera, you can sell the truck. That's plenty to live on, and they can't evict you sooner than thirty days, and you can fight that, no problem. Make it sixty, at least."

"And what about Child Services?" she said. "They come here and take Nadine, pending, what, who knows, pending a mountain of paperwork and pleading to case workers and judges and every day we don't know where she is. And every day she's gone makes it harder to get her back."

"You think Reid's going to call CPS out of pure spite?"

"You know him better than I do, Lyle."

"I really don't think he'd take it that far."

"You don't *think*." Sera pointed to Nadine, asleep on her blanket. "You willing to risk her because you *don't think he'd take it that far?*" She turned away and resumed packing.

"Take the truck." Lyle took off his glasses and wiped his eyes. "Our checkbook, too."

Sera pushed down on a duffel bag with her fist, fought with the zipper.

"You should probably go someplace–"

"I'll figure it out," she said.

Time

BLACK TELEPHONES

The more heated their argument, the colder the silence that followed. Lyle would avoid Sera out of resentment or sometimes caution, and their living space shrank further. A reminder of how far short he was in providing for his wife and child. He would wait for Sera to fall asleep before he settled beside her. If she were awake, they would each be too stubborn to speak first and would lay apart with their backs to each other and listen to the clock. So, Sera would close the bedroom door behind her and Lyle watched television or played music with the volume low until he heard the last of her moving about. Flushing the toilet, running the sink after she brushed her teeth. The closet door sliding open and shut.

When he was younger, those same sounds had come from the far end of the house after his father was gone. He never spoke to his mother because he never saw more than her sleeping form beneath the sheets, her arm or sometimes her leg spread across the empty space of her bed. He only heard the sounds of running water, cabinets creaking open and drawers knocking shut at odd hours of the night.

If he was supposed to be a man, then with his father in jail, he was the man of the house. He was supposed to look after his mother but she was a ghost. He kept the refrigerator stocked and the power on and waited for his mother to come back to life and tell him everything would be okay. He waited at

home while she slept, waited with the lights off and the phone unplugged, waited in the hospital lobby after being bandaged and stitched for her to come bring him home. He was waiting for a ghost, with nobody to wait on him. When he looked back, that's what made leaving home so easy.

Lyle carried Sera's bags down and Sera carried Nadine. He told Sera to get a motel room, show her ID and pay cash. To not call home, no matter what. Call Carla, and Ray could deliver the message. Sera started the engine while Lyle was still talking. She wiped one eye and drove up the ramp and into the street.

Lyle wrapped the remaining cat litter, box and all, into a contractor bag. A bowl of water skinned with dust and lint, another crusted with canned food. He trashed those as well, then shut off the lights, closed the windows and curtains, deadbolted the front door and fixed the chain. Quiet. Grey light suspended in the air, cast from nowhere. Walls, floors and furniture the color of ash. Maybe now he could sleep.

He lay in the dark and traced a crack in the ceiling – more unrepaired quake damage – hoping the phone would ring yet hoping it wouldn't. He was still wearing the dress shirt and tie from his meeting with Reid. He changed, brushed his teeth, then took a walk. There was a meeting that night. Ray would be there, but it would be wrapped up by the time Lyle figured out the bus route. He passed bars and movie theaters and waited for a plan to crystallize but none did. Reid would either find out soon or not at all, come knocking immediately if he did and maybe, if Sera was right, call Child Services out of spite. There was no plan to be had, otherwise.

The alarm woke him at seven. He called work and said he needed another couple of days, said he had a family emergency. He brewed a cup of sweet tea and took it with him on another long walk. Ray or Carla hadn't called to say they'd heard from Sera or that she was with them. Sera hadn't called to say where she was or that Child Services had found her and taken Nadine. Reid hadn't come knocking, and nobody from work

had said there was somebody looking for him. He'd phone Ray when he returned home, find Sera and ask her to come back. Ride out the rest of his probation and apologize to Sera for everything, all of it, leaving no more secrets.

~

The business card wedged into the front-door jamb bore the County seal and said Division of Child Protective Services below the agent's name. He'd missed the agent by minutes, so Reid could be en route himself or sending uniforms.

The answering machine was empty. Lyle walked a quick lap through the complex and picked up the first daily paper he found still unclaimed. Back inside – deadbolt, chain – he peeled apart the local news section where health code violations and outstanding warrants were published in the back pages and scanning the second column of names he found, Edison, Lyle with Violation of Probation Agreement listed beside it.

Six months in jail. No hearing, no appeal. No income and most likely no job when he got out. Sera on her own with Nadine until then. She could sell the truck, buy something cheaper. Ray could help her unload his record collection and the landlord could keep their deposit.

Lyle distracted himself for a while, enjoyed a feeling of normal routine while he could. He put on Earl Hooker while he did the remaining dishes and took out the trash. He emptied the refrigerator, unplugged it and propped the door open, snuffed the pilots on the stove and water heater, shut off the gas lines. He took his time changing. Whatever he was arrested in would be what he wore on his release. He considered the weather and not getting stared at when he boarded public transit near the jail. He tucked his ID and two $20.00 bills into his pocket, dropped his wallet into the firebox of documents along with his watch, ID bracelet, spare glasses and whatever jewelry Sera had left behind. He

added the firebox key to his keyring, which he'd leave with the building manager along with written permission to hand them over to Ray or Carla.

Every minute he wasn't in jail was a chance for his plates to be flagged and Sera pulled over. For the uniforms to know CPS was looking for Nadine seemed like a longshot. But still. He picked up the phone and dialed Ray's shop. Someone answered, shouted Ray's name and set the phone down. After a minute, Ray came on the line.

"Who's this?" Ray never answered with *hello*.

"It's Lyle. I'm – Listen, Ray, I have to go in." Machinery droned in the background. The scream of saws and drills and metal on metal. Lyle imagined Ray at the phone, his finger jammed into his empty ear. "Wait, have you heard from Sera? Is she okay? Or do you, sorry, I'm not thinking straight. I should have asked about her and Nadine first."

"This morning," Ray said. "Carla spoke to her. She's fine, least as much as she's got your little girl. She'll be at our place tonight, after Carla's shift."

There was nothing different about Ray's voice, a low growl that he preferred to keep clear of phone lines and recording devices. The condemnation Lyle heard came from his own mind, not from Ray.

"What about this *going in* business?" Ray said. "Only heard pieces, but sounds like you're jumping at shadows. Didn't know you better, I'd say you might want to back off the crank."

"Wish you were right. But CPS was by the place earlier. I was out, but they left a card."

"You don't think maybe it was a routine welfare check?"

"No. My PO ratted me out. There's a warrant on me, saw it in the paper this morning. So I'm going to finish my stint in County. Sera can give you the details."

"Do what I can to help you, brother, you know that. Can't see the rush, though. Figured you be happy to let them do the legwork."

"Anybody runs my truck plates, they'll pull Sera over. I can't have that."

"Like a couple of uniforms are going to know to hand your little girl over? You think too much of the authorities. Last thing I figured you for, thinking they got any kind of act together. When's the last time you saw all four hubcaps on a squad car?"

"I hear you, but I won't risk it. I go in, they stop looking for me. Sera can walk across town with Nadine in a stroller and not have to worry."

"How much time you got left?"

"Six months."

"You can do it. Make all this bullshit a thing of the past, once and for all."

"Don't think I can."

"Don't see where you got much choice here."

"I'll figure something out."

"Word is you keep saying that."

"Yeah, I know. Listen, Ray, I'm leaving the keys to our place with the building manager. He knows Sera, but I'll give him your name and Carla's. Also has the key to the lockbox on my ring, for the valuables. Sera knows where it is."

"Hey, brother, forget that stuff. We'll get your ladies settled in, then I'll come see you after, soon as I can. Meantime, keep your head low. There's a meeting at the jail. Not sure what day, but I know the guy. I'll get him word, so you got someone to cushion your landing. Wear a good pair of boots, nothing steel-toed. They usually let you hang onto them, save you wearing those shitty canvas slippers. Make sure you got extra glasses."

"Thanks, man."

"Love you, brother."

"Love you back."

Lyle hung up. He couldn't recall his parting words with Sera, but they hadn't been *I love you*.

He stopped at the Puerto Rican bistro where they'd held their wedding reception. Sera could be driving somewhere,

and a delay put her and Nadine at risk. But he'd eaten jailhouse food before and figured he'd be dropping a lot of weight in the coming months. He took a seat at the counter, ordered a plate of black beans and fried plantains with a limeade and paid up front. His food arrived and he ate as though ravenous and was still wiping his mouth on his way out.

The sign outside Ford's said MOTORCYCLE PARKING ONLY, but there wasn't a bike to be seen. No light inside but for a row of neglected transom windows and a television. A few afternoon drinkers sank their elbows into the bar, upholstered as it was in blood-red at its lip and cut with knives or burned with cigarettes and patched with bumper stickers. They stared silently up at the television or down into their glasses like swimmers half-asleep at a pool's edge. Lyle could count two or three unfinished beers to his name, maybe a half-dozen sugary holiday drinks over the years, the kind he knew better than to ask for at a place like Ford's. He'd intended to save his remaining cash for bus fare when he was released, but he reckoned that was admitting he didn't expect to find Sera waiting.

"Help you?" The bar man dropped a coaster down, kept one eye on the game overhead.

"Um, whiskey. Thanks."

The bar man stared back for a beat. "Okay?" he said, dragging it out, waiting for something.

Lyle imagined those sleepy drunks were now awake and staring at him. He said, "Whiskey, *please*."

The bar man chuckled and said, "You got it."

Rows of bottles behind him but the bar man reached for somewhere down near the sink. Lyle figured out the awkward pause right then, that he hadn't named his whiskey. He wouldn't have known. The bar man slid a shot glass his way.

"Whiskey," he said. Louder than voice level, like talking to a foreign tourist.

Lyle knocked it back like he'd seen people do with shots and felt his face twist, his eyes go water-blind and his throat

catch fire. He set the glass down, almost missing the bar, and it rolled away on its side while the bar man laughed so hard he was almost silent. Lyle dropped his remaining cash onto the padded rail and left, walking eight blocks to the police substation without throwing up.

"What can I do for you?" The desk sergeant looked familiar. Hundreds of slack-eyed faces behind government desks had blurred together over the years and everyone under humming lights inside yellow walls looked the same to Lyle.

"I've got… There's a warrant for me. *Lyle Edison*. I figured I should come here, to you guys."

He'd left their apartment almost an hour earlier. The fugitive's reception in his imagination had since metastasized from a lone officer's terse command – *Stand up and face the wall, hands on top of your head* – to a whole squad with their guns drawn while he lay face down on the linoleum. But he was calm, grateful for the whiskey in his blood.

"Last name, again?"

"Edison. First name, Lyle."

"I asked for your last name." The sergeant's voice stiffened.

That's more like it, Lyle thought. Control the situation. Keep your suspect in line.

"Excuse me," he said. "Edison. Sir."

"First name *Lyle*, that correct?"

"Yes, sir."

The desk sergeant typed with two fingers as though the department had been issued Cyrillic keyboards that morning, then he stopped and stared at his monitor for a leaden moment.

"All right." He pointed to a row of plastic chairs. "Sit down. Somebody will be right with you."

The floating sensation from the whiskey had faded before anyone came for him. He waited, uncuffed and unwatched, and reconsidered how his father was able to do so much for so long.

"Lyle Edison?" A patrolman who looked too old and too out of shape to still be in uniform stood before him.

"I'm Lyle."

"This way. Walk ahead of me. When we get through that door, keep your eyes front and follow the yellow line."

No cuffs, just a hand on Lyle's shoulder as they walked. The officer took another set of prints and snapped a single Polaroid, then recited a checklist of questions to which Lyle replied *no* to every one.

Are you a member of or affiliated with a street gang or criminal organization? Do you have any enemies that you know of? Has anyone threatened you? Do you have any reason to believe someone might want to harm you? Do you wish to harm yourself, or think you may wish to harm yourself in the future? Do you have any medical needs such as diabetes or epilepsy? Are you injured or in need of medical attention at this moment? Do you speak any language other than English?

The absurdity of the interview struck Lyle as one of Reid's scare tactics, his PO desperate to see if Lyle gave anything up. Lyle imagined stopping back at the Puerto Rican place that same evening before knocking on Ray and Carla's door with takeout for everyone. He and Sera would talk and he would hold his daughter again.

"Okay." The officer set his clipboard down, handed Lyle a large envelope that read INMATE PROPERTY. "Remove your belt and empty your pockets on the table."

~

A dozen inmates lined up beside the idling Sheriff's Department shuttle, a reconditioned school bus with steel mesh covering the windows. They still wore their street clothes but their hands were cuffed to waist chains, which served the gangbangers to keep their pants up and not look like penguins. Whether they were actually gang members at all, or siblings, distant relatives, from the same block or just had common friends, they clearly considered themselves a unit. They spoke a hybrid of Spanish

and coded slang or threw hip-level hand signals to each other, their fingers splayed and crossed into shapes that were meaningless to Lyle but significant enough to flash only when the deputies weren't looking. They ranged in age from twenty to forty, with nicknames more cartoonish than menacing but Lyle didn't care to sort further specifics. Staring invited trouble that would make his six months very painful or very short.

He was one of five white men in the group. The other man his age was undoubtedly indigent and Lyle reckoned the man's 5150 had slipped through the cracks along the way and not for the first time. Skin sagged around his wiry muscles. Scabs on his elbows and face. He muttered along with whatever alien transmissions he'd tapped into and looked about with eyes like black, humming marbles. Something had long ago bypassed his higher wiring. Dashboard impact or his old man's backhand, power lines or paint thinner or aliens had patched him straight into his own brain stem and left him there.

A pair of twenty-something skate punks wore haircuts that made Lyle feel old. One sported baby fine blowfish spikes tinted green, the other had dyed black flaps wilting asymmetrically into his face. Both wore their sides and back buzzed short, with oddly shaved patches like surgery prep unfinished. They threw chin juts to the gangbangers and prefaced everything with, *Yo, homie*, and conducted themselves as though they were street-toughened through hip-hop videos but came from rich lawyer parents. The pair likely imagined jail would be like high school. The other young man was alone and kept his face down, a trembling bird of a boy without a mark on him or any illusions about his destination.

Ray had said, *Keep your head low*. Lyle stared ahead, locked on to the Central or South American flag tattooed on an inmate's bare skull, but his senses were juiced to full wattage, recording everything at triple speed. This unchecked rubbernecking was a liability. Eye contact with the white inmates was equally hazardous, as any mistaken solidarity with Bird Boy or the

skate punks would number his days accordingly. And chances were good the mumbling drifter suffered visions of God or cluster headaches he blamed on radio implants. He'd have a much looser trigger pull for eye contact with suspected agents, plus a freakish tolerance for stun batons.

The inmates boarded the bus and the deputies cuffed their wrists to the U-bolts welded between their knees. His seatmate dug a hard elbow into Lyle's bicep and said, "Cochón."

Lyle turned slowly to the young Latino man beside him. Crew cut with a wispy mustache and goatee. No lines or teardrop tattoos on his face, his wide, brown, doe eyes softening his gangster staredown. No question the kid could drop Lyle in a second and probably would for sport, first chance that came along. But his hardened brows and faint smirk, everything about the set of his face was at the mercy of Lyle's reaction, the approval of his buddies, his *rep* according to everyone else. He was dangerous indeed, had long ago tempered those emotions the streets considered weak but still remained a species removed from Lyle's father, whose expressions were hooked to no outside opinions and had no feelings of his own to temper, only those of others to observe and imitate.

Lyle looked away and his seatmate left him alone.

~

Ray sat on the opposite side of the glass partition, his eyes on the exit door and for a moment he was oblivious to Lyle. Then he turned and picked up his handset and Lyle did the same.

"What put that grin on your face?" Ray's mouth moved but his words came through a narrow tunnel of static in Lyle's ear.

"Didn't realize I was grinning," Lyle said. "It's just, I sat face to face with a killer the other day. Had us in the same room, no guard. But you're behind glass."

"Other way around," said Ray.

"Yeah, right." Lyle paused and said, "They just took me

in. I sat in the substation lobby for a long time after the desk sergeant looked up my warrant. Could have walked right out. Then they just took me in and booked me, like I'd interrupted their card game or something."

"Expected them to thank you?"

"No," he said. "Just, I don't know. How's Sera and Nadine?"

"Little girl is pure sunshine. Sera's as hollowed out and pissed off as I've seen anyone in a long time."

"You come here to give me shit, Ray?"

"You asked how your wife and daughter were doing. I told you. You want me to say they're fine, then all right, I could have saved myself the bus fare."

"Ray, I'm sorry. I didn't–"

"Hey, Lyle. Suck it up. Not here. Save it for when they hand you a fruit basket and show you the gates. For now, you're still a fish. Don't go thinking yourself any smaller."

Lyle nodded. "Sera talk to you?"

"Some. Mostly to Carla. In confidence. But I seen her family didn't exactly stampede to your side when Nadine was born. And you're here. I gather it's not the first time you've disappeared. Maybe it runs in the family, whatever. But she's alone, Lyle. Blind man could see that. Day you got married, you said you'd tell me what's going on. I'm listening."

Lyle stared down at the table top. Decades of grime wedged into the seams and corners of the visitor's booth. "My father is a serial killer," he said.

"Okay." The comprehension settled across Ray's face and softened his eyes. "Explains a few things."

"I was in high school when he made the news," said Lyle. "They got him dead to rights on murder one, then linked him to a second victim. He bargained his way out of the gas chamber by fessing up to seven others."

"Jesus," said Ray. "Can't imagine what something like that would do to a kid, young as you were."

"Named me after himself. And I'm not only Junior, but

practically a dead ringer for him at my age in spite of my injuries. My teeth, the other stuff? Got jumped a bunch a times, bad. Dropped out of school and spent most of my time at home or in the emergency room."

Lyle pointed to the scar on his cheekbone, told that story, then another. They were his words, spoken with his voice. But he was someone else, standing over his own shoulder and watching this *Lyle* person recount his time spent on the business end of a suburban witch hunt, yet again. He broke off mid-sentence, back behind his own eyes. He looked down, scratched at the laminate surface with his thumbnail, then regarded Ray through the hairline hashmarks in the glass between them.

"Saw his mugshot at the library," Lyle said. "Scrolling through the microfilm and I stopped right smack on his face. Big as life and staring right back at me, all lit up. About had a heart attack."

"My guess is you paid him a visit," said Ray. "That who this killer was you met with?"

"Yeah."

"Means you left the county and your PO busted you for it."

"Probably could have cleared it with him," Lyle said, "if I'd made something up."

"Fuck your PO. Should have cleared it with Sera. Better yet, forgotten about it."

"News flash, Ray. Sera doesn't report to my PO, *I do*. Sera doesn't go to court-ordered rehab for a drug problem – a drug problem she doesn't have – and Sera doesn't piss in a bottle for somebody who's just waiting for her to screw up because Sera wasn't nailed literally holding the bag that she didn't know existed until the cops found it."

"Listen to you," said Ray. "Year-and-a-half of meetings and your thinking's still old brain. All this with your old man was what, fifteen, twenty years ago? Don't get why you decide now you need to go on some vision quest. Violate your probation,

get yourself locked up and risk custody of your daughter over ancient history."

Lyle took a long breath and said his father's full name out loud, slowly. "Hear me, Ray? That's who raised me and I sat there face to face with him. Nobody watching and nothing between us. You understand now?"

"No, I don't." Ray scratched his chin, raking his fingers through his icicle beard. "Never heard of the man."

Lyle pressed two fingers to his forehead and counted silently to ten.

"Said you'd changed your name," Ray said. "That why?"

"Yeah."

"Sera know this?"

"Sort of. Told her from the beginning I changed my name. And why I did it. She knows my birth name, too. You and Sera are the only people I've ever told."

Ray waited.

"But I didn't go through the courts. I tried, but I wasn't eighteen. They just bounced it back."

"Sera's married name is one you got off a streetcorner, bootleg ID, is what you're saying."

"No, it's better than that. This guy was – he did real work. Probably for some dangerous people, maybe the government. But I got everything, birth certificate, all of it. And not one employer, cop, judge, landlord, not even the IRS, has ever figured it out."

"Not sure if that makes it any better. You tell her this, too?"

"Yeah. Not the first time, I mean. Came clean the other day."

Ray's eyes flared for a heartbeat, forecasting his open palm to Lyle's head were it not for the glass between them and then his expression relaxed again.

"She's worried about you," he said softly. "Misses you. I'm supposed to tell you that. And she loves you very much."

"She told you to say that? Thought I was in the dog house."

"You are. Doesn't mean she ain't worried, too. People can be

complicated that way. And she is. Worried, I mean. Practically sick with it."

"I'll be fine."

"You're not listening, Lyle. She loves you, same as you do her. Only you keep pulling rank, playing Superman."

"I'm trying to protect her, both of them, from this shitstorm I created. I'm owning up to my actions, Ray."

"It ain't all your doing, Lyle, remember? Owning up's all well and good, but not if you can't tell what's your doing from what's not. And as for the stuff that *is* on you–"

"Ray–"

"The stuff that *is* on you, *Lyle*, if it's worth all your trouble protecting her, then it's worth her knowing – it's her right to know – what the threat is. Hiding half your life from the woman you married, then deciding on your own what's best for her because of it, that just makes you a stranger, piece by piece. Hard for Sera to love a man she doesn't know. And the longer she's alone, the more she decides for herself what's best for her. And her daughter."

"My daughter, too."

"Little proof of that, she didn't half look the part."

"Fuck you, Ray. You finished?"

"Are you? Nobody knows who your father is or gives a shit. But you won't get past it. Changed your name, disappeared, hid the truth from your wife time and again, squared off with your old man, hugged your inner child and communed with your spirit animal. While your flesh-and-blood child needs food, diapers and a daddy. A man who can put his personal shit on ice when his wife and daughter need him, who doesn't leave his family in the dark every time he needs to get in touch with his power squirrel. Someone who can tell his issues to take a fucking number. So, Lyle, are *you* finished?"

Lyle listened to the ringing in his ears. A passing guard leaned over and said to start wrapping it up, then walked on.

"I cleaned the place up best I could," Lyle said. "My keys are

with the building manager, like I told you, and you're cleared to pick them up. Carla, too. I mean, if Sera needs anything from the place and doesn't want to go back, just yet. The title's in the glove box, let her know, if she needs to sell the truck before I'm out."

"Forget about all that, right now."

"Unless I can get out of here yesterday, I've got no job, and Sera and Nadine have no apartment come the first."

"Less you got information to barter with, just do your time, straight. Six months, pretty sure you could do that holding your breath. If it comes to it, we'll get Sera loaded out, no sweat. Get some rest, keep your head low, hit the meeting, try to exercise and enjoy what sunlight you can get."

"Not funny."

"I wasn't joking."

"Time's up," the guard said.

"I love you, brother." Ray tapped his chest. "With all of it. I will not leave you hanging, but I won't sweet-talk you either."

"Right," said Lyle. "Likewise. And tell Sera I love her." He held his hand up for a moment, not sure if inmates really did press their palms against the glass with a visiting loved one. Ray grinned and shook his head, rapped the partition twice with his knuckles, then hung up.

~

There were a limited number of payphones for the inmates to share. A recording informed both parties that conversations would be recorded, and the phones were rigged strictly for outbound collect calls. The surcharges were extortionate beyond the pale of phone sex or psychic hotlines so the county had no cause to impose time restrictions. The line was never less than a dozen men and their calls never less than twenty minutes. When mealtimes or fights broke up the wait there was no saving a place for next time. Lyle's attempts to contact

Sera came to five hours of waiting, by the common hall clock, and in seven days he never once spoke to her.

Lyle hadn't feared for his safety since the transport from the substation. The streetwise serial offenders and civilian section eights were elsewhere under lock and key, while he shared the company of fools and fuckups that gave him a view of the world through the eyes of Nestor Reid. The rampant candor among the petty criminals on the tier gave credence to those who protested their innocence. The bondsman's commission on Lyle's original bail had equaled several months' rent that Lyle never saw again. Were he facing another accusation, even an outright lie, he had scant savings or collateral for another bond. Suspicion alone was enough to keep an innocent man caged for a year before the court kicked him loose, and looking suspicious was easy in the eyes of anyone richer and cleaner than the suspect.

Following this chain of thoughts led to a dead-end of dread wherein his life, his wife, daughter and home were acts of imagination instead of memory. And in those moments he saw his future, the years to come spent eating and sleeping when ordered and staring at the undersides of bunk beds.

At lights out he dreamed of an enormous farmhouse and its tangle of hallways built by scarecrows.

DEAD ORCHARD

The Untuned stood in irregular rows, stuttering in and out of frequency with the passing interference. An overhead plane or the thrumming charge in the darkening storm clouds. A sweep of wind upturned a sheet of roofing metal deflecting all their signals at once and for a moment the dirt field was empty but for a single pair of scarecrow cross ties. Then the Untuned reappeared rooted in place, each of them facing west with the whites of their eyes gone black and fixed on the fading horizon.

He walked among them, stopping to meet their eyes but they didn't see him. He was accustomed to being conspicuous, so being the invisible man within a silent crowd filled him with an uncertain dread. Black birds perched on the cross ties and called to each other. Icarus looked to the sky and said, "I have done everything you asked." Then he walked the grounds to gather kindling before the rain came. Firewood was scarce but he left the scarecrow frame standing.

He reckoned by the doorways that the house had been built by someone of his equal height. The stone fireplace was intact but decades of fierce weather, rot, vermin and vandals had worn the greater structure to a husk. The shifting foundation had canted door jambs and ruptured plumbing. Thieves had ransacked the cabinets and closets, squatters had abandoned sleeping bags, soiled clothing and empty bottles. Someone had written *The Tin Man Is Much Too Powerful* in charcoal across a plywood window

cover, and on the living room wall another had spray-painted *The Blood Clot Boys*. A washtub beneath the chandelier was half-filled with grey water. The stain on the ceiling had bled to the size of the rug below it and broken ribs of lath jutted through the crumbling plaster. If the room upstairs had flooded, then the roof above it had caved. Icarus hadn't explored beyond the ground floor, certain the staircases couldn't hold his weight.

The dining table's surface had been etched in the same manner as the benches in jail. "You monkeys and your words," said Icarus. He brought two chairs to the fireplace where he'd filled the hollow of his kindling pile with couch stuffing and set a match to it. The fire grew and Icarus broke the ladderbacks from the chairs with his bare hands and followed with their legs, then split the seats over his knee. The sky darkened and the rain came and Icarus fed the flames.

"I have done everything you asked of me," he said again.

He was cold and couldn't remember ever feeling so. He'd been walking for weeks and his joints ached and his feet bled. A silverfish crept along the baseboard and slipped through an open wallpaper seam. Icarus stabbed at the embers with a wooden slat. The rain hissed against the walls and a drop of water fell from the ceiling into the washtub. A roach scuttled across an old newspaper, stopped halfway and sat still for a few minutes, then scurried off.

Thunder reminded him of looking down onto storms. Clouds pulsing with light, electricity snaking about their crowns. He had seen countless such storms on remote frozen planets and in deep space nebulae but could recollect only a single image no different than what a man could observe from an airplane. The New Brain had its limits and he had reached them a long time ago. His old life was draining away.

He walked back outside and circled the house. Corner posts leaned off-center and awnings sagged as though the structure were melting. The redwood warped and pulled at nail heads, whole planks had fallen away and others were loose with gaps

wide enough for his thumb. But the red door was straight and flush as though the carpenter had packed up his tools moments before. By its location at the rear of the house it should have led to the kitchen but there was already a back door to the kitchen and Icarus knew that from the inside only one of the two doors would be visible.

"Not having a face don't mean you shouldn't wipe that look off it," Icarus said. "Quit staring at me. You're just a door. Don't think you're so special on account of the no-place you go to. Lots of things go nowhere and do nothing. People, too. Ones with rubber stamps and plastic badges what park themselves behind glass and decide whether you got a name or can get a job or sleep indoors. But you don't decide nothing. I walk through you or not, that's on me. Can't even open your own self. You just got to hang there between one place and the next looking all red and shit. So get off your high door horse."

He stepped closer.

"What? You think you can stick a fork in me on account of I got to light up some furniture? You think I feel the cold and wet for the first time means I'm ready to tap out? You'd like that, wouldn't you? Like I ain't already seen what's on your other side, a long time ago. You forget, there was nothing long before there was wood and brass and pretty red paint to make the likes of you. I seen where you go long before you were around to block my way to it. You think I'm going to wipe my feet and waltz on through at the first sign of bad weather or a ripple of radio silence from the Mother Howl?" Icarus waved to the Untuned surrounding the house. "You think I'm going to leave them staring at the backs of their black eyeballs for the rest of forever on account of you shaking your brass at me? That's not going to happen. So best keep your deadbolt on."

And Icarus walked away.

~

"Mr Edison, I'm with the State Attorney's office."

He gave his name but Lyle paid no attention. The lawyer was young enough to have lingering acne and his suit fit him like a cloth box, likely the first he'd ever bought for himself. His briefcase was the sort grandparents gave for a graduation present. They shared a small visiting room with a window to the corridor and another with a view of the outside.

"How are you this afternoon?"

"How am I?" Lyle said. "Saw my best friend a couple days ago through a glass wall," Lyle said. "Had to talk to him with a telephone."

"I don't make the rules, Mr Edison." Both men took a seat and the lawyer spoke again. "You have information for us? Regarding a homicide?"

"Homicides. Plural."

"Okay," said the lawyer, an expectant rise to his pitch. He took a pen from his pocket and wrote *Lyle Edison* and the date in the margin of a legal pad, then waited, blanking his face for the effect of authority and composure but the anticipation bled through. Perhaps acting the liaison to convicts gaming the system with false alarms came with the entry-level territory, somewhere above fetching dry cleaning for the corner offices. But this particular errand could prove a career maker. The lawyer said, "Five minutes, Mr Edison. I wouldn't waste it."

Lyle pronounced his father's name, slowly and clearly. Made sure the lawyer spelled it correctly.

"This the victim?"

"No. Far from it."

"Wait," the lawyer said. "We studied this case. Pled out on murdering some girls a long time ago."

"Nine," said Lyle. "He copped to a total of nine victims."

"No, I remember. There were a couple of others, three or four, max."

"There were nine. Seven women along with two men who

had the bad luck of seeing something maybe could have saved the others."

"We won't argue about it, Mr Edison. The case is closed and I doubt he's even still alive."

"He's very much alive. So is his son."

"You know this guy's son?"

Lyle waited.

The lawyer removed a file from his briefcase, took out Lyle's arrest sheet and ran his fingers down the front, scanning for something but Lyle couldn't imagine what. "You?" he said.

Lyle nodded.

"You prove this?"

"Yeah."

"Why'd you change your name?"

"Seemed like a good idea at the time."

"I'm not sure how this is of any help to us. Assuming you're telling the truth, let's start with when and where you filed for your name change."

"I didn't."

The lawyer blanked his face again, concealing his ambition like trying to hide a gas leak. "So, in addition to narcotics trafficking, you're confessing to felony ID fraud?"

"You want to try to prove my ID is fraudulent, have at it, by all means."

"We will, absolutely."

"Yeah, do that. See what happens. I've been trying to punch holes in it from day one. Guessing I got a good ten years on you, means you were learning to ride a bike around the time I left home. By now, I couldn't tell you my old Social Security number with a gun to my head."

"Your point?"

"My point is I'm way past fake papers. I *am* Lyle Edison. You couldn't prove I'm someone else any more than you could prove the same for yourself. Trust me, you're not going to impress anyone at your office by trying."

"Our time is up, Mr Whatever."

"Edison." Lyle reached for the legal pad and pen and wrote out his full birth name appended with *Junior*. His hand was steady. He wrote down his place of birth but drew a blank on trying to recall his actual birth date. Was he a year older or younger? He jumped backward a month from the date on his license and the rest of his birth date fell into place.

"This you?" said the lawyer.

"Used to be."

"No Social?"

"Told you, I forgot it. Took me a minute to blow the dust off my date of birth, as it is."

"What do you want us to do with this?"

"Check it out. So you know I'm not bullshitting you."

"And what is it you think we'll find?"

"Nothing," said Lyle. "I mean, you'll find a few things. Birth record, definitely parents' info. Some school transcripts, maybe. I don't know where that stuff turns up on these things. One driver's license, maybe vehicle registration if the DMV goes that deep. A couple years of tax and banking history."

"Okay, great. You've still given us no information about any homicides."

"This guy," Lyle tapped the legal pad, "is the son of a serial murderer and he can tell you plenty. But whatever you find on him will come to a dead stop at age seventeen. After that, there's no college, no job history, no passport, income, arrests or library cards. He was never reported missing or dead. He's a ghost."

"That doesn't–"

"Spend a few minutes on it, okay? You'll also find a picture. DMV or yearbook or something."

The lawyer shook his head.

"Look," Lyle said, "do it or don't. Suit yourself. It'll take you twenty minutes to run a background check with what I've given you. Twenty minutes to figure out, for certain, whether

I'm full of shit. But you'll see that guy is me, and he knows things your bosses will want to hear. So send one of them."

Lyle stood and flagged a guard through the window.

~

Does a guilty man or an innocent man sleep better in jail? Cops had a saying – Lyle had heard it somewhere – on how the innocent and the guilty awaited interrogation. One panicked and prayed while the other passed out. Lyle couldn't recall who did what nor which one he should consider himself. With each day he woke fully rested without having spoken to Sera he asked himself, Does this make me a monster?

They'd segregated him to a tier of inmates with no gang affiliations, mostly nonviolent offenders. Many spoke openly of their crimes, a practice roundly discouraged among harder convicts. Most had drug charges, typically for possession. The diffusion of misdemeanor assaults among them amounted to a single drunken bar fight when taken together. Those arrested for concealed weapons should have by all indications shot their own feet but were as lucky as they were dim. Lyle was one of the few serving an actual sentence among those who could not afford bail pending trial. He lay in the overlap of two competing boom boxes and stared at the metal ribs on the underside of the top bunk. A card game to his left, a fight over a comic book to his right. He imagined his daughter on his chest, her hand clamped to his little finger, holding her head up as long as she could to take in a few seconds of her world without blinking.

There were days when Nadine had slept only in Sera or Lyle's arms while they stood fully upright. She squawked as soon as Sera bent over her crib or if Lyle tried to lie down and shut his eyes with Nadine asleep on his chest. Lyle eventually learned he could sleep half-reclined against the couch's armrest, a pillow between his head and the wall with Nadine none the wiser. He

listened to his daughter's steady breathing and stroked her tiny back and when he thought she was fully asleep Nadine would churn her arms and legs in a brief and languid fit of climbing before dropping her head back to his shoulder and then was quiet again. Lyle would drift off and later wake to Sera lifting Nadine from his arms at last without protest. He would brush his hand across Sera's hip and she would stroke his knuckles once in reply before putting Nadine to bed.

Since Nadine's arrival, Lyle had lived on precious rations of time and there was never enough for sleep, for his daughter, for his wife or for himself away from them both. Time was now in such abundance as to be worthless. The alarm on his nightstand, his watch, dashboard clock and the time clock at work had been swallowed by a single industrial clock in the common hall of the county jail. Sometimes Lyle could see the hour hand move.

And sometimes he imagined staring into the sun, dead center in a dome of clear blue without a vapor trail or wisp of cloud, as though he were floating on his back with the horizon beneath him. The longer he stared, the closer he drifted until the shimmering gold edge was a single monstrous curve, a riot of fire and molten hurricanes the size of continents. Sometimes he felt the heat on his face.

~

A week passed without word from Lyle. Sera admitted to herself that she was in some profound way broken, that she had confused not making bad choices with making good ones, and had mistaken any life better than her childhood home as being right and normal. Her parents had often said, when you have children of your own, you'll understand. As she watched her daughter gape at the room around her, twisting about to roll herself over, Sera could fathom little of her parents that wasn't criminal. She'd waited tables on the graveyard

shift during high school, saving to move out the day of her eighteenth birthday. She went to the beach after work with a sleeping bag she kept in her trunk and returned home in the morning to shower and dress for school. It was safer risking her life as a girl sleeping alone on the beach than under her parents' roof. Before she met Lyle, she'd told her mother over the phone that she would never let her or her father near any child of hers, ever. And that was the last time she spoke with either of them.

Now she was alone among her friends in parenting classes and book clubs as the only woman with a husband in jail, a dark forecast for her daughter's future. The roster of old boyfriends and lovers would scroll through her thoughts and she took this for a signal she'd been marooned with those thoughts for too long. They led her dangerously far from Nadine.

Sera circled PETITIONER beneath MARRIAGE OF and wrote her name. She'd been using it for less than a year. The options below NULLITY OF MARRIAGE had only one that applied: FRAUD. Exposing Lyle would keep Nadine from her father for years, and subject him to more incarceration, more punishment than he'd already endured. She checked PETITION FOR DISSOLUTION OF MARRIAGE. There were six pages of forms. Sera folded them together and stashed them in her bag and then lay down on the blanket beside Nadine.

The last few months had been like flying, the world shrinking beneath her until once-familiar places were too small and far away to recognize and then out of sight altogether. Clothes she hadn't worn in ages were like props from a stranger's life and she missed none of it. She never tired of the tiny world she now lived in with her baby.

Since her daughter's birth, Sera had watched Nadine take in the world, blank and wide-eyed. Then one day she twisted her neck and moved her eyes at the sound of her father's voice. She was alive and part of her yet emerging as her own person in a million ways small enough to miss with a blink. She saw

her own face in Nadine, a strange and beautiful mirror and sometimes with the right expression or light Nadine flashed shades of Lyle.

Lyle was not helpless. Nobody was trying to take Lyle away from her against his will or without his understanding. She would not be like her mother and father, nor resign control of Nadine to anyone who was. She held Nadine with one arm and with the other she fished the court documents from her bag. Lyle would understand.

~

Another empty room with another metal table. Sun streaming through the window grime and security mesh somehow felt cold against his skin. The match head flare of the orange jail sweats had lost their shock to his eyes and the food had lost its color, days of nothing but dull grey and green. The Latina woman wore a shirt the color of red wine with her suit, her nails were painted to match and if she noticed Lyle staring she gave no indication. She was lost in a mound of files and the men in the room paid her no mind. They wore black suits and could have been triplets or even headless for all the attention Lyle paid to their faces. The Latina woman cleared her throat and the men all seemed to step back. She gestured to a chair at her corner of the table and one of the headless triplets ushered Lyle to sit.

"I remember you," she said. She squinted at him as though he were sitting in the dark, but there was a trace of a smile in the lines around her eyes. She was older than Lyle by a couple of hard decades, if not more.

"I'm sorry," Lyle said. "From where?"

"It was a long time ago," she said. "My name is Agent Maya Cruz." Her voice was warm, as though she had offered her hand to Lyle, but she hadn't. She lowered her glasses to survey Lyle's face the way the doctors had when he was younger. "I don't remember this." Agent Cruz stroked her own cheek with

her finger, miming the shape of Lyle's scar. "When did that happen?"

"I got jumped more than once, after my dad made the news. Don't know exactly what happened when. Spent a lot of time in the ER."

"Indeed, you did." Cruz cut a stack of files to remove one from the center and leafed through it. The photos were upside down and the eyes were black, swollen shut. A mass of gauze on one cheek, the lips lost in caked blood but parted enough to flash broken teeth. Lyle looked away until Cruz shut the file, then he looked back to her.

"All the King's horses and all the King's men," she said. "You're quite resilient."

"Mostly lucky."

"Or blessed, depending." Cruz tilted her face like she'd heard a strange noise and squinted at him again. "You didn't used to look like him."

"How do you know?"

"You were a young man, then. I watched you for three days on a monitor while the investigators interviewed you." Cruz shut her eyes and raised a finger, then opened them and said, "You had a carton of chocolate milk the first morning. For lunch, you had fries and a Coke but didn't touch your hamburger. They said you were in shock. They were right, but I don't think that's why you weren't eating. You had potato chips and a tuna sandwich for dinner. And you did it all again the next day, and the day after that. My instructions were to observe, but not to take notes or interfere in any way. I was to run out for your chocolate milk or potato chips and log my receipts. I'd been with the department for a year. I remember one of the investigators raised his voice at you the third day and said you were wasting his time. I stopped him in the hallway and said you were stalling because you felt safe at the police station, and that's why you wanted to come back. The man I worked for gave me a stern reprimand in front of everyone and relieved me for the rest of

the week. The last time I saw you, you had a concussion and were getting stitches and you didn't know I was there. And then you disappeared." Cruz flared her fingers and said, "Poof."

Lyle sat still, listening.

"I don't suppose you can tell me who's responsible for your vanishing act?"

Lyle shook his head.

"I thought not, but I had to ask. Some of us might be willing to overlook past transgressions and put him – *him*, yes? – to work. He's good, made you a ghost."

"I know."

"But here you are."

"Poof," said Lyle.

Cruz smiled. "Mr–"

"Edison, please. Or just Lyle. Please."

"Very well, Lyle. You may call me Maya." She indicated the others in the room and said, "*They* call me Agent Cruz."

"Maya, the guy you worked for back then. I remember him, sort of."

Cruz nodded.

"I'm guessing he's somewhere in the State Capitol, by now."

"Oh, he's much more ambitious than that."

"Okay, but I'm guessing he doesn't like you. Or didn't."

"I encountered people like him when I applied to the academy," said Cruz. "And ever since, with every exam, every rank, even when I joined the Bureau. Every day. He's not unique, and he's not here. I am. And I'm prepared to listen to you."

"Okay, but I tell you what I know, you could seriously embarrass him, make yourself a powerful enemy."

"I could. But I don't know what you have to tell me or whether it's true. Because if I only embarrass myself," Cruz said, "there are people who would see that as proof they've been right all along."

"Yeah."

"Tell me, Lyle, what would you do in my position?"

"I have no idea."

"Then why don't you tell me why we're here, and I'll decide how to proceed."

Lyle looked down at the tabletop and pondered his emerging pattern of sitting in fortified rooms empty-handed and ill-prepared to barter with people more powerful than himself.

Cruz said, "Your father was arrested on suspicion of homicide and pled guilty to that and eight others."

"I know."

"So you know we closed the files."

"You never gave it another thought? Like maybe your boss back then was so eager to use the case as a stepping stone that he left a few victims twisting in the wind. Or you just never thought it out loud?"

"Mr Edison, think very carefully before you speak again."

"He was horse trading, Maya. There were others he never gave up."

"And you have proof of this?"

"No." Lyle bit his lip, held his breath for a moment. "Maya, you seem sincere to me, but I'm out of my depth, here. I've got no lawyer, so I have to trust you. I don't believe my father's case was ever properly closed. I think you believe the same thing. If I'm wrong, okay, but if not, can you at least say so?"

"Lyle."

"Let me try it this way–"

"Lyle. Your father bargained his way out of a death sentence. I've always believed that and I'm not the only one. And there are other victims who have been forgotten because of that."

"I don't think he was afraid to die," said Lyle. "He just liked the game."

They both listened to the echoes from the jailhouse halls for a minute before either of them said anything.

"That's a terrible truth to understand," said Cruz. "Lyle, when did you last see your father?"

"Nine days ago, I think. Paid him a visit."

"That's a federal offense, young man." One of the faceless triplets spoke up. "Entering a government facility using false identification."

"Lyle," said Cruz, "this is Agent Doyle."

Lyle looked to Doyle, then back to Cruz.

"What'd you two talk about?" said Doyle.

"I don't remember."

"I think you do," said Doyle. "And we have the makings of a conspiracy case."

"You know," said Lyle, "my PO is the alien super-cyborg of assholes, not to mention I've been alone in a room and practically touching knees with a guy who murdered people to pass the time. So save the bad cop routine for someone else."

"Agent Doyle," said Cruz. "Would you excuse us, please?"

Doyle waved to the other two men and the three of them left Lyle and Cruz alone. Cruz opened another file and slid a photograph across the table to Lyle. A black-and-white photo of a decrepit farmhouse on a stretch of barren land.

"Do you know this place?"

Lyle shook his head. "I have a hunch, though."

"You've never seen this house, this place before?"

"No."

"You want to trust me, Lyle? How am I to trust you, then?"

"You know when I last saw my father," Lyle said. "You know I'm his son and you know I violated my probation when I left the county. Surely you put all that together. But you asked the question to set me up anyway."

Cruz sat quietly, her head bowed as though in prayer.

Lyle said, "That's my great-grandfather's farm, isn't it?"

"It was. According to the estate lawyer, it's yours now. Are you aware of this?"

Lyle nodded.

"I had my suspicions about it back then," said Cruz. "A lot of us did. We could never prove any contact between your father and your grandfather at the time of the killings. We couldn't

produce cause for a search warrant and your grandfather refused to consent. Did he ever say anything to you, Lyle?"

"Never met him."

"Do you know why he would want to protect your father?"

"Because nobody wants to believe their own flesh and blood is a monster," Lyle said. "And he'd already believed it more than most. But he's dead, right? A ghost."

"He is," said Cruz. "He willed the property to you. And you've had contact with your father. That may be enough for a judge to sign a warrant."

Lyle pressed his palms to the table to steady himself.

"You may as well throw my wife and daughter to the street while you're at it."

Cruz consulted another file. "And what does Nadine, no Sera, what does she know about all of this?"

"Nothing," said Lyle. "Listen, you could probably get a warrant on the basis I had contact with my father. That seems weak to me, but I'm not a lawyer. And I don't have legal possession of the property yet, nor have I said anything about linking it to my father's case. Let's say I do. Just supposing I know something, I mean. Whatever I tell you gives you probable cause to search, I don't know, wherever. You do what you want, you find, whatever, without me, then I'm screwed. I go back to jail for the next five months and change and I lose my job, my wife and daughter. And they lose the apartment, and Child Services takes Nadine away."

"Horse trading," said Cruz.

"It's not like that." Lyle put his face to his hands, rubbed his eyes. "I'm not going to be like that, I mean. Just hear me out."

"I'm listening."

"Look, I step up as my grandfather's heir, the place is mine for the taking. I could give your agency a blank check to bring on the dogs and shovels. You wouldn't need a warrant, you wouldn't risk embarrassing yourself by expending a few man hours like you would by trying to get a judge's signature."

"Will you do that?"

"I'd have to confess to twenty years of identity fraud."

"A judge could grant you immunity."

"I need out of jail, too."

"I can't do that."

"You're prepared to give the bootlegger who made my Lyle Edison papers a job, but you can't knock down a few months on a bullshit trafficking charge?"

"We could ask to have your probation reinstated."

"Child Services is trying to take my daughter. They've come around once, already."

"I could be stretching my neck very far for nothing," said Cruz. "You must understand, the right thing would be to tell us if you know something."

"I understand."

"You do? You're trading lives for leniency."

"I can't work, we're about to lose our apartment and there's a good chance we may lose custody of our child. Over nothing. Tell me, Maya, what would you do in my position?"

Maya Cruz gathered the files she had opened, put the photograph away and pushed everything aside.

"I don't know, Lyle," she said. "I think, in my heart, I would choose to protect my family."

The sensation of suddenly awakening struck him again, the way it had when he stood in the prison visitors' lot as though put there by magic. He felt the air on his skin and the room seemed somehow larger and brighter as if he could turn around and see the sun through an enormous picture window behind him. Nadine was going to be safe, with or without him, and that was enough.

"Getting an immunity deal for fraud shouldn't be difficult, if you're willing to come forward under your real name as heir to the property. But your current situation is with a different court."

"Maya–"

"Listen, Lyle, please. I can't promise anything, but I can say that judges look very favorably on sentencing when a defendant provides information that solves a homicide. Especially more than one. If there is a factual basis for your plea, and I think there is, you can prove who you really are and provide information that leads to closing multiple cold files, the Bureau will explain this to the judge and ask him to reconsider your sentence. That's the best I can do. But I will do it. "

"I'm not," Lyle paused, "I'm not bartering, here. I'm asking. That's all I've got."

Cruz smiled and bowed her head briefly as though in silent prayer again. Then she looked back at Lyle and said, "I will consider your request. And my office will be in touch as soon as possible." She extended her hand and said, "Thank you for what you're doing. For everything."

~

The guard called out "Edison!" after morning lineup. He was handing out letters and postcards, envelopes full of legal documents. They couldn't inspect legal documents, so inmates were called to a guard desk to receive such packages where they opened them under watch and a guard removed any paperclips or staples.

Lyle stood at the desk, a bank of monitors behind the guard, angles of the jail in miniature. The orange inmate sweats were grey, but there was no other telling if the signal was color or monochrome based on the walls, floors, doors and bars.

"I'm going to open this where you can see me," said the guard. "I'm not viewing any confidential correspondence." He tore open the seal and slid the documents out enough to remove the paperclip, then he tore out the metal tab at the center used for resealing it. He ran a wand over the rest, then slipped the documents through the till beneath the glass.

Everything moved in slow motion, the sound in Lyle's ears drowning out everything else. It was Sera's handwriting on the face of the envelope, but it was a large, white envelope meant to hold documents flat. Nobody put paperclips on a love letter.

Lyle took the papers back to his bunk. There was no note, no handwritten explanation or cold injunction from a lawyer. There was no threat regarding alimony, though Lyle knew nothing about alimony. Were they married long enough for it to apply? Had he provided any sort of life for her to become *accustomed to*? There was no mention of custody or child support. He couldn't argue either. Wouldn't.

Cut adrift again, that feeling of being tethered to himself from a distance. Through the haze of shock and ringing pain, he felt some surprise at what he didn't feel: anger or crippling loss. No outrage of *why*? Nor the internal pleading of the same.

A voice said, "Of course."

And the tether pulled tight and reeled him in and he was back inside himself.

"Of course," he said again.

As long as Sera were married to him, their daughter was under the scrutiny of Child Services. Without Lyle, Nadine stayed out of foster care. It was the smartest play to make, and Lyle was grateful Sera could do something without him to protect Nadine.

Sera's as hollowed out and pissed off as I've seen anyone in a long time.

With good reason. And once divorced, being together would be all but impossible. He would have spent his life protecting no one from nothing.

He had thirty days to respond, but wouldn't leave Sera and Nadine exposed for that long. She was doing the right thing. But when she was gone, she was gone. Lyle returned to the guard station and requested a pen. He signed the documents, tore the flap from the original envelope and before sealing it for the outgoing mail he wrote:

Sera–

I won't fight you on this. I understand that what I've done has cost you, and I know you have Nadine's well-being at heart. Please know that I love you with everything I am, and nothing will ever change that, whether we're together or not.

But I am asking for one last thing from you, for the chance to do what I've failed to do so many times in the past: to make a decision about our family, as a family. Sit down with me and talk, please, and I promise I'll listen to you. If we both agree that us not being together is the best thing for you and Nadine, then I will accept that, but please give us a chance to make the decision together. You have my signature on the divorce papers. If you don't want to meet, then so be it, I understand. I don't have the right to expect anything from you, the way I've been. You once said that marriage means you don't get to walk away, that you don't have to worry about the other person walking away. Please don't walk away. Please. Because we'll never be able to put things back together if you do.

I have a hearing soon, or a deposition or something, I'm not sure how they'll do it. There's a woman from the FBI who knows about my father. Maya Cruz, she's an agent. You can probably reach her at the field office and she can tell you about it. I'd really like to see you there, if you can make it. I miss you so much it hurts and I can't show it in here. I fall asleep thinking of Nadine and I wake up thinking of you. But I may be able to help them, the feds, and they may be able to help me, in return. Or maybe not. I may be stuck here for the duration, and I don't expect you to wait for me. I may not have been a good husband, but I can still be a good father and I'm asking you to consider that, whatever you do.

You and Nadine have changed my life, and I want to share my life with you for as long as it lasts. Just a few days, please. After that, we can go our separate ways and I'll do everything I can to help you raise Nadine, to be a father to her, and I won't drag your life down with mine any more.

All my love,

–Lyle

~

Her feet were bare. A hoop of silver-like thick wire around one ankle, a tattoo of the sun on her other. A breeze blew and she shimmered from view and left a patch of weedless dirt where she'd been standing. Then the breeze died and she stood in front of Icarus again, appearing like an old lightbulb flickering to life. Military trousers the color of dark leaves and a black hooded sweatshirt. Short dark hair and a soft chin. Large teeth that seemed slightly too far apart. He imagined her smile had once been arresting, electric.

"Y'all look alike to me," Icarus said.

He at once recalled sitting in a church with strange things in his blood that were blocking the Mother Howl's transmissions. Forced to contemplate his world of dirt through the eyes of a common monkey, he sat awash with shame and regret for himself, and uncertainty for the Mother Howl.

"I'm sorry," he said to the young woman. "I been too long in this monkey leather. The worst of me gets the drop on my tongue, sometimes. But I should not have said that. It was true, once. Long time ago. But not anymore. I don't suppose you can tell me your name, Miss?"

The Untuned woman stared past him.

"Never you mind. Only met one of y'all was ever able to hear me or elsewise look back. Even you did reckon I was here, you forgot your own name a long time ago. That much I know. Been there myself."

He lifted his hand to her shoulder but didn't touch her. After hesitating long enough for his fingers to tremble he dropped it back to his side.

"Indeed, you got a name. Can't suppose none of y'all can heed the Mother Howl's beckon if you don't know it's your own self being called. Not your fault. My duties and my circumstances obliged me to cash my clock in the company of many an ignorant monkey standing all incredulated at the

bottom of a hole with their fist around the neck of a shovel what's got their name on it, asking the dirt how it is they got there. The longer the dirt don't talk back, the longer they don't get to schematizing how to climb out. But I got me this New Brain what forgets things sometimes. Like some of y'all are in holes you had no part in digging."

She had dense rows of earrings like surgical sutures and a plum-colored birthmark at her hairline. Blunt fingertips, cracks in her knuckles and dirty, unpainted nails. The hands of someone who had worked hard for a living or cut statues from marble or fought in a ring.

"Nadine," Icarus said. Her name came to his mind from nowhere and eclipsed any remaining memory of existence before he fell from the sky.

Her eyes broke with the distance and met his before the breeze picked up again and she shimmered out of sight. When the signal steadied and Nadine returned, she was again staring into the distance. The ground beneath her was undisturbed. Wherever her flesh and blood were buried, the Untuned Nadine was here with the others.

The more details Icarus observed, the harder he found it to do likewise with the other Untuned, but he did so nonetheless.

They were all women and they had all died young. The marks on their necks and wrists attested to prolonged restraint and slow, violent ends. All but Nadine were moored at the site of their remains but each wore a common expression from their last moments alive. Pain, denial and desperate hope. They had all died the same way but each had lived a life of her own.

Icarus said, "I got to go soon. But somebody will come for you and you will get your names back. I promise you."

Then he returned to the rear of the house and said, "I believe we've met." And Icarus reached for the red door.

THE WORD

The noise in Lyle's ears was louder than ever and his skin hummed as it had the split second before he'd totaled his pickup the year before. And just like that split second, time had frozen. The world outside the jail walls like some mythic afterlife devised to take the stink off the present, the metal stairways and doors, brick walls and linoleum tile beneath caged lights the color of water stains.

Guards barked orders three inches from an inmate's face. *Open your mouth. Squat. Run your fingers through your hair. Raise your right leg. Now your left.* They checked each inmate with medical gloves and pocket flashlights, searched every article of clothing each time it was taken off or put back on. They read inmates' mail. They exalted scraps of ordinary life to privileges granted or revoked at whim. A stick of gum, a clean blanket, first in line for hot water, another hour of television. Everyone clocked on one side by the System and the other by a whispering subclass of inmate without solidarity to anyone, who would sell out their cellmates for a half hour of sunlight or an extra packet of sugar. At the end of it all a man was splayed and flayed beneath laboratory lights, his skin held apart with butterfly pins with his lungs, liver, failures, secrets, family, ambitions, addictions, injuries and still-beating heart exposed to the world. There was nothing left *of* himself to keep *for* himself. A man so far gone will hold his ground wherever he finds it at whatever cost. A

dispute over a pillow sends one inmate to solitary, a fistfight over a portion of oatmeal sends another to the infirmary.

Eyes front, feet together, hands at your sides. That was the standing order for the tally six times a day. At the morning head count a guard put his hands to Lyle's jaw and turned his face as though appraising a quarter horse.

"Happened to you?"

"Slipped," said Lyle. "Hit the bunk rail by accident."

"You been clumsy lately, Edison."

He'd explained the cut on his forehead the day before as a collision with a low-hanging shower head. His turn at the phone had finally arrived but a pair of goons had been strong-arming the line. Buzz-cut white guys in XL jail sweats and the soft muscle of retired football players. They called everyone *bro* and gave a high-five to every newcomer or weak fish who gave up commissary credit and allowed them to make a call. Lyle's turn at the phones came twice, both times he told the payphone mafia to get fucked and both times he cursed himself for choosing to stand his ground over getting through to Sera.

The guard let go of his face and stood nose to nose with Lyle.

"You hurt yourself again without reporting it, we're going to have a problem. We understand each other?"

Lyle always paused before answering a guard, dragged the exchange out. "Yes, sir."

"And wipe that smile off your face."

"Yes, sir."

Lyle heard that command more than any other: *Wipe that smile off your face.* Shouted at him nose to nose or lockjaw-hissed in his ear. Smiling at a guard was an affront to the System, evidence there was something in the inmate which they'd failed to take away.

He smiled because after so many years the joke was still on every single employer, landlord, traffic cop and court official, and neither Nestor Reid nor the guards logging his every waking minute were savvy that Lyle Edison was not Lyle Edison. He

couldn't escape the aching hollow left by Sera and Nadine's absence nor the common hall clock that stretched minutes into days. But the shouted commands, the threats and the strip searches were all someone else's problem. With each indignity the System inflicted, Lyle said to himself, *You still don't know who I am. You have the wrong man.* This made him smile.

While the System cut open and exposed everything they could of the wrong man, the right man floated above the earth in the warmth of the sun. Lyle drifted in that place between waking and sleeping. He heard the music, card games and arguments on the tier but his dream paid the waking world no mind and played itself out. Nadine was both there and not there. Asleep in her crib near the foot of their bed and though he couldn't see her, he knew she was there as sure as holding her in his arms the way one knows things in dreams. The bed and the crib were in the jail, the chaos all around but Nadine was safe. Everything balanced on a warm current of air miles above the ocean and bathed in sunlight. Sera climbed atop Lyle to roust him from his sleep and Lyle knew it was the night they had conceived Nadine even though Nadine was already there and it was daylight.

He saw his family in the dream the way God might, the past, present and future a single instance. And amidst the noise of the jail Sera whispered in his ear the way she had that night, the way she was that very moment and would someday and she said, *I love you, Lyle.* And Lyle said, *You have the wrong man.* Then Sera was gone. He tried to reach for her but couldn't move. His body turned to lead and he was falling two-hundred miles per hour toward the water two-hundred miles below, clear luminous blue that would turn to a slab of glass long enough to shatter his bones when he landed.

~

After he'd stripped and handed over his sweats, the guards did their routine inspection. Lyle thought, *You have the wrong man,*

but it no longer made him smile. He stood in front of the guards longer than usual, waiting. Another guard entered, holding a paper bag marked *Edison, L.*, with his booking number. The guard wore rubber gloves and handled the bag as though it were a bird's nest.

Inside, Lyle's clothes had been neatly folded. He recalled the deputies searching them as he changed, but nothing else. Somewhere, a young cadet who had dreams of a career in law enforcement was in a metal property cage folding inmates' street clothes under the supervision of his training officer.

Lyle had picked his clothes considering the future weather and wanting to look as conspicuously ordinary as possible. He hadn't considered the possibility of standing before a judge.

He asked, "Don't suppose you got a stray dress shirt and tie around here?"

"Lawyer should bring that for you," the guard said.

"I don't have a lawyer."

"That's why we brought in your property bag. Step it up now, inmate. We got to move."

Lyle dressed, hoping the denim work jacket covered his t-shirt or that the judge was a Hank Williams fan.

~

The stenographer was dressed in bright green, a color Lyle hadn't seen since stopping to eat before turning himself in, the stucco walls of the Puerto Rican cafe almost a match for the bright tropical shade of the clerk's dress and it transfixed him.

"Lyle? Hello?" Maya Cruz stood with a tall, cadaverous man wearing a bow tie.

"Hi," said Lyle. "Sorry."

"Lyle, this is Mr March, your late grandfather's estate lawyer."

March looked exactly as Lyle would have pictured such a

man. He shook hands with him, March's grip cool and weak.

"Agent Cruz gave me everything," March said. "By all evidence, you appear to be the rightful heir to twenty acres of dust. I hope you weren't planning on getting rich, son."

"No, sir."

"Very good, then. You also understand there's no paper trail linking you to Lyle Edison, yes?"

"What are you saying?"

March said, "Legally I can't accept your claim."

"Then I can't," Lyle said. "There's no point—"

"Nothing has changed, Lyle," said Cruz. "What Mr March means to say is that we need a judge to review your claim and make a formal ruling. That's what we're here for, today."

"That's correct," said March. "Once the court acknowledges your birth identity, the property is yours. I just need your signature on a few things." He gestured to a stack of papers at the table, a row of yellow tabs along the right edge. "It looks intimidating," said March, "but it's all standard, I assure you. And you understand what I mean by signature?"

"Of course," said Lyle. "Oh, right. Yes, I understand."

"That goes for everything in here, Lyle," said Cruz. "As of this moment, you are no longer Lyle Edison. Is that clear?"

"What about our agreement?"

"I keep my promises. I've already spoken to the judge in your case and he is willing to oblige. This is yours." Cruz handed him a white courier envelope. "The first page outlines our agreement in writing. The second page is a consent form to search your property. We have some time, so look them over."

Lyle opened the envelope and leafed through the papers as Cruz spoke. Beneath the forms was another photograph of the house, in color, more recent than the photo Cruz had first shown him. The roof had caved and the surrounding lot was dotted with bright red stakes.

"What's this?" Lyle said.

"You don't recognize it?" said Cruz.

"It's the house, my grandfather's place, I know. Somebody been planting there, recently?"

"How do you mean?"

"The red stakes."

"We thought you could tell us about those. They're new, both recently placed and the wood is fresh and, according to the sheriff, split from a single piece of oak, probably an old door. That accounts for the red paint on two sides. You know anything about that, Lyle?"

"No. Pot farmers squatting there, maybe?"

Cruz laughed. "Well, we know you're definitely not a pot farmer. They're markers, Lyle. Put there within the last forty-eight hours. Is there anything you want to tell us?"

"No."

"Any idea what they might be marking?"

"Maya, I... No, I don't know what those are doing there. I don't even know where the place is. Please."

"Lyle, it's okay. I had to ask. Nothing has changed. Now please look over the other documents before you sign them."

"I will," said Lyle. "But what about the judge, here? I'm confessing to felony fraud."

"You won't be charged."

Lyle hadn't noticed the man to his left and the man hadn't introduced himself. He placed a sheet of typewritten letterhead on the table among the others.

"I'm here with the State's Attorney's office. This is your written immunity. Take a moment to look it over. Once we have your signature, we can get this hearing underway."

"All this paperwork," said Cruz. "I know it's daunting."

"I'm used to it," said Lyle.

Lyle read everything and the words bounced off his eyes. He asked Cruz for a pen and signed, pausing after his first name.

Maya Cruz rested her hand on his shoulder. "You left Lyle *Edison* outside this courtroom," she said. "Go ahead, it's going to be fine."

He signed his last name, the name he'd been given at birth. *Does my signature look like his, too?*

"Very good," said Cruz. "You have a minute to say hello before the judge arrives."

"Hello?"

Cruz nodded over her shoulder to Sera seated in the gallery behind him. The universe vanished for a heartbeat and for a lingering second it felt as though it had reappeared inside Lyle's chest, expanding at the speed of light.

"Hi," he said.

"Hi."

Her eyes were shining wet and her smile mixed with a host of other expressions and Sera pushed them back all at once, trembling with the effort.

Lyle said, "How did you know?"

"She left a message, Cruz did. Carla told me after–" Sera caught herself. Wiped her eyes.

"I'm so sorry," said Lyle.

"No," said Sera. "Please, not here."

"Okay, so, how are you?" Lyle winced. "Sorry, I mean, I don't know."

"You," said Sera. "Are *you* okay?"

"I will be. Nadine's good? With Carla?"

Sera grinned. "Sort of. Ray won't give her up."

"All rise." The bailiff was calling the court into session.

Lyle put his hand to Sera's face and said, "I love you." And Sera put her hand to his.

The judge bade the court good morning and everyone sat. Opening remarks were made and documents were presented. Cruz spoke. March spoke. The representative for the State's Attorney spoke. Lyle heard only the steady piercing tone in his ears. Cruz stood up and Lyle heard her say, "Yes, your Honor."

Lyle folded his hands in front of his face, just under his nose and breathed. The way he did when he put his nose to Sera's

neck after she fell asleep in his arms and he caught the echo of that memory in his hand from touching her face.

"Lyle." Cruz was motioning for him to stand and when he did she put a hand to his shoulder and said, "Time to do this, Lyle."

Lyle looked across the room to the judge draped in black and the sound in his ears was so loud it hurt. A shrill, humming wire piercing both eardrums and shivering down to his fingertips and stomach and knees and he forced himself to tune it out, to breathe and look at the judge and speak the words he'd spent more than twenty years trying to forget and through the noise he heard someone say to him:

"Please state your full name for the record."

ACKNOWLEDGMENTS

Peter Maravelis provided much-needed guidance through some dark woods during the writing of this book, which began as a writing jag in a cramped hotel room with Will Christopher Baer. Damir Zekhtser saved the very early pages from the shredder and gave me a place to stay, as did my brother, Mick, as well as Scott Krinsky who, along with Chris McGilvray and the Six Finger Films crew, brought one of the chapters to life with their short film, "Smoke & Mirrors." Bigtime thanks to Troy Jackson and Howard Swain for their respective portrayals of Icarus and Twenty-Long. Wendy Dale opened her door in Boliva during a critical phase of writing. Rob Roberge and was on hand for moral support and shelter, in no particular order. And Rob, along with Stephen Graham Jones and Caitlin Myer, provided invaluable editorial feedback on early drafts. David Corbett and Ed Bianchi stepped in with tactical support on some eleventh-hour plot logistics. My temporary home in Seattle would not have been possible without Sue Sinner, M.A.L, my sister, Shannon, and most of all my brother-in-law, Charlie Wright, who offered work, shelter, and many a (still ongoing) pint-fueled debate on all the really important stuff.

Barney Karpfinger, Cathy Jaques and Sam Chidley refused to give up on this book; Benoît Virot likewise believed in it, and Théo Sersiron's notes helped shape the story into what

finally arrived with my editor, Daniel Culver, who made this all happen.

A host of other good folks rode shotgun along the way: Jeff Aghassi, Ray Bussolari, Kareem Badre, George Griffith, Jason Wood, Steve Erickson, Patrick O'Neil, Jillian Lauren, Bernadette Murphy, Sara Gran, Robb Olson, Phil Clevenger and Frank Bill.

Finally, those who made the above short film, among other things, possible during all of this:

Dennis Widmyer, Rob Hart, Bob Demars, Richard Kriheli, Gordon Highland, Shawn Brenneman, Aaron Deering, Jimi Kallaos, Fred Nanson, Jeff Monico, Daniel Rehling, Steph Vander Veen, laura weir, Jess Stetson, Andrew Cook, Matthew Kopriva, the McGilvray Family, Eric Blair, Livius Nedin, Benjamin Langley, Freddie Arnold, Aaron Fischer, Jonathan Hoffer, Kevin Tieskoetter, Robert Bailey, Eve Edelson, Berto Martin, Ian and Christina Gilman, Kai Gradert, Dawn O'Brien, Brian Hicks, Timo Kiippa, Mike Peters, Duncan Westley, A. Illikainen, Peter Goutis, Mark Runnels, Marc Gallo, Jennifer Hefner, Blake Gentry, YankeeRunningDog, Ron Russell, Chi Lieu, Lorna Herf, Anthony David Jacques, Steve Yatson, Paul Fritz, Adam Rains, Greg Runnels, Tara Joeng, Matthew Kaley-Burton, Sean Krinsky, David Turner, Jason Tanamor, Matthew Vaughn, Erika Zavala, Logan Rapp, Caty Farley, Jonah Blossom, Kristin Layton, Guy Intoci, Roger Sarao, Brian Green, David Roberts, Trace Roberson, Layla Lyne-Winkler, John Feld, Dan Donche, Sylvia Wood, Harry Magnan, Chuck Richey, Christian Rogne, Kristin Keyes, Larry Weinberg, Yvonne Holecek, Ales Holecek, Jackson Ting, Jeff Robinson, Jerry Whiting, Matthew Joy, Scott Wells, Craig Crabtree, Danielle Duarte, Liana V. Andreasen, Svetlana Cherches, Cristian Tane and Paige Howie.

This is where I say, "I think that's everyone." But it's probably not. I guess I'll write another book and try again.